Christian Petersen Remembered

Christian Petersen

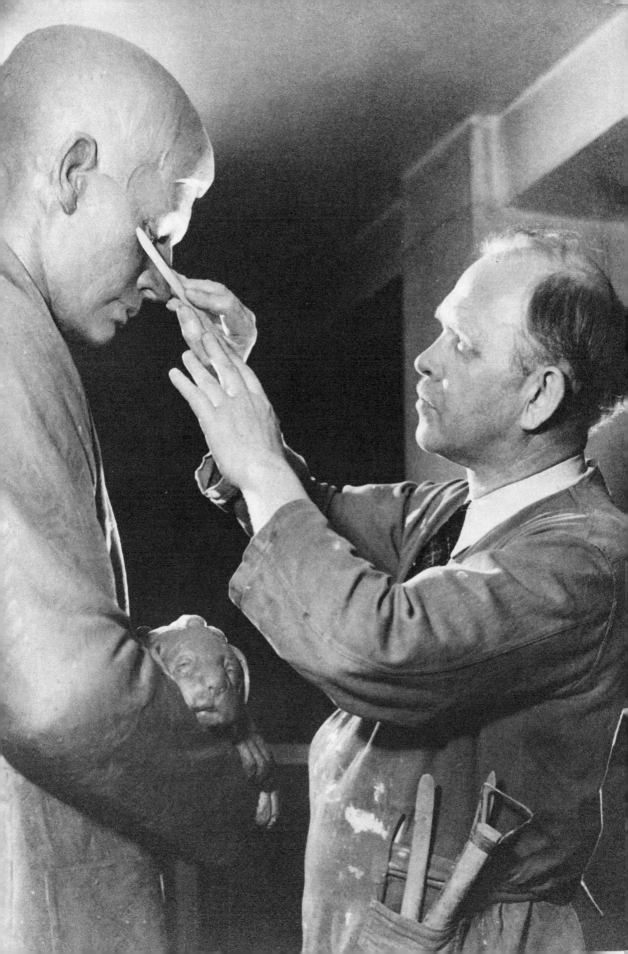

Christian Petersen Remembered

PATRICIA LOUNSBURY BLISS

 Iowa State University Press / Ames

For Charlotte and Mary—
and all who will remember Christian Petersen

ABBREVIATIONS FOR SOURCES OF FIGURES

CPP: Christian Petersen Papers, Department of Special Collections, ISU Library. In most instances, photographs were by staff of the Information Service.
AUTH: By author.
CONT: Contributed by source named.
CGP: Original photographs from the collection of Charlotte Petersen. Contributed to the author in May 1985. In many instances, name of photographer or source is not known.
SVO: Photographs taken on location by Connie Svoboda, senior student, ISU College of Design, 1984.
BRUN: Provided by the Brunnier Museum and Gallery.
ISU: Provided by the ISU Information Service.
CIAA: Provided by the Central Iowa Art Association, Marshalltown.

FRONTISPIECE: Christian Petersen, 1937. **CPP**, photo by John Barry.

© 1986 Iowa State University Press, Ames, Iowa 50010. All rights reserved. Composed by Heuss Printing, Inc., from author-provided disks. Printed in the United States of America.

Poems appearing in Chapters 4 and 6 reprinted with permission from the J. C. Cunningham estate.

Christian Petersen's unpublished writings and sketches reprinted with permission from Mary and Charlotte Petersen.

No part of this book may be reproduced in any form or by any electronic or mechanical means, including information storage and retrieval systems, without permission in writing from the publisher, except for brief passages quoted in a review.

FIRST EDITION, 1986

Library of Congress Cataloging-in-Publication Data

Bliss, Patricia Lounsbury.
 Christian Petersen remembered.

 Bibliography: p.
 Includes index.
 1. Petersen, Christian, 1884 or 5–1961. 2. Sculptors—Iowa—Biography. I. Title.
NB237.P4B55 1986 730′.92′4 [B] 86–21065
ISBN 0–8138–1346–8

Contents

Foreword

PAT BLISS has crafted a memorable and moving biography of the sculptor Christian Petersen. Her narrative of his remarkable half-century career is based on months of research on the Christian Petersen Papers and many productive interviews with Petersen's widow, the late Charlotte Garvey Petersen.

The author traces the sculptor's long career from early East Coast years to Iowa, when, in 1934, he joined Grant Wood's federal art workshop at the State University of Iowa in Iowa City. There he began his first project for Iowa State College, the bas relief sculptures for the Dairy Industry courtyard.

At forty-nine Petersen became temporary artist-in-residence at Iowa State. He remained there for twenty-seven years until his death in 1961. In an exceptional career as a resident sculptor, the Danish-born artist created hundreds of outstanding private portrait and studio pieces and thirty-eight sculptures for the college.

Thirty-three of his works can be seen today on the Iowa State University campus. Ten are nationally recognized campus landmarks, fifteen are important studio pieces or sculptures for building interiors, and six are superb faculty portraits (which remain from over twenty-three busts or plaques of faculty and staff members). Ten other notable Petersen sculptures are located in churches and schools in the Ames and Gilbert, Iowa, area.

In 1934 Iowa State College President Raymond M. Hughes understood the importance of the arts and humanities, not only in education, but in day-to-day living. Through his vision Charlotte and Christian Petersen came to Ames and began establishing an early tradition of sculptures created for a public college campus. This tradition is being renewed today on the campus through the efforts of many.

All of Christian Petersen's best works were created in Iowa. Although most are now owned by private collectors, major commissioned sculptures and studio pieces are publicly accessible in Marshalltown, Dubuque, Dyersville, Cedar Rapids, Mason City, Sioux Center, Ventura, and Des Moines. They represent the Iowa sculptor's extraordinarily diverse artistic skills and accomplishments.

Christian Petersen Remembered bestows well-deserved recognition upon both Christian and Charlotte Petersen. They once considered abandoning Christian's sculpture career for more lucrative commercial design work on the West Coast in the mid-years of the Great Depression. But together they decided to remain in the Midwest at Iowa State College, so that Christian could be a full time sculptor in an environment where he believed

an emerging American art would flourish.

We can be grateful for that significant career decision of over fifty years ago. Because of it Christian Petersen pioneered as a working and teaching sculptor at a land-grant college, creating a rich heritage of unparalleled three-dimensional art in Iowa and at Iowa State University.

Thanks are extended to Pat Bliss for patiently researching and writing this tribute to the artistry and love of the Petersens. Her initiative, coupled with Charlotte's remembrances, serve to remind us of the wonders of Christian Petersen—artist, teacher, father, husband, friend, and humanist—and the art he created for his beloved family, friends, students, and the communities of Iowa State and the world.

His sculptures are a state and national treasure that will bring pleasure to many, many people in years to come.

Lynette Pohlman, Director
Brunnier Gallery and Museum
Iowa State University

x

Preface

THIS BOOK began in March 1983, when the College of Veterinary Medicine at Iowa State University asked me to interview Charlotte Petersen, the widow of Christian Petersen, and record her memories of *The Gentle Doctor* sculpture, the veterinary bas relief mural, and other major landmark works her husband created for Iowa State College from 1934 to 1955.

As an Ames, Iowa, resident for more than thirty years, I recalled having seen several of Christian Petersen's outdoor sculptures at Iowa State, but beyond that I knew very little about him or his career. The question presented itself: *Who was Christian Petersen, really?* Most people on today's ISU campus know very little about the man or his career.

I had never met the late sculptor or his widow, whom I discovered to be a delightful and articulate octogenarian with a flair for enjoying literature and drama, and boundless Irish charm. One interview led to many more, and eventually to this book.

For two years, during many enjoyable conversations and lunch dates, Charlotte shared her vivid memories from past decades. I honored her request not to interview the Petersen's daughter, Mary, regarding her father's work at Iowa State. "She was just a growing child during those years," Charlotte wisely pointed out. "I'd like this to be a story written for her, too."

Charlotte's commentaries augmented research in the Iowa State University library and the Christian Petersen Papers in the library's department of special collections, along with interviews or correspondence with the sculptor's former students, friends, and associates. These combined sources gradually revealed a story punctuated with poignancy and humor. It is a *love* story, really. Charlotte and Christian were deeply devoted to each other and their daughter; they loved Christian's work, their friends, the bright young Iowa State students, and the enchanting world around them. Because they were in love with life, they accomplished much in their thirty years together.

Christian Petersen was a Dane, an American, and an Iowan whose artistic accomplishments were achieved with the help of Charlotte's enduring encouragement and devotion. Many surprising elements of his career have been undiscovered or unrecognized until now.

For example, Charlotte was delighted to learn that her husband created over 300 works in his lifetime, about a hundred of them before they met in 1929. "We never counted them," she noted. When she read the outlines for this book in September

1984, Charlotte offered this encouragement: "It will probably read like a novel because it will have a lot of drama and quite a cast of characters."

An Ames resident for more than fifty years, Charlotte moved to Rockford, Illinois in May 1985, to be near their daughter, Mary Charlotte. She died December 15, at the age of 86.

Both she and Mary read the manuscript for this book in the summer of 1985 and graciously approved it. Through Mary Petersen I located Christian Petersen's children by his first marriage and told them the book was scheduled for publication. They are: Helene Petersen Male of Vista, California; Lawrence Christian Petersen of Burbank, California; and Ruth Petersen Sollenberger of Burbank.

This is not meant to be a scholarly art history nor a critical appraisal of Christian Petersen's works. It is, rather, a narrative story and a biographical reporting effort. An overview of American art in the early decades of this century, however, is provided as essential background for understanding Petersen's career and works in the context of his era.

The Christian and Charlotte Petersen story has been untold for too long. It has been my privilege to discover it and write it.

P.L.B.

Acknowledgments

To longtime friend, Jay Serovy, for initiating this project and introducing me to Charlotte Petersen.

George-Ann Tognoni, Phoenix, Arizona, sculptor and former student of Christian Petersen, for her considerable artistic talents, friendship, and encouragement.

Beverly Gilbert Bole of Des Moines, who helped Charlotte Petersen convey her gifts of documents and memorabilia to the Iowa State University library department of special collections in 1972.

Isabelle Matterson, manuscript curator for the Christian Petersen Papers, who catalogued the superb collection; and to Stan Yates, Becky Seim Owings, Maria Valdes, and university archivist Laura Kline, for their assistance at the department of special collections, ISU library.

John McNee, director of public services at the ISU library, for many helpful suggestions regarding research sources.

Frank Ramsey, DVM, professor emeritus of the Veterinary College, for his keen appreciation of Christian and Charlotte Petersen's contributions to Iowa State.

Dr. and Mrs. John Salsbury, who generously provided the gift of the first limited edition bronze sculpture of "Pegasus" for the Veterinary College library.

John Anderson, editor of *The Iowa Stater* alumni newsletter, for publishing two stories which brought responses from readers in 22 states.

Lynette Pohlman, director of the Brunnier Museum and Gallery, for her interest in every phase of this project.

Ann Pellegreno, writer and friend, for editorial suggestions regarding the first manuscript draft.

Mary Petersen, for providing a collection of previously unpublished photographs for the book.

Dick Bliss, a loyal Iowa Stater who has shared the challenge of this project with me.

And, most of all, to these very special people who contributed their personal commentaries or valuable data:

Harriet Allen, Ames, Iowa
Louise Baker, Goleta, California
Viola Kietzke Barger, Sidon, Mississippi
Marian Moine Beach, Lakewood, Colorado
Louise and Harry Beckemeyer, Shaker Heights, Ohio
Jim and Margie Buck, Ames, Iowa
Dale Burrows, Huntsville, Alabama
Elizabeth Ann Clagg, Las Vegas, Nevada
Robert R. Cunningham, Fairfield Bay, Arkansas

James W. Dixon, Wilmington,
Ohio
John J. Edenburn, DVM,
Dell Rapids, South Dakota
Mac Emmerson, DVM, Ames,
Iowa
J. W. ("Bill") Fisher,
Marshalltown, Iowa
L. M. Forland, DVM,
Northwood, Iowa
Mary Jean Stoddard Fowler,
Houston, Texas
Martin Fritz, Madison, Wisconsin
Marjorie Garfield, Marco Island,
Florida
Patrick Gillam, Marshalltown,
Iowa
Marie Born Green, Lincoln,
Nebraska
Margaret Morgan Hauptmann,
Harrisburg, Illinois
John Herrick, DVM, Scottsdale,
Arizona
Mrs. Bayard Holt, Ellsworth,
Iowa
Glenn E. Jensen, Carmel, Indiana
Paul Frank Jernegan,
Mishawaka, Indiana
Bernice Kennedy, Santa Clara,
California
Edna Mortensen Kiely, Des
Moines, Iowa
Nile Kinnick, Sr., Omaha,
Nebraska

Maggie Kolvenbach, Mt. Kisco,
New York
The late Marion Link, Nevada,
Iowa
Miriam Lowenberg, Seattle,
Washington
Dycie Stough Madson, Godfrey,
Illinois
Ann Munn McCormack, Marco
Island, Florida
Lewis G. Minton, Louisville,
Ohio
Lois LaBarr Moses, Ames,
Iowa
Leo C. Peiffer, Cedar Rapids,
Iowa
Neva Petersen, Rochester,
Minnesota
Herbert D. Pownall,
Laramie, Wyoming
Helen Nerney Shaw, Warren,
Rhode Island
Marjorie Cunningham Shrigley,
Tucson, Arizona
Sheila Dunagan Sidles,
Centerville, Iowa
Bernard J. Slater, Ames, Iowa
Jean Stange, Mesa, Arizona
Martin G. Weiss, Beltsville,
Maryland
The late Dale G. Welbourn,
DVM, Neola, Iowa
Dori Bleam Witte, Sedona,
Arizona

PROLOGUE

A Letter from Grant Wood,
January 1934

"We came to Iowa on a shoestring."

—CHARLOTTE PETERSEN

CHRISTIAN and Charlotte Petersen were traveling west on the highways from Illinois to Iowa in the depths of a winter snowstorm and the Great Depression: mid-Janaury 1934. Their dilapidated old Ford joggled over rutted and snowpacked roads, bouncing the precious few household items and clothing they had hurriedly piled in the back seat.

Difficult weather and roads were mere matters for them, however. This was a joyful journey from Belvidere, Illinois, toward full-time work in Iowa City, Iowa, for the sculptor Christian Petersen.

The famed Iowa painter Grant Wood, who had hired him, expected Christian to report to the federal Public Works of Art Project in Iowa City. The workshop was housed in a converted swimming pool area of a building, which was an armory and gymnasium at the State University of Iowa for many decades. Christian was to be the lone sculptor among twenty-five painters working in the makeshift studio under Grant Wood's supervision.

Wood had earned sudden fame in the late 1920s for his precise paintings of the Iowa countryside and people. And when the federal government needed someone to direct a relief project for unemployed artists, he was a logical and willing choice.

Christian Petersen was to earn the standard workshop salary of $26.50 a week. Grant Wood had mentioned in a letter that Petersen's first project would probably be modeling bas relief gate markers for Iowa state parks. And he added, "You may be broke and need carfare. Wish I could advance you some cash, but I am broke, too."[1]

When Wood's letter arrived at 628 Buchanan Street in Belvidere, it was a total surprise to both Christian and Charlotte Petersen, neither of whom had ever met the famous Iowa painter. Because their finances were woefully thin, they borrowed two pennies for the stamp on Christian's eager

reply to Grant Wood:

January 18, 1934

Dear Mr. Wood:

Received your good news last night—thanks heaps. Best letter I have had since I don't know when. You are right, I am broke—else I'd be there today—as it is I don't believe I can be there before Monday—have to raise a loan for traveling expense. Wish I could make it sooner—but now I don't see how I can make it before Monday. See you then, making up for lost time. Rarin' to go, I am.

sincerely,
Christian Petersen[2]

Charlotte Petersen recalled in 1984, at the age of 85, that her Danish-born husband "gave out a big Nordic whoop for joy" while she danced an impromptu Irish reel to celebrate the arrival of Grant Wood's letter. She remembered how they "scurried around, borrowed gasoline money from an artist friend, and were on the road from Belvidere to Iowa City within two days.

"And that's how we came to Iowa—on a shoestring," she summed things up five decades later, adding a characteristic shrug and her usual light-hearted laughter.

Christian Petersen Remembered

1 A Journey from Denmark to America, *1894–1929*

"They came to a farm in Paxton, Illinois, but after a few years they moved to New Jersey, to be near the sea."

—CHARLOTTE PETERSEN on the Petersen family emigration from Denmark in 1894

AS a nine-year-old boy in 1894, Christian Petersen emigrated with his family from Dybbol, Denmark, to a farm near Paxton, Illinois. The Midwest American countryside resembled their beloved dairy farmland of Schleswig in southeastern Denmark.

Although they appreciated the quiet beauty and productive soil of the Illinois prairie land, the Petersens missed being near the sea. After about three years, they moved to another farm near the New Jersey coast, where they could sniff the fresh ocean breezes and taste salt in the air.

Peter and Helene Lorensen Petersen were Danes whose families had lived in the North Schleswig territory for many generations. The coastal meadows and fields of the province had been battlegrounds for Prussian-Danish wars in 1849 and again in 1864, when the territory was occupied by the Germans. By 1894, they were parents of two young sons, both of whom would one day be old enough for military conscription by the Prus-

sians. Perhaps one day they would be forced to wage war against their beloved Denmark.

Facing an uncertain future as Danish citizens living under Prussian rule, the Petersens sold their farm and emigrated to America, where they could live and work in peace.

In Denmark and in America, young Christian contributed his share of labor to the family farm work, vying with his brother for the privilege of driving the big draft horses with plow or cultivator or caring for the dairy herd. He loved working with the animals, often spending his spare time sketching the powerfully built work horses or the sleek, gentle cows. Many decades later he reminisced about his childhood days in a book titled *Iowa, Beautiful Land,* by Jessie Merrill Dwelle:[1]

I have been asked about the beginnings of my interest in sculpture. That is difficult to say. I believe the first tool I ever used was a chisel— even before using a pencil. I could have not been more than five or six when I began using

the tools in my grandfather's workshop.

This was in Denmark, after my grandfather retired from active work as a carpenter and pattern maker. In this shop, no tools fascinated me more than the chisels. I did not think of them as sculptor's tools. But I secured pieces of wood and made boat after boat, then took them down to the seashore, which came right up to our farm.

I don't know which gave me the most joy, making these little boats—sails and all—and copying the rigging of the sailing ships that passed, or sailing on imaginary voyages. However, the love of carving has been with me ever since.

Education of a young artist

At the age of fifteen young Christian Petersen entered Newark (New Jersey) Technical and Fine Arts School as an apprentice in the die-cutting trade. "I had always shown a desire to draw, which I did whenever I had the chance (sometimes when I should be doing something else) and on whatever kind of paper was handy," he explained. He worked on the farm during the daytime and attended evening classes at the Newark school. "Here, of course, I was put through the regular art education— even two years of architectural drawing," he added. Fascinated by architecture, young Petersen would have liked to become an architect, but he lacked funds for higher education.

Graduated from the technical school at seventeen, he began working days as a beginning die cutter, attending night classes at Fawcett School of Design in Newark for the next three years. Living at home and using his savings for tuition, Petersen enrolled for further art training at the Rhode Island School of Design in Providence about 1905.

A tall and handsome Danish-American at the age of twenty-two, Petersen enrolled at the Art Students League in New York. There he met young George Nerney of Attleboro, Massachusetts, who became his steadfast friend for the next fifty-four years. A photograph in the Christian Petersen Papers at Iowa State University shows Petersen with Nerney at a New York bar, posed with a schooner of beer, one foot casually perched on the brass rail, his derby hat tilted at a rakish angle.

George Nerney wrote many decades later: "I met Christian Petersen in the fall of 1907. We were brought together in a common bond of art interests . . . I was thrown in with Petersen in our local [Attleboro, Massachusetts] Y.M.C.A. gymnasium; we made frequent trips together to the Boston Museum of Fine Arts and Rhode Island School of Design; we were together in sketch classes that met occasionally in Attleboro."

"Through it all, I found Petersen to be a remarkable combination of physical and mental strength. In the gym he was like a young Viking god. In his quiet way of reading and acquiring knowledge, he always seemed to possess an unusual analytical mind; always quick to receive ideas with an eagerness to understand the problems which confronted him; having an unusual spiritual nature, a gentleness and consideration for others that alone would be sufficient to mark him as an exceptional man."[2]

The Art Students League, New York

The Art Students League was the premier American art education in-

4

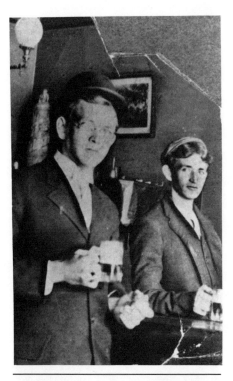

CHRISTIAN PETERSEN AND GEORGE NERNEY
IN A NEW YORK SALOON, CIRCA 1907. **CPP**

pany of Attleboro, a firm producing fine medallions and commemorative jewelry. Both were design artists, but Petersen also employed his training as an itaglio engraver and die cutter. Eventually, would-be artist George Nerney was pressured by his father to return to the family optical manufacturing business, the Bay State Optical Company in Attleboro. From there, Nerney kept in touch with Christian Petersen for the next forty-three years, mostly through long, well-written letters, which always discussed Christian's career, offered suggestions for sculptures, and included friendly words of encouragement.

Apprenticeship to sculptor
Henry Hudson Kitson

stitution at the turn of the century. At its zenith, the league could boast that such notables as sculptors Gutzon Borglum, Daniel Chester French, and Augustus Saint-Gaudens had once been students or faculty members there.

Christian Petersen studied life drawing under George Bridgeman, who was regarded as one of the best drawing teachers in America and was a distinguished league faculty member for four decades. The young Danish artist also attended classes at the Beaux Arts Institute of Architecture and Design in New York.

In 1907 Petersen and George Nerney worked for the Robins Com-

After Nerney joined his father's firm in Attleboro, Christian Petersen accepted an apprenticeship in Boston with English-born Henry Hudson Kitson, a distinguished sculptor who had completed a number of monumental works in America around the turn of the century, including "The Minuteman" at Lexington, Massachusetts. A superb bas relief and portrait artist, Kitson had been commissioned by the state of Iowa in 1904 for an Iowa Civil War Memorial in Vicksburg, Mississippi, at a fee of $100,000.

The monument is a semi-circular peristyle (crescent shaped) with Doric colonnades, measuring sixty-four feet wide and twenty-six feet high.[3] Kitson had won medals at both the Paris Exposition and the Columbian Exposition in Chicago in the late 1800s. He was in the prime of his career at the age of forty-seven when young Petersen

arrived at his Boston studio, eager to learn from the accomplished master sculptor.

The prestigious association with Kitson brought Petersen sculpture commissions from the state of Iowa in following decades. In about 1926 Edgar R. Harlan, director of Iowa's State Historical, Memorial, and Art Department, commissioned Petersen to do portrait busts of Young Bear and Pushetonequa, who were Iowa Mesquakie Indian chiefs.

Subsequently, Petersen created plaques or busts of Harlan; Des Moines *Register* editorial cartoonist Jay N. "Ding" Darling; pioneer Iowa business leaders Simon and Phineas Casaday and Henry Nollen; E.T. Meredith, secretary of agriculture under President Woodrow Wilson and later editor and publisher of *Successful Farming* magazine; and Henry Cantwell Wallace, secretary of agriculture under President Warren Harding and publisher of *Wallace's Farmer* magazine. Petersen was also commissioned to create bronze markers for the birthplaces of Iowa governors.

Beginning a die-cutting career in Attleboro

After about a year of work under Kitson, Petersen returned to Attleboro, where he married Emma L. Hoenicke in 1908. They established a home with a small studio at Third and Mechanic streets, where their three children were born: Helene in 1909, Lawrence in 1912, and Ruth in 1915.

The artist did freelance die-cutting work for many of the fraternal jewelry manufacturers in the city. One

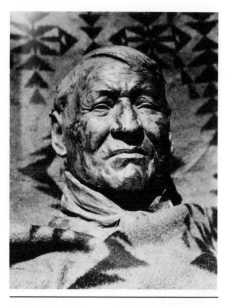

MESQUAKIE CHIEF YOUNG BEAR, 1930. **CGP**

HENRY CANTWELL WALLACE
OF IOWA, 1926. **GGP**

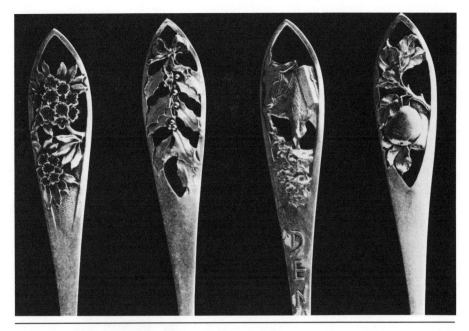

SILVER SPOONS FOR THE ROBINS COMPANY, ATTLEBORO, MASS., 1925.

of them was the Robins Company, which specialized in fine silver and gold medallions, collector's spoons in sterling silver, and commemorative portrait medals. With a family to support, die cutting took precedence over sculpting for Petersen. He earned an average of $400 a month, enabling the family to own their home and accumulate considerable savings. But he yearned to be a full-time sculptor.

Praise for the artist's die-cutting artistry

His friend George Nerney had words of high praise for Christian's artistry. In a letter to an Iowa writer several decades later, Nerney wrote: "Pete's work at the Robins Company was, for the most part, very constricting, but he did it with an honesty and skill in his craftsmanship of carving steel that would lead one to just talk in superlatives. His great strength, his simplicity of thought, his directness of approach gave a technique that has been unmatched."

A set of sterling silver spoons manufactured by the Robins Company, for which Christian Petersen crafted the minutely detailed openwork dies, earned praise from George Nerney:

If you could see the steel masters from which they were reproduced, you would see a type of craftsmanship that has been sorely neglected in the arts. Petersen's craft work has a better foundation than that of Eric Gill or St. Gaudens, when one was a stone cutter and the other a cameo cutter.

Nerney referred to early artistry in the fine jewelry industry by two artisans who later became distinguished sculptors. He obviously rated Christian Petersen's die-cutting work as exceptional. He explained, "If you could see a child's portrait, no larger than a thumbnail, which he made by chasing [engraving], you would know it to be one of the very choicest pieces of child portraiture that has ever been produced. The delicacy and firmness were marvelously combined."[4]

The Boston *Transcript* in June 1918 carried a profile story on Christian Petersen and noted:

> [Attleboro] for many years has offered industrial training in commercial art. According to the theory of the ancient guilds, it must, therefore, have turned out many a great artist or craftsman. It has turned out many good workmen but few noted artists. Yet it gives many opportunities. In the midst of them works Mr. Petersen, doing for his daily task the cutting of design in dies of steel, that terrible metal the conquest of which gives its masters such power . . . He has his own shop, to which come orders for work from the great factories. Here, when he has fulfilled those orders, his time is his own for sculpture.[5]

Beginnings of a sculpture career

Petersen was quoted in 1920 in another Boston newspaper, *The Traveler,* about his yearning to sculpt: "Die cutting was too mechanical. I wanted to do something more, well, more inspirational. That's why I started to model [in clay] a bit."[6]

Probably the first sculpture-in-the-round commission of Petersen's career was a Spanish-American War Memorial in 1913 for Newport, Rhode Island: a classic, womanly "Liberty"

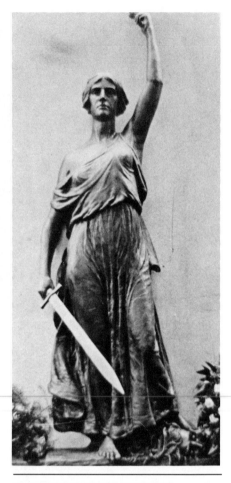

SPANISH-AMERICAN WAR MONUMENT, NEWPORT, R.I., 1913. **CPP**

figure holding aloft a torch and wielding a sword. This sculpture, placed in Equality Park, typified the war memorial sculptures erected in public parks all over America in that era. Late in life, he would look back on statues of this genre with disdain, including even his own such works. They were, however, bread-and-butter work for generations of American sculptors, whose

commissions were mostly from municipalities, states, or the federal government.

Sculpture in America was typically executed on a grand or often colossal scale until the turn of the century. The subjects were usually war heroes and statesmen, carved in the magnificently classic styles of the Greeks and Romans. Not until World War I did American sculptors begin to memorialize ordinary foot soldiers. Petersen was one of the earliest to do so.

In the 1920s he carved a bas relief medallion of a doughboy bayoneting a grotesque beast which represented war. Some years later, he turned again to a war theme in three studio pieces, none of which was ever commissioned. The first of these was a full figure sculpture titled *Carry On* in about 1920. It was based on a line from the poem "In Flanders Fields," by John McCrae: " . . . To you from falling hands we throw the torch." A mortally wounded soldier heroically passed the torch of liberty to his compatriots. The whereabouts of the half-scale sculpture are now unknown. In 1932, the sculptor proposed a full-sized bronze of that piece as an American Legion World War I memorial, but it was never commissioned.

Three other military-theme sculptures were created later in Petersen's career. Each war sculpture conveys the profound emotions of the artist concerning war, for which he had a deep and abiding hatred. The last of his war sculptures was so emotionally jarring for viewers that it was displayed publicly only twice—for brief periods—after World War II ended.

Petersen was not a pacifist, how-ever. Although he harbored a brooding concern about the civilian and military victims of war, he also showed sculptural fervor for the American role in both World Wars. Charlotte Petersen explained in 1983, "Christian was an old-fashioned patriot who was thrilled at hearing the 'Star Spangled Banner' and always took off his hat when the flag went by."

Early sculpture commissions in the East

The city council of Taunton, Massachusetts, signed a contract with Petersen in about 1920 for a low relief bronze memorial for a hospital nurse named Janie Flynn, who died during a civilian influenza epidemic in 1918. At about the same time, the artist created a small bas relief of a whaling ship for the Annie Seabury Wood Memorial at New Bedford, Massachusetts. That city, impressed with the first work, commissioned Petersen for the *Battery D Memorial* honoring area soldiers who served in an army artillery unit during World War I. The memorial was a bronze doughboy in full field uniform carrying an artillery shell ready for loading.

A widened reputation for superb portraiture and medallion work earned the artist a number of important commissions during the 1920s. He created bronze busts of three former Rhode Island governors: Emery J. Sans Souci and Aram Poithier in 1920, and R.L. Beekman in 1923. He is also known to have designed portrait medallions of President Woodrow Wilson, General John Pershing, the Rev. John Moore of Brooklyn College, Chief Justice

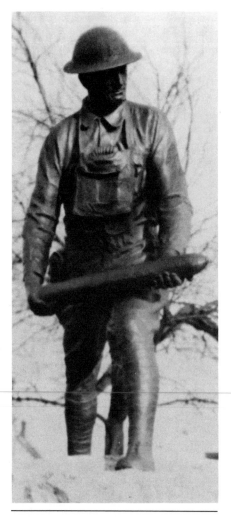

BATTERY D MEMORIAL, TAUNTON, MASS., 1913. **CPP**

Charles Evans Hughes of the United States Supreme Court, and Harvard President Charles W. Eliot.

Petersen created either bas relief or bust portraits of Dean Peter Lutkin of the music school and Bishop George C. Stewart of Northwestern University in Evanston, Illinois; Joseph and Franz Wood, founders of the Wood Brothers Threshing Machine Company in Boston; Cyrus Farnam, New York painter; Frank Ormand Draper, superintendent of schools in Pawtucket, Rhode Island; C. Arnold Slade, painter, of New York and Paris; John Cotton Dana, director of the Newark, New Jersey Art Museum; the Prince and Princess Bibesco of Rumania (probably the children of the reigning monarchs, of whom Henry Hudson Kitson had created portrait busts); Knute Rockne, Notre Dame football coach; and Father Sylvester de Escalante, pioneer missionary of Cedar City, Utah.

By the mid-1920s Petersen was carving numerous studio pieces (works which were not commissioned) and contract sculptures. One of his studio sculptures was a full figure study of John Burroughs, the naturalist, poet, and writer. Another was a full figure of Vitus Bering, Danish explorer who discovered the Bering Strait. In about 1919, he was commissioned for a bronze plaque memorial honoring Ruth Holden and Alice Illinsworth Haskell of Attleboro. The plaque was relocated at Sturdy Memorial Hospital in Attleboro during the mid-1950s. Another commissioned work in 1920 was a bas relief, the *Albert E. Scott Memorial,* a tribute to a World War I soldier from Newark.

The artist carved several major studio sculptures during the 1920s, but whether they still exist is unknown. One of these was a study of Edgar Allen Poe, which was either displayed or owned by the Boston Conservatory; another was a figure of a young Paul Revere. Of the latter, the Boston *Transcript* commented:

Because Paul Revere was a silversmith, Mr. Petersen has modeled a figure of him suita-

DEAN PETER LUTKIN, SCHOOL OF MUSIC,
NORTHWESTERN UNIVERSITY, 1931. **CGP**

ble to be set up in that city that has for many
years been a populous silversmithy as well as
a home for the making of many and varied or-
naments and articles of jewelry. In this place,
Attleboro, Mr. Petersen does his work. For the
likeness of Revere . . . he brought out the
youthful figure and the thoughtful face, the
young hands holding the silver vase and
measuring calipers. . . . The portrait qualities of
Mr. Petersen's work are remarkable.[7]

The sculptor was also featured in
a story in *National* magazine of Janu-
ary 1922. The story was approving of
The Frontiersman, one of Petersen's
many Lincoln studies. Because he

deeply admired Lincoln, he created a
series of thoughtful and unusual Lin-
coln sculptures during his long career.
The earliest piece "portrays Abraham
Lincoln as a young man at rest, after
splitting rails. . . . The sculptor has
molded the splendid proportions and
features of the immortal Lin-
coln . . . with such a vast degree of
accuracy and insight that one is almost
sure Petersen had known this, Ameri-
ca's savior, all his life!"

The *National* referred to Peter-
sen's figure study of naturalist John
Burroughs: "Himself a lover of nature
and of the woods and fields, Mr.
Petersen has found in this a mission
of work that brings out all that fabric
of interwoven nature and human na-
ture . . . a lasting memory of the man
as he was."[8]

End of a marriage and a die-cutting career, 1928

As Christian Petersen's East
Coast sculpture work began earning
him deserved recognition in the late
1920s, he was invited to exhibit pieces
in a number of galleries, including
East Orange, New Jersey; Providence,
Rhode Island; and the Harcourt Gal-
lery in Boston.

Having reached a decisive point
in his career, he decided to drop die-
cutting work and turn his artistic ef-
forts exclusively to sculpture.

Encouraging words came from
George Nerney, who strongly advised
his friend "Pete" to expand artistic
horizons and become a full-time
sculptor. Whenever Christian Petersen
encountered either triumphs or
tragedies in his life, Nerney was
there—if only through his voluminous

letters—advising his friend to think, dream, and grow as a sculptor.

But when Christian told his wife Emma what he planned to do, he encountered her vehement opposition. His die-cutting earnings were substantial and he was assured a lifetime career in that trade. Devoting his efforts solely to sculpture probably seemed to her a tremendous financial risk. Apparently a number of other conflicts had smouldered and flared between them over the years. Because their differences were irreconcilable, the marriage had become unbearable for both. When they agreed to a divorce in 1928, their youngest child was about fifteen years old and the other two were grown and self-sufficient. Petersen signed over their home and entire savings to his former wife and departed for Chicago in late winter, 1928. He was determined to begin a new life and career in the Midwest.

All he took with him was a battered suitcase with clothing and a few sculpting chisels. In his pocket was a signed contract to create *Fountain of the Blue Herons* for the A. E. Staley Company in Decatur, Illinois.

The Midwest: scene of a new American art

For more than a decade as a sculptor in Attleboro, Christian Petersen had resented the trendsetting influence of the eastern America epicenters of art. In the mid- and late 1920s New York was seething with ongoing struggles between classic and modern artists, critics, and galleries.

He saw wide-open opportunities for artists in the Midwest, away from the European-influenced art milieu of the East Coast. Regional painters Grant Wood of Iowa, Thomas Hart Benton of Missouri, and John Steuart Curry of Kansas were winning national recognition for their uniquely American subjects and styles, which were part of the "new wave" of a genuine American art.

As for sculpture, Petersen revered Lorado Taft of Chicago, whose pupils were creating notable works across the Midwest. A naturalized American since the turn of the century, Petersen loved his adopted country and wanted to become a sculptor among the regional painters of mid-America.

Richard D. McKinzie in *The New Deal for Artists* (1973) deplores the early 1920s art scene. "A name for its own sake became important, talent and the quality of individual paintings were often ignored, and prices of art works depended upon the artist's rank in the 'star system.'"[9]

An emerging American art was cited by Thomas Craven in a 1934 *Harper's* magazine article, "Our Art Becomes American."[10] Citing the new regionalist painters, Craven said:

These men have taken art into the open air, away from the jurisdiction of specialists, esthetes, Bohemians, and political fanatics, and have placed it in reach of the people. . . . Grant Wood is here to stay, a powerful factor in our declaration of independence in art, despite the attempts of the New York followers of international theories and French processes to treat him as a fad. [Wood is] the pioneer in the regional movement of art in America.

Craven noted that the new American regionalists "have not come from a land of abstractions, but from the great productive center of the nation, where . . . the industrial and agrarian as well as the cyclonic things of un-

tamed nature, are of supreme importance. . . . " And he concluded: " . . . the only fundamental truth for the artist is life as it is actually lived."

Christian Petersen returns to the Midwest

Three decades after he began a new life and career in the Midwest, Christian Petersen explained why:

My youth was not in Iowa. My first visit to Iowa was sometime in the early twenties, if my memory serves me right. I went there at that time to do a portrait for a medal—the subject being the then president of Bankers Life, George Kuhn. This led to several other commissions—among them relief portraits of Frederick M. Hubbell and Henry Nollen, as well as some others.

This visit was all I needed. The country and the people so impressed me that I longed to return to the Midwest. And eventually I came back—with the feeling that probably here was the place, in the very heart of America, where an American art might flourish.[11]

Petersen was destined to be part of the "new wave" of American art. He would follow a trend that was noted by Rene d'Harnoncourt, director of the Museum of Modern Art in New York and one of the few eastern authorities who expected "real American art to spring from the Middlewest rather than the East."[12]

In the 1920s Petersen had created a portrait bust of John Cotton Dana, head of the Newark museum. Dana was also a strong advocate for an emerging American art. During their portrait sessions, Dana probably encouraged Petersen to pursue a sculpture career in the Midwest, where the regionalist painters were pioneering in new American subjects and styles.

As he headed by train from Attleboro to Chicago in 1928, the artist was determined to bring sculpture into the everyday lives of Midwest Americans. He believed they were uninfluenced by critics' choices of what was supposed to be beautiful or popular. In later years he looked back on his views of art in 1928.

A number of years ago, I had the feeling that the center of culture would eventually find itself in the Middlewest. I felt the East had so much conscious culture that it was subject to spells of indigestion—and it was taking to 'isms' as some folks take to patent medicines.

Here in the midwest, I felt folks would be more natural, and I have found it so in the main. There are some who are ruled in their judgment by what the professional critics and writers say. Some critics are honest and in earnest, but much of our criticism is what is now termed a "racket."

So judge for yourself. Create an American art, here in the rich soil of the middlewest, where America has its roots. Here shall be the soil and the seed and the strength of art.[13]

Collapse of the American economy—and Petersen's career

After arriving in Chicago, Petersen wrote Edgar R. Harlan in Iowa asking him to ship the busts he had sculpted of Mesquakie Indians Young Bear and Pushetonequa to an exhibit at Kroch's Chicago Gallery.[14] He also inquired about shipping the busts of Harlan and Jay N. "Ding" Darling, editorial cartoonist for the Des Moines *Register*. The sculptor told Harlan that the Pennsylvania Academy of Art was interested in showing them and the Indian portraits at its 1930 annual exhibition.

Petersen was living temporarily at the Chicago Y.M.C.A. in late October 1929, when the stock market collapsed

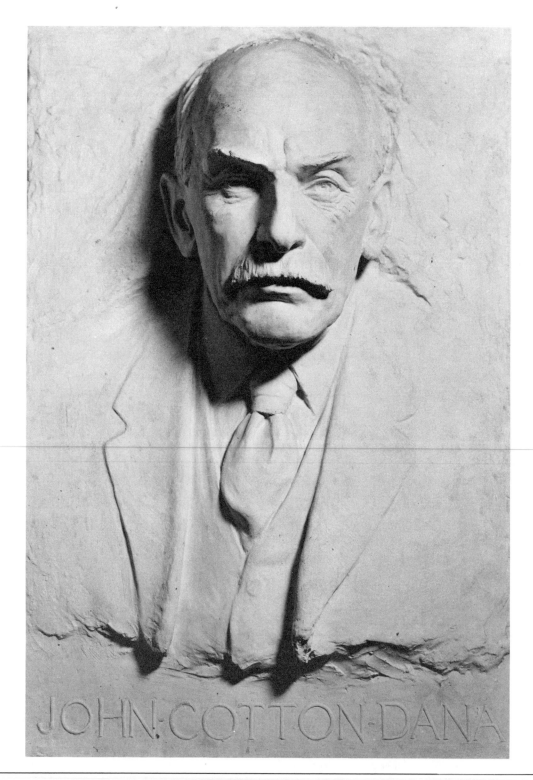

JOHN COTTON DANA, DIRECTOR OF NEWARK, N.J. ART MUSEUM, 1920. **CGP**

and the financial disaster of the Great Depression began. As November went by, his plans for a new career dissolved, along with the hopes and dreams of many other Americans. When the sculpture commission for the Staley Company was hastily postponed, he was jobless and almost destitute.[15]

The artist owned little more than the suit he wore and a few coins in his pocket when he decided to seek temporary work as a die cutter. The immediate goal was money for food and shelter. His sculpture career would have to wait while he resumed die cutting—if he could.

In late November 1929, Petersen walked into the offices of the fine jewelry manufacturers Dodge and Asher. There, two fortunate events occurred: he was hired immediately as a die cutter, and he met a charming young Irish-American woman named Charlotte Garvey.

A stolid Viking meets an elfin Irishwoman

Charlotte Garvey Petersen vividly described the first time she met Christian Petersen: "It was just after the Depression hit us all. I was lucky to be working as a secretary for a company called Dodge and Asher, and Christian came in seeking die-cutting work. They specialized in fine jewelry, trophies, fraternal emblems, and awards. Apparently Christian Petersen had worked for the company's East Coast business, and they knew he was one of the four best die cutters in the industry."

She described his entrance into her life:

One chilly November day, a tall, polite man in a rumpled suit and wearing no overcoat came out of the cold and into our office. He asked me if he could see Mr. Asher. I ushered him into Asher's office and asked if he minded waiting a few minutes, because Asher hadn't arrived yet.

Eventually, my boss did get there, and soon I heard the two men talking in the other room. I was enchanted with Christian's interesting, soft voice and his manner of speaking. So, on some pretense or other, I went into the office to leave some papers on the desk so I could get another look at this man Christian Petersen.

That day, he looked so old, so tired. But I saw that he was sketching, and there, on the paper, was a beautiful figure taking on life, right there as he worked. So I tiptoed out.

Fifteen minutes later, he walked out of Asher's office, tipped his battered hat, and thanked me for allowing him to see Mr. Asher. Then he strode down the hall, whistling an opera theme called "Women are a fickle lot." He had arrived at our office a tired and somewhat defeated man. But he strolled out with a job and a jaunty air about him. I liked that.

He was hired to start work the next day, at a hundred dollars a week. I was very much impressed with Christian Petersen.

Christian Petersen was a tall, ruggedly built, somewhat stoic Dane, while Charlotte Garvey was a vivacious, outgoing, and diminutive Irish-American. It was an unlikely match of personalities, but Charlotte was entranced by his quiet, polite Scandinavian ways, and Christian was buoyed by her Irish charm. After several weeks of work at Dodge and Asher, Christian had admired her only from afar. He finally asked if he could walk her home from work, and after several delightful walks, he invited her out to dinner.

Their courtship lasted two years, "Pretty typical for those times," Charlotte Petersen said. Because she had lived in Chicago for a number of years, she knew how to arrange inexpensive tickets for concerts, the opera,

and the theater. "Christian loved movies," she noted, "so we enjoyed those, too. And he really enjoyed my cooking."

Charlotte has always preferred not to talk about Christian's life before they met that year in Chicago. "All I know," she has said, "is that Christian was a lost soul when we met."

The aspiring sculptor was sombre, introspective, and despairing when he met Charlotte. She was a blithe spirit, ebullient and cheerful, a woman who loved life and found a great deal of humor in it.

This fortunate encounter of a rather stoic Viking and an elfin-humored Irish woman was to become a partnership of complementing contrasts. When they announced their forthcoming wedding in 1931, however, their friends and relatives were dubious about the match. A long and successful marriage seemed unlikely between a deeply devout Irish Catholic and a disillusioned Danish Lutheran.

Furthermore, Christian was forty-six and Charlotte was thirty-one. He was an artist, a pensive man with an intensely creative mind, who had abandoned a well-paying job on the East Coast to pursue his sculpture ambitions. Charlotte was a capable office secretary, with a streak of independence and a finely-tuned sense of the comedy in life. Outgoing and articulate, she had a flair for drama and a love of poetry and literature. Christian stood well over six feet two inches tall, with a rugged Scandinavian physique. Charlotte "was a whole foot shorter, and I tended to be a bit plump," she explained in later years. "We were quite a pair."

Furthermore, Petersen was a divorced man. That carried a stigma, not only because it was forbidden by Roman Catholic church law, but also because it was frowned upon by the Danish Lutheran Church and American mores of the era. Neither Christian's nor Charlotte's families were enthusiastic about the nuptials.

Charlotte summed it up in her usual pragmatic style: "He needed my youth and enthusiasm, and I needed his maturity and strength. We were a good match, and we knew it. And we just didn't care what other people thought about it." She added, "He needed me, and I needed him. Through all our years together, Christian's enduring patience helped me, and my eternal optimism helped him."

They were married December 15, 1931.

2 A Scandinavian-Irish Partnership

"Raymond Hughes and Edgar Harlan brought us to Iowa."

—CHARLOTTE PETERSEN

AFTER their wedding, Christian continued die cutting for Dodge and Asher while Charlotte worked as the office secretary. They carefully saved most of their paychecks for the day when Christian could return to full-time sculpting.

With Charlotte's encouragement, Christian temporarily rented a small studio in Chicago early in 1932 to resume work on *Fountain of the Blue Herons* for the A. E. Staley Company in Decatur, a commission that had been temporarily postponed when the economy collapsed in 1929.

But by mid-1932 they were weary of city life. They had been invited to share a large old mansion in Belvidere, Illinois, owned by Juliet Sager, a longtime friend of Charlotte's, and so they resigned their jobs and moved there. Christian repaired various items in the house and stoked the coal furnace as payment for their rent. Living expenses were from their savings.

The Petersens planned to live temporarily in Des Moines during the summer while Christian worked on portrait sculptures arranged by Edgar Harlan. If all went well, they would spend another six or seven months in Des Moines again in 1933. By then, they hoped to buy the Belvidere house as a combination studio and home. With that in mind, they eventually signed a handwritten agreement with Juliet Sager noting their intent.

As the Depression continued to send recurrent shock waves through the American economy, it was obvious that major sculpture commissions would not be likely for Christian Petersen. Their first two years of married life "were full of joy and disappointment," Charlotte recalls, "but we worked together to arrange the Des Moines portrait contracts to keep us going."

The portraits that brought Christian and Charlotte to Des Moines for two successive summers were instrumental in bringing them back to Iowa permanently.

Americans in distress, 1934

Just before the new year of 1934, the Petersens—like many Americans—had endured a long and grim economic siege, which had brought financial disaster and unemployment to millions, many of whom lost homes, farms, businesses, life savings, and jobs. After Franklin Delano Roosevelt was elected president in November, 1932, his new administration rapidly embarked on a series of programs in 1933 providing emergency employment and relief funds for Americans who lacked grocery and shelter money.

Christian and Charlotte were typical of many other people who were too self-reliant to accept federal relief. They shared the house with Juliet Sager and spent the last of their savings for food and coal while Christian sought work—any kind of labor—in late 1933.

Time magazine for January 19, 1934, summed up the status of Americans who were victims of the shattered economy.[1] A below zero cold wave had swept the nation the previous week, adding to the miseries of "20 million people with no means of obtaining fire or food, except from the public purse." New Deal administrator Harry Hopkins had been authorized to set up emergency relief programs to provide four million people with cash for food and fuel in the midst of the winter's bitterest cold.

Four million Americans were to be employed in the government's new Civil Works Administration (CWA). Congress had agreed—except for one lone dissenting vote—that $950 million would fund CWA programs in the

fifth winter of the Great Depression.

In authorizing a new grant to the CWA, the Public Works Administration funded repair and decoration of schoolhouses and public buildings, along with road construction and public health projects. Grant Wood was appointed director of an art group assigned to create original murals for Iowa post office buildings and for Iowa State College, a land-grant institution in Ames. And, although Christian and Charlotte Petersen had no inkling of it, a Public Works of Art Project sculpture program was developing at Iowa State College that would launch a twenty-one year career for Christian as artist-in-residence. There, he would create faculty portraits and a series of major landmark campus sculptures unparalleled in American art and educational institution history.

Time magazine also cautiously mentioned a temporary federal government problem: a budget deficit estimated at over $25 billion. Most economists viewed the situation as a necessity, however, to be easily overcome when America's economy regained productivity and stability.

For 20 million Americans, food and shelter needs were urgent. Because no federal relief programs had previously existed, homeless, unemployed, and hungry people had to depend on community charities for sustenance. Many persons who had lived frugally all their lives, saving money for "rainy day" emergencies, were stunned when their savings were wiped out in bank failures. Federal insurance protection for savings accounts was enacted too late for them.

A financially fortunate element of

American society had few worries about mundane matters like paychecks or grocery money. For those whose life savings or jobs remained intact, *Time* advertised a nineteen-day Caribbean and West Indies cruise for $235, a new Studebaker sedan for $665, a revolutionary new automobile called the "Chrysler Airflow" (billed as a triumph of American automotive engineering and later established to be just that), and an innovative business product called the "electromatic typewriter," manufactured by a young company called "International Business Machines."

Along with millions of other Americans, the Petersens were without any negotiable assets. They owned little of value except for an old car. Their total resources were their combined talents, energies, ambitions, and determination to weather the economic storm.

Iowans in a shattered economy, 1934

The stolid Des Moines *Register* in late 1933 boasted 238,231 statewide circulation.[2] It helped spread the good news across Iowa that farmers would be loaned 45¢ a bushel on their unsold corn in a new federal program aimed at putting $15 million back into circulation by Christmas. Seventy-two million dollars were earmarked for Iowa farmers in 1934. One farmer was reported to have applied for $135,594 in corn loans, an astonishing sum, which rankled the beleaguered farmers who were trying to retain ownership of their land. Critics predicted that speculators would buy cheap corn, borrow federal loan money on it, and

use those funds to purchase land at distress prices from destitute farmers. Undoubtedly this did happen and fortunes were made on the misfortunes of others.

In the quiet little college town of Ames, Iowa, the *Tribune-Times* published an editorial that viewed the projected $25 billion national debt as reasonable in view of the hard times.[3] A front page story noted that within two days after the new law took effect, the Federal Deposit Insurance Corporation (FDIC) insured $850,000 deposited in Ames banks. Longtime Ames residents recalled five decades later that much of that money had been hoarded bills and coins, previously stashed in mattresses and buried in coffee cans around town during nationwide bank "holidays" and failures.

At Jameson's menswear store, new suits were advertised for $19.50. The classified ads offered home butchered beef for 5¢ a pound, stewing hens at 11¢ a pound (live weight), and pork chops for 12¢ a pound. Only one job opening was listed, for "a live-in hired girl" at $3 a week.

Most of the 10,000 Ames residents were not exchanging cash for much of anything except groceries and coal. Only two houses were advertised for rent in town, and only one was listed for sale. A *Tribune-Times* story noted that 300 Story County families received emergency food in a government relief program in January, while a society page story reported that the Ames Golf and Country Club completed "another successful year" in 1933 with a total of 200 family memberships.[4]

Ames was riding out the depression with remarkable stability because

many of its residents were fortunate enough to be employed by Iowa State College or the Iowa Highway Commission headquarters there. Although budgets and pay rates had been cut by the college, faculty and staff people retained their jobs and paychecks. The college administrators later reported to the state board of education that no layoffs or terminations occurred from 1930 to 1934, despite falling enrollments and funding during the first four years of the Great Depression.[5]

Sojourns in Des Moines, Iowa: 1932 and 1933

Correspondence by Edgar Harlan about the Petersens reveals a poignant story about the first of Christian and Charlotte's two sojourns in Des Moines.[6] In 1932—the first year of their marriage—they lived for several months in the Iowa capital city while Christian finished work on portrait commissions arranged by Harlan. The sculptor did a magnificent bust of former Governor George W. Clarke for the Iowa Historical Museum in Des Moines. In later years he created portrait busts of governors Clyde Herring, Nelson Kraschel, and George Wilson.

Their new Des Moines friends kept Charlotte and Christian busy in a whirl of social events. "We spent many evenings on the porch of Governor Clarke's home in Adel," Charlotte fondly remembered, "enjoying the view on a warm summer night."

Often invited to dinner by prominent Des Moines people, the Petersens were grateful for the social courtesies—and even more appreciative of the food. Their hosts were unaware that the Petersens might not have eaten for a day or two. Five decades later, Charlotte told how Christian admonished her one evening before they went to a dinner party: "Charlotte, don't eat too much." She explained: "We hadn't eaten for about three days. Our hotel bill was so big we just couldn't move out, so Christian was doing a bust portrait for the owner in part payment." Charlotte continued, "When we were getting ready to go to the dinner party, Christian warned me not to overdo it on eating. He was afraid I'd get sick from too much good food after having nothing to eat for quite a while."

She added that both of them were so hungry, "We could have eaten the tablecloth."

The Harlan correspondence includes brief letters regarding Christian and Charlotte Petersen's 1932 stay in Des Moines, when they lived at the Elliott Hotel and accumulated a bill of $165. The state of Iowa and the Des Moines people who had commissioned portraits were painfully slow in remitting fees for Christian's work. A hundred dollars for a portrait of a child was not a significant amount for a wealthy Des Moines family, but, "It was all the money in the world to us," Charlotte Petersen remembered, "and we were too proud to ask people for the money they owed us."

Christian and Charlotte had attempted to live on fifteen cents a day for food for almost two months. After Christian lost twenty pounds and became ill with pneumonia late in 1932, Charlotte appealed to Harlan for payment from the state of Iowa for the bust of Governor Clarke, explaining that they were "a little short of cash" and needed funds for living expenses.

GOVERNOR GEORGE CLARKE OF IOWA, 1932 PORTRAIT BUST. **CGP**

Harlan was concerned and dismayed. He felt personally responsible for the late payments and was chagrined that prominent—and wealthy—Des Moines people who had ordered portraits at very small prices were neglecting to pay the artist promptly. After a few telephone calls to key people, Harlan and a group of the Petersen's Des Moines friends located a comfortable boarding house for them, quietly paid their hotel bill, and saw to it that portrait fees owed Christian were promptly paid. Harlan then escorted Christian and Charlotte as his guests on a week-long car trip through Iowa, showing them some of the scenic and historical spots along the way. The trip ended with a visit to the Iowa State College campus and an introduction to President Raymond M. Hughes.

Looking back on Christian's first meeting with Raymond Hughes, Charlotte commented: "He came out of that big building, bounded down the long flight of steps two at a time, and told me 'I think Hughes has something going here, maybe a sculpture commission.' " As the difficult months of 1932 rolled by, however, they forgot about that possibility.

When Christian and Charlotte returned to Belvidere late in 1932, he began work on a sculpture for the Mishawaka (Indiana) Centennial Commission, for which he had signed a contract earlier in the year.

Mishawaka, Indiana—an unfinished sculpture commission

In the city of Mishawaka, Indiana, a bronze tablet erected in 1932 marks the location of a sculpture that Christian Petersen never completed—through no fault of his.

Petersen carved preliminary models for a sculpture of Princess Mishawaka, for whom the city was named, but was never permitted to finish the commission.[7]

A Mishawaka Centennial Foundation adviser recalled: "My father . . . was instrumental in commissioning Mr. Christian Petersen of Chicago as the sculptor for the proposed bronze statue to memorialize both the centennial of the city's founding and the . . . legend surrounding the naming of Mishawaka." Paul Jernegan explained that Petersen completed a low relief preliminary sketch and two small-scale models for the project, which was to be located "near the south bank of the St. Joseph river . . . called Lincoln Park."

A centennial committee sponsored a sculpture fund-raising carnival on the main thoroughfare of the central business district, but Jernegan said that "the carnival failed to produce the anticipated revenues. Consequently the bronze sculpture was never executed in the depressed economy of the times. This was always a bitter disappointment to my father and the entire committee . . . this single failure to realize the planned permanent memorial spawned many distorted stories and rumors through the years."

Rumors at that time hinted that sculptor Christian Petersen ran away with the carnival proceeds, which Jernegan and his father emphatically refuted at the time and ever after.

"During the thirty years that I maintained an architectural office in Chicago (1950–1980)," Paul Jernegan stated in 1983, "efforts were made to locate Mr. Petersen, but without suc-

MODEL FOR "PRINCESS MISHAWAKA" SCULPTURE, 1933. **CONT** *Paul Frank Jernegan*, 1983.

wars. Treacherously wounded by her jealous Indian lover, she was rescued and protected by her white lover whom she marries."

The plaque includes this legend: "The monument was planned and the tablet given by the local Lions Club. Erected in 1932. Christian Petersen, sculptor."

The Milwaukee Lincoln Competition, 1933

Typically Christian Petersen shrugged off such disappointments as the abandoned Mishawaka project, turning his energies toward new projects, never regretting past disappointments. Charlotte recalled a 1933 Milwaukee competition for Abraham Lin-

ABRAHAM LINCOLN,
FOR MILWAUKEE COMPETITION, 1933. **SVO**

cess." Jernegan was pleased that the coincidental occasion of the Mishawaka Sesquicentennial in 1983 was an opportunity for him to correct any erroneous information that may have existed in the city historical archives.

Jernegan described the sculptor's models for the proposed bronze statue of "Princess Mishawaka." An eight-by-thirteen-inch bas relief and two eighteen-inch figures were submitted by the artist in his proposal for the full-figure bronze sculpture. The Princess Mishawaka is memorialized on the bronze tablet: "The daughter of Chief Elkhart was buried near this spot, in 1818, dying at the age of thirty-two. She was a beautiful, graceful, athletic and brave Indian maiden, the central figure in the local Indian

coln sculptures, for which Christian created a small plaster model of a seated, informal Lincoln. The piece won an honorable mention in the awards, but Charlotte explained "We later found that the winner had been prearranged; Christian's work had absolutely no chance, nor did any of the more than forty other pieces other sculptors had entered." She said that "Christian decided not to enter any more of these competitions, because it was expensive to ship a model to them and pay to have it shipped back." The small model was purchased thirty years later by the Gilbert, Iowa, public schools and has been displayed there since.

Belvidere, December 1933

As the 1933 holiday season began, Christian and Charlotte Petersen found themselves with exhausted financial resources. New sculpture commissions were not forthcoming, nor could Christian afford materials for studio pieces. They were sharing the house with Charlotte's friend Juliet, who by then was well aware the Petersens could not afford to buy the property as they had planned to do a year earlier. Christian was trying to earn money for food and fuel by working at any kind of labor, but he was competing with many other breadwinners in the town. Charlotte recounted that nevertheless they celebrated their second wedding anniversary and the Christmas season "with joy, because we were thankful to have shelter—and each other."

December 1933 began a series of bitterly cold days and nights. The Petersens were living mostly on pen-

nies, determination, and Charlotte's enduring optimism and humor when an unexpected letter arrived from Grant Wood inviting Christian to join the federal art workshop in Iowa City, Iowa.

Unbeknownst to Charlotte and Christian, Iowa State College President Raymond M. Hughes had collaborated with Edgar R. Harlan in late 1933 to begin a letter-writing campaign in behalf of the Danish sculptor. They enlisted help from influential Des Moines friends of Grant Wood.

In his earlier years as president of Miami University in Oxford, Ohio, Hughes had encouraged students to discover art, music, drama, literature, and the world of ideas—then called the "liberal arts," in later decades "the humanities." Charlotte Petersen praised President Hughes because he "had a reputation for bringing artists, poets, drama groups, or musicians to the Miami campus whenever he could. And he wanted to do the same thing for Iowa State College."

While working in Des Moines in 1932, Petersen was commissioned by Raymond Hughes to create a posthumous portrait bust of Louis Pammel, a pioneer scientist in botany and bacteriology at Iowa State College until his death in 1931. Working from photographs, Petersen created a bust portrait, which was inspected by a committee of college officials well acquainted with Pammel. The likeness was unanimously approved. In fact, one of the delegation, Mirsada Hayden, surveyed the portrait and was obviously astounded, according to Charlotte Petersen, who remembered Miss Hayden exclaiming, "It breathes!" When the committee gave its favorable verdict to President

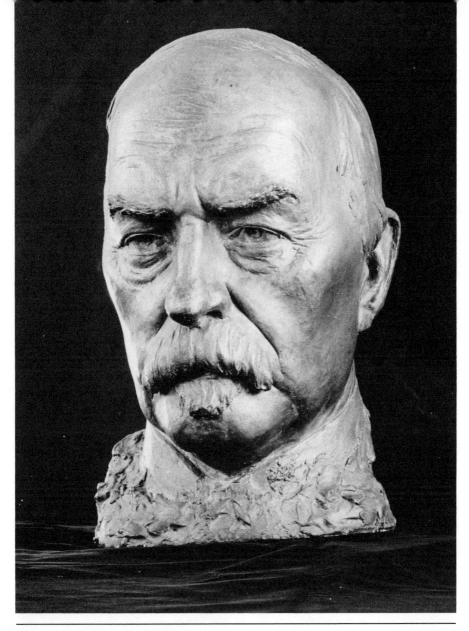

LOUIS PAMMEL, IOWA STATE COLLEGE,
1933. **CGP**

Hughes, he knew that Christian Petersen's talents would be welcomed at Iowa State.

In mid-1933, as President Roosevelt's new public works programs were being launched, Hughes discovered a way to bring the sculptor to the Iowa State campus. He contacted Edgar Harlan, and suggested that influential Des Moines people who knew Grant Wood write him recommending Christian Petersen as a valuable addition to Wood's Iowa City federal art workshop.

A letter-writing campaign

While Christian and Charlotte lived temporarily in Des Moines in 1932, the sculptor worked on bronze bas portraits of Gardner Cowles, publisher of the Des Moines *Register and Tribune* and his son, Gardner Cowles, Jr. In 1933, his major commission was a series of bronze portrait plaques of officers, directors, and founders of the Equitable Life Insurance Company, including Frederick Marion Hubbell and his sons. As the word spread through Des Moines social circles that an exceptional portrait artist was temporarily residing in the city, more commissions came to Christian Petersen from families who wanted bas reliefs of their children. He was also contacted by civic and municipal committees who wanted to commission memorials of founders and philanthropists.

Responding to Raymond Hughes's suggestion, Edgar Harlan recruited Des Moines *Register* columnist Harlan Miller, newspaper executive Reese Stuart, Jr., and cartoonist Ding Darling for a letter-writing campaign directed at Grant Wood. Darling had generously shared his own studio space with Petersen and was instrumental in promoting a 1933 showing of his works at the Younkers Tearoom Gallery, the only showcase for art in Des Moines in that era. A sudden flurry of unsolicited letters about Petersen from a number of influential Des Moines people reached Wood in the waning weeks of 1933.

Wood wrote Petersen a somewhat apologetic letter in early January, 1934, explaining that he would like to find an appointment for the sculptor, but he mentioned "filled quotas" for

GARDNER COWLES, SR., 1932. **SVO**

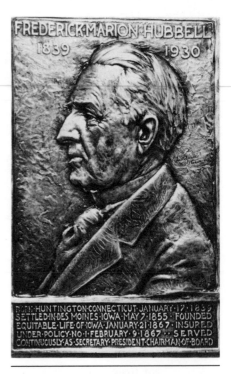

FREDERICK MARION HUBBELL, 1933. **SVO**

Iowa artists and expressed doubt that a resident of Illinois could qualify.[8] Christian had never met Grant Wood and was therefore surprised by the initial letter. Charlotte said that her husband placed little hope that anything would materialize. "He shrugged it off and forgot about it," she added.

Apparently Wood was impressed by Petersen's recommendations, because he did find an appointment for him shortly after the first letter. On January 18 he invited the artist to join the Iowa City art workshop. When Hughes and Harlan heard that their friend was appointed to the Iowa federal art project, they must have congratulated each other and their Des Moines cohorts for a successful campaign.

Although Christian Petersen was unaware of it, he would eventually live in Ames, not Iowa City, and he would work for Iowa State College, not the federal art workshop.

President Hughes had found a way to hire the artist to design original sculptures for the Dairy Industry building, built in 1928 as one of the most technically modern dairy manufacturing and teaching facilities in the United States. The building surrounded an unfinished quadrangle courtyard, 102 feet wide and 124 feet deep, where Hughes envisioned a tranquil campus garden. He wanted a sculptured fountain and reflecting pool, enhanced by graveled walkways, a clipped lawn, beautiful shrubbery and flowers, and an outdoor patio where students and faculty could enjoy ice cream produced by the Dairy Industry department.

Hughes had heard that Christian Petersen understood the relationship between architecture and sculpture; he also knew that Petersen liked to design fountain sculptures with reflecting pools. *Fountain of the Blue Herons,* for the Staley Company in Decatur, had been well received by the company in 1932.

The Petersens regarded Wood's invitation as a "miracle and a dream that came true," but, according to Charlotte, there was no mention at that time of a project at Iowa State College.

She and Christian left Belvidere hurriedly for Iowa City. As the old Ford pushed its way westward through the Mississippi bluff country and the snow-covered rolling hills of eastern Iowa, they sensed the vitality of the productive midwestern farming country and its close-to-the-earth people. They had enjoyed their temporary stays in Des Moines; it appeared now that Iowa City would be a wonderful place to live. On that wintry January day, Christian and Charlotte both felt like they were coming home—to Iowa.

The Iowa City months, January-August 1934

President Hughes had managed to arrange a federal PWA grant and National Youth Assistance funds in late 1933 to finance sculptures for the dairy courtyard. When Christian Petersen reported to Grant Wood in Iowa City, he was told that his assignment was not to create bronze gatepost sculptures for state parks, after all, but to size up a sculpture project at Iowa State College. Christian was to begin preliminary drawings for the dairy courtyard sculptures after he conferred with President Hughes and Martin Mortensen, a native of Denmark who

was head of the dairy department at Iowa State College.

The Petersens remained in Iowa City for the next seven months while Christian worked on the drawings and clay versions of bas reliefs and a fountain at Iowa State College.

While Christian immersed himself in work, Charlotte retreated from the bitter winter temperatures to their room at the University Memorial Union in Iowa City, venturing out only to search for an economical apartment with cooking facilities. They had to settle for two rented rooms in an old, rambling house.

Most of the occupants, including Grant Wood, were members of the federal art group. "We quickly became acquainted with the young painters who were in Grant's workshop," Charlotte remarked, "all of them as poor as we, but just as happy to be working and growing together." Some of the artists were working on murals for the Iowa State College library, so they shared rides in Christian's old car as he went back and forth to confer with Raymond Hughes and Martin Mortensen. "Everyone shared what they had, whether it was food, an old car, clothes, or a hotplate for cooking up potluck stews," Charlotte fondly reminisced.

She described a Public Works of Art Project sale of paintings by Grant Wood's muralists. One young man priced a superb landscape with a tag

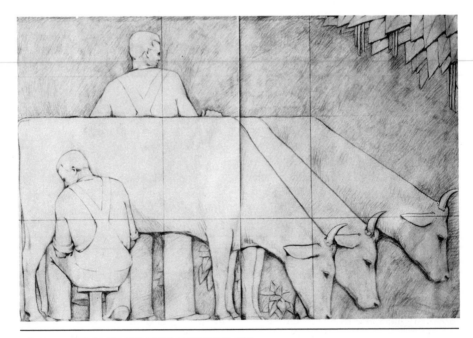

ORIGINAL DRAWING FOR THE DAIRY SCULPTURES. **CGP**

PETERSEN IN THE UNIVERSITY OF IOWA ARMORY, 1934. **CPP**

reading: "Two dollars—or less." "That dear boy," she wistfully recounted, "wasn't much of a salesman for his work."

The landlady at the rooming house spent most of her time in a rocking chair adjacent to the front hall, where she could watch the comings and goings of her tenants. She often rocked furiously, her Bible in her lap, shaking her head and muttering about the pranks and antics of her tenants, whom she regarded as sinful and unconventional people. They were noisy, they came and went at all hours of the night, they laughed too loudly, and they often went to outrageous costume parties. But they did pay their rent for the dilapidated furnished rooms.

Charlotte and Christian Petersen were not part of Grant Wood's established "in" group, a fun-loving coterie of established Iowa City writers, artists, and actors. "We ranked right along with the young painters, at the bottom of the heap," Charlotte explained. One of these was John Pusey, a Sioux City native whose brother, Nathan, became president of Harvard several decades later. "John was a deeply thoughtful and serious young man who became a close friend of Christian's. He had been in World War I and often had terrible nightmares. We tried to help him." Half a year later, Pusey arranged a commission for Christian from the Eli Lilly Company for an annual biochemistry medal, which has been awarded ever since.[9]

Artists were traditionally regarded by most Iowans (if not most Americans) as an unconventional and rebellious element of society in the 1930s. The Iowa workshop painters were

neither. In reality they came from solid farm or small town families all over the state, comprising a group of talented young men who were attempting to find economic survival, useful work, and some laughter in the gloom of the Depression. Many of them turned out to be only temporary painters, pursuing other careers in later years. Charlotte Petersen believed that "laughter made the difference between giving up and keeping going." And the Iowa City sojourn in their lives, although brief, "was a wonderful time being surrounded by gifted young people who loved their work, loved people, and loved life, like Christian and I did." She added: "Things were sour enough without having a sour attitude toward the world. We looked for the joy, and we found it."

Moving to Ames was to be a different sort of challenge for the Petersens. They were leaving a state university with a fine arts department for a state college where "applied art" courses were only for women students in home economics. If Iowa City people were knowledgeable about art and artists, Ames residents were rather staid by comparison and lacking experience with working artists. With its technically oriented curriculum in science, engineering, and agriculture, Iowa State College was not a higher educational institution likely to include an artist-in-residence on its teaching staff. Despite these apparent drawbacks, Christian Petersen was to become a resident artist there for the remainder of his career.

Determined to bring original artworks to his campus, Raymond Hughes chose the person he considered the perfect candidate to help accomplish that goal: Christian Peter-

sen, sculptor. The college president was struggling to expand the curriculum, but was hampered by legislative squabbling over the higher education role of Iowa State, restricted funding in a depressed state economy, and enrollments that dropped from 4,318 in the fall of 1930 to 3,292 in 1933.[10] Nevertheless, he inaugurated a campus lecture series and expanded the Iowa State College Press from a campus printing service to an incorporated book publishing facility. And he pondered how to pay Christian Petersen appropriately for the artist's talents and skills.

By August Christian and Charlotte were ready to move to Ames, where Christian would begin working on the innovative bas relief panels he had designed in Iowa City. He looked upon it as an arduous task fraught with technical obstacles and the possibility that terra cotta might not be a sculpture material that could survive Iowa's climate extremes. Fifty years later, however, the bas reliefs he created for his first Iowa State College project had remained remarkably intact—as beautiful as they were when they were installed in the spring of 1935.

Sculptures at a land-grant college, 1904–1934

Iowa State College pioneered in campus landscape architecture from the moment its first president Adonijah Welch tossed handfuls of acorns on the prairie grass to indicate spots for planting trees in 1868. Later, in 1916, a Danish-born landscape architect from Chicago, Jens Jensen, was retained by college officials to augment a campus plan developed in 1906 by John Olmstead, partner in a nationally prestigious landscape architecture firm in Boston. Jensen supervised tree and shrubbery planting on the central campus and the enlarging of a small pond, later named "Lake LaVerne" in honor of LaVerne Noyes, a college alumnus who gave $10,000 for landscaping materials.

Christian and Charlotte had met Jens Jensen in Chicago. The landscape architect had grown up in Dybbol, Denmark—Christian's home village—and was a childhood friend of Christian's father. When the Petersens arrived in Ames, they were "bowled over with the beauty of the campus," and were astonished to discover handsome original sculptures on the facades of two campus buildings.

One of the works was created for the college thirty years before. The other had been in place for over a decade. The 1904 Engineering Hall featured four carved stone "Muses," classic figures representing engineering specialties: geology, mining, civil engineering, and mechanics. These immense Greco-Roman sculptures-in-the-round were installed on pedestals high atop the facade of the building and were directly commissioned by the architects.

In 1924 Nellie Verne Walker began sculpturing bas reliefs on the library at Iowa State. She was a native Iowan who had studied under Lorado Taft, a distinguished Chicago sculptor. Christian Petersen had hoped to work under Taft during his stay in Chicago, but the Great Depression cancelled those plans.

Nellie Verne Walker sculptured two handsome bas reliefs on the east facade of the college library. The

south panel represents educational programs for men in 1900: engineering, science, veterinary medicine, agriculture. The north bas reliefs portray the curriculum for women: art, home economics, literature. Ames native Neva Petersen (no relation to Christian) recalled being a high school student in 1924 and watching the woman sculptor perched on scaffolding, carving the reliefs in the limestone facade two stories above ground. "You can imagine how impressive it was to see a real, live sculptor in 1924. And there I was, watching a woman sculptor forty feet high," Neva Petersen added.[11]

In his youth Christian had hoped to become an architect, but lacked the funds to pursue higher education. He wrote in later years:

The use of sculpture as decoration—especially with architecture—has been practiced from time immemorial. Architects of today are using sculptures more and more. Some of the most important sculptures of the past have been those which have been created as part of some building, for instance, the Parthenon.[12]

A pay cut for the new Iowa State College artist

Because Petersen was to work in Ames instead of Iowa City, he was to be paid directly by Iowa State College. President Hughes could arrange only $25 a week for the sculptor, and apologetically told him so, explaining that the college could not match the PWAP amount of $26.50 a week. Petersen told Hughes not to worry about the pay rate, however, because accomplishing the dairy project was the immediate objective. If the sculptures were well done, a better salary would undoubtedly result.

Across the state of Iowa in 1934, carpenters earned an average of $1,181 a year, school teachers $1,295, and college teachers averaged $2,685.[13] If Petersen could earn his PWAP salary for the entire year, his total would have been $1,378. His salary prospects at the college, however, were even less. A nine-month appointment would pay him only $900.

Raymond Hughes was a man with deep empathy and compassion. He knew the Petersens were totally lacking financial resources. He also realized the artist had no college degree, which was a requirement seldom waived for faculty appointments. Feeling personally responsible for bringing Charlotte and Christian to Ames, he invited them to be guests in his campus home, "The Knoll," when they arrived in town. He later arranged rental of a vacant college-owned house on the campus for them—and was roundly criticized by campus gossips for doing so. Hughes loaned them funds to pay medical bills when Christian and Charlotte grieved over the loss of a stillborn son.

Petersen thus began his sculpturing career at Iowa State working for $25 a week, without a kiln, without a studio or a fine arts department, using the cheapest available materials and makeshift equipment. The Fort Dodge Chamber of Commerce donated a quantity of native Iowa clay for the terra cotta dairy sculptures; a small workspace was available in a ceramics laboratory for the artist's tools and clay.

The sculptor was on temporary, three-month appointments, earning half the salary of the lowest ranked instructors in applied art. The head carpenter, plumber, and painter for the college would earn $2,660, $2,375,

and $2,090 for a full year's work, compared to Petersen's $900 for nine months. The lowest-paid unskilled employee at the college heating plant earned $1,492, or about $16 a month more than Christian Petersen would earn.[14]

Charlotte looked back on her husband's first year at Iowa State and emphasized, "Money was the last thing we cared about. We were overjoyed at the opportunity for Christian to do what he loved best—and we both knew how to live on very little." They both plunged into their new life at Iowa State with typical enthusiasm and a sense of discovery. After all, neither of them had ever been college students. When the throes of the Depression eased, they planned to further Christian's sculpturing career elsewhere. Meanwhile, the sleepy little college town of Ames, Iowa, seemed a perfect place to live, work, and grow.

The dairy project begins

Professor Martin Mortensen, a native of Denmark and head of the dairy industry department at the college, welcomed Christian Petersen to the campus. He was pleased with the plans for a terra cotta mural depicting the history of world dairying.

President Hughes asked Christian to report to a professor named Paul E. Cox, head of the ceramic engineering department, who had been given the assignment of helping the artist kiln fire panels for the mural. Cox must have had considerable misgivings about the project, which was a formidable technical challenge. What did an impractical Danish-born artist know about kilns and ceramic technology? How could Cox improvise a way to produce bas relief panels with donated clay, a small laboratory kiln, and unskilled student laborers?

Furthermore, Cox was probably doubtful that an artist would have much practical knowledge for the project. He knew very little about Christian Petersen until early one morning when a powerfully built middle-aged man—sporting a tiny moustache and wearing a neat but shabby suit—entered the ceramics engineering lab. He quietly inquired, "I'm Christian Petersen. Are you Professor Cox?"

3 Iowa State College Artist-in-Residence, *1934*

"Milke, and chese, and buttere for ther bred."

—Inscription on interior bas reliefs,
Dairy Industry Building, written by
J. C. Cunningham

WHEN Professor Paul E. Cox first met sculptor Christian Petersen, he may not have been prepared to greet the artist with total cordiality. Before Petersen was even on the campus, Engineering Dean T. R. Agg, reacting to instructions in late February from Iowa State College President Raymond Hughes, had asked Cox to find the most economical way to produce and kiln fire the terra cotta bas reliefs for the dairy courtyard project.

Cox received the first shipment of small panels in March. After kiln testing them in his laboratory, he realized he was saddled with a formidable task, but was willing to attempt it.

Cox was an intensely practical art pottery designer and kiln expert, having begun his career at Newcomb College in New Orleans, the major center for art pottery in the south. His teaching at Iowa State had spanned fourteen years, during which time the ceramics art curriculum had developed into the ceramics engineering department. By 1934 he was the head of the department.

Christian Petersen was a relatively unknown sculptor whom President Hughes had hired to create terra cotta panels depicting the history of world and American dairy technology. The artist, as far as Cox knew, had little or no experience with large-volume terra cotta production and kiln work.

When Petersen introduced himself that September morning, Professor Cox came directly to the subject at hand. A torrent of pent-up comments rushed out of Cox. He first reminded the artist that his original clay panels proved too large for the existing kiln. Petersen had originally designed them for firing at a Chicago commercial kiln. When he was told by Hughes that the college could not finance commercial firing, Petersen redesigned the one-piece panels into a series of small sections, which could be assembled to form large bas reliefs. Six of these would be five feet high and seven feet wide; the seventh would be an identical height, but would measure twelve feet in width.

The larger center panel was de-

signed as the focal point of the sculptures, with a fountain piece flowing into a reflecting pool. For this, Christian Petersen had sculpted dairy animals in high relief up to sixteen inches in depth. The noses of three Jersey cows were poised at the waterline, keeping them moist and shining from the gentle cascade of water in a two-level, semicircular fountain, which slowly overflowed into a reflecting pool measuring eighteen feet wide by twenty-five feet long.

Cox told Petersen that firing the terra cotta for the center panels would be nearly impossible because of the extreme depth of the bas reliefs. He saw no way to fire those sections without creating awkward mortar joints and ruining the design. Furthermore, Cox informed the sculptor, there was minimal funding available for materials and labor on the project. Clay and plaster had been donated by the Chamber of Commerce at Fort Dodge, while National Youth Assistance grants would pay for some student labor. But the man hours required to produce the sculptures would be gruelling for everyone. "Grog" for the terra cotta mixture was to be manufactured by salvaging and grinding old firebrick from a razed heating plant at the college, then combining the grog in proper proportions with the native Iowa clay—a mixture that could have highly unpredictable results from kiln firing if it was not correctly proportioned.

Cox also told the sculptor that ceramics experts in the industry—several of whom Cox knew personally and had consulted—were skeptical that the project would be successfully completed. "Some of them think it can't be done," Cox pointed out, "because

of warpage, shrinkage, cracking, uncontrollable moisture losses, and other technical problems." His concluding salvo was vehement: "Our deadline to finish this project is mid-May."

Cox was testing Christian Petersen.

He wanted no esthetic theories or "small talk" from an artist who was not willing to work personally and physically toward the production of his sculptures. He knew that some sculptors created only small clay models, relying on skilled workers for the arduous tasks of carving stone, making casting molds, or preparing terra cotta for firing. He also knew that casting the original clay panels in plaster, pressing the terra cotta mixture into the negative molds, then kiln firing and trimming the panels would be physically demanding and dirty work. He was not going to assume total effort and responsibility for producing terra cotta sculptures in behalf of the sculptor. Petersen would have to share the workload and the responsibility.

Charlotte was not present when her husband first met Paul Cox, but she remembered Christian's description of the first encounter between two dynamic men. When Christian came home late that day, his only white shirt was smudged with kiln dirt and his suit trousers showed he had worked around considerable ceramic dust. She laughingly recalled, too, that his close-cut grey hair had an attractive but mysterious reddish cast.

He was tired but happy, telling Charlotte that he had met a remarkable man that day, a man named Paul Cox, who was probably the most knowledgeable ceramicist in the United States. "He said there were fireworks

at first," Charlotte explained, "but after the air cleared, the two of them went right to work." His reddish hair resulted from a shower of ceramic dust, which fell as he inspected a kiln.

He told her how he had stood quietly during the professor's tirade, listening attentively while Cox paced back and forth in his cluttered office, unloading a barrage of technical reasons why Christian Petersen's sculptures would be difficult to produce with the limited facilities, student labor, and kiln space.

Petersen was also measuring the mettle of the man with whom he would work closely during the next nine months. Cox's veritable soliloquy of anger and frustration revealed his suspicion that he had become the victim of an overly ambitious brainstorm of an impractical artist and a technically naive college president, both of whom expected Cox to make the project a success.

Removing his shabby suitcoat and rolling up the sleeves of his one and only dress shirt, Christian Petersen produced a whimsical smile, eyed Cox with an air of Nordic resolve, and tugged off his ancient necktie. He announced in his quiet but firm voice: "I'm willing to work day and night, if necessary."

He further explained, "I did all kinds of manual labor in a brickyard for several years when I was young. I loaded the kilns, watched over them for hours on end, and unloaded the product. It's hard work. They tell me you never walk away from hard work. Neither do I. Shall we try it?"

Christian Petersen thus began a partnership with Paul Cox. Cox loved a challenge and always welcomed an opportunity to experiment or innovate,

as did Petersen. The mercurial ceramics engineer and the tall, soft-spoken Dane shook hands, Cox removed his own suitcoat and tie, and both of them went into the lab. The professor showed the artist a strange-shaped platform on wheels, which stood upon a pair of steel rails leading to an arch-shaped kiln.

"This," Cox told Petersen, "will probably do the job for us. We'll have to make it work."

The "Cox Kiln," as it became known in the ceramics industry, turned out to be a major achievement for its inventor. For Petersen it was the key to his future career as Iowa State College artist-in-residence. The two men became working partners, leaders of a crew of ceramics students who were privileged to work and learn on the difficult and challenging project.

Because the Cox kiln could accommodate only five to eight pieces per load, repeated firings were needed to manufacture the terra cotta panels. The process lasted from September until late April, requiring at least 100 firing periods of 60 hours each, plus a two-day cooldown between loads.

The artist, together with the ceramics engineer and a team of students combined efforts to produce a series of terra cotta bas relief sculptures unlike anything created before—or since—in American art history. No campus-produced sculpture of this medium, size, scope, and quality exists on any campus in the United States. "No one else would be brave or foolish enough to try it," Charlotte Petersen said.

One of the students who worked on the project remembers the feelings of dedication and achievement shared

by everyone. Lewis Minton, a 1936 graduate in ceramics engineering at Iowa State College, was one of the student laborers hired by Cox. He looked back on his part of the team effort and gave high praise to the professor and the artist: "Those were hard times. The Federal National Youth Program kept most of us students in school" Minton wrote in 1983: "Cox was, to me, a great ceramic man, widely known and loved by his students. My two and a half years under Cox proved to be a great practical help in my later ceramic career in pottery and heavy clay products."[1]

From mind's eye to finished sculptures

At the Iowa City workshop in early winter 1934, the sculptor first created small bas relief models for the approval of dairy industry head Martin Mortensen and President Hughes, later expanding the approved designs into full-scale, one-piece clay bas reliefs. These were later redesigned into small sections suitable for firing in the Cox kiln.

After test-firing the first batch of six sections over a period of about eight weeks in March, Cox reported the results to Hughes, who wrote to

CHRISTIAN PETERSEN, LOWER RIGHT CORNER, WORKING IN IOWA CITY CWA WORKSHOP, 1934. **CGP,** *clipping from Des Moines* Tribune.

Petersen in June: "The six panels which Professor Cox burned have come out of the kiln in beautiful shape and are a far more beautiful color than I anticipated, and are a deeper, richer color than the samples he submitted. He thinks that all six panels are quite usable. While one or two are slightly warped, this is so slight that I believe it will be entirely unnoticeable when the panels are set."[2]

Hughes went on to explain that the college could not afford $750 for commercial terra cotta kiln firing in Chicago, and that Cox seemed "quite willing and able to do a good job on them . . ." He explained that the finished terra cotta would involve grinding and fitting the panels before

they were set in the courtyard wall and added this caveat: "Cox tells me that there are two panels . . . [for] which it is extremely difficult to prepare the clay without cracking, owing to the form of the modeling. He may need some specific help from you on these as he has tried to get them off twice and failed . . ."

Ecstatic over the beauty of the test panels, Hughes was unaware that Cox had put forth prodigious—and rather heroic—personal effort on the test firings. He had first rebuilt an old "drier car" into a sectioned kiln cart that could be moved in and out of a kiln chamber he built to accommodate it. One end of the cart was eighteen inches thick, forming the kiln "wick-

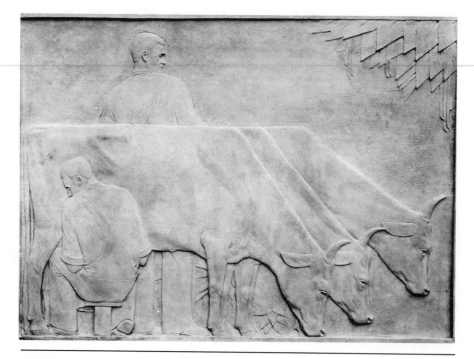

ORIGINAL CLAY VERSIONS OF PANELS: PANEL 1. **CGP**

et" or door. Cox also experimented with plaster molds of the original clay designs, test mixtures of grog` and clay, and techniques for pressing the terra cotta mix into the negative plaster molds. Finally, Cox calculated the probable moisture losses and shrinkage that would occur in a totally unproved terra cotta mixture and unorthodox kiln design. He combined considerable intuitive guesswork with his vast accumulated knowledge for the test firings, and he produced the panels with which Hughes was so pleased.

Paul Cox was the sort of individual who accepted neither a challenge nor a failure lightly. When he had encountered disastrous results in preliminary kiln work on two of Peter-sen's high-relief dairy cow panels, the man whose students called him "a ceramic genius" was not willing to give up, although he must have had serious doubts whether the fountain sculpture's major theme panels could be produced. He had staked his ceramics reputation on doing the job, and he wanted the work for his students. But he resolved to challenge the skills of the artist who designed it when the opportunity arose to meet him personally.

In his May 1934, report to Hughes, Cox carefully figured the costs and hours of work necessary to produce the sculptures, estimating student labor, fuel oil, firing time, and miscellaneous materials needed. He

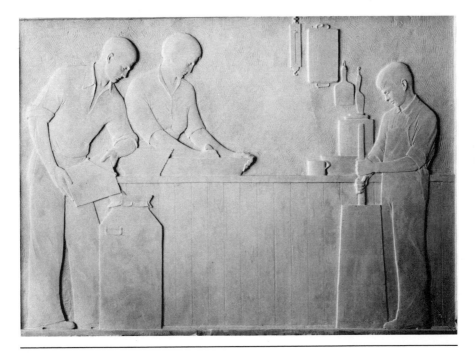

PANEL 2

figured total costs at $55.70 for each panel, or under $7 for each of eight small section pieces.

Cox wrote in his letter to Hughes: "Two or three of the sections are very difficult to deal with in a laboratory plant. Thus far they have been total failures in the pressing process." And he added, "Sculptor Peterson [sic] left unwanted borders that increase the cost of finishing work and increase the pressing difficulties. THESE TROUBLES HAVE BEEN CORRECTED BY HIM IN THE OTHER PANELS. This means that part of the mold-making work on this must be done again. Not a difficult or very costly job."

Cox originally estimated a total of $552 for the entire project, which at that stage included only four side panels and one central bas relief. As the fall weeks rolled by, Christian Petersen—at Cox's urging—added two more side panels, so that the composition stretched across the entire south wall of the courtyard, about seventy-five feet wide.

Cox, anxious to begin the project, could not do so until the fall college quarter, when students would be available for work. He had told Hughes in May the advantages of doing the work in the ceramics laboratory: "Helps students to go to college. Gives education of a valuable sort to students and faculty. Uses Iowa clay rather than Indiana clay. Advertises

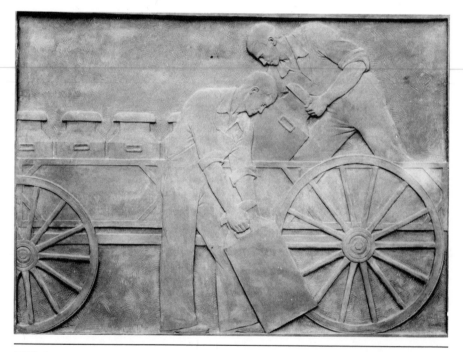

PANEL 3

40

the college work. Covers a slack period in student enrollment for the department staff. Has industrial research, or rather, industrial development value."[3]

Because most of his students needed some kind of paid work in order to finish their studies, Paul Cox personally took on the responsibility for completing the job successfully. He was determined to make it work, but he didn't want the artist to be in the way or complicate the production process.

Petersen and Cox become a dedicated team

Beginning in September, Petersen and Cox turned their abundant energies and skills to the job, helping student workers convert ten tons of Iowa clay and seven tons of grog into a series of ashlers, or metal kiln frames, for firing. They quickly determined that each panel would require nine small sections, not eight. And they would have to manufacture terra cotta top sills and foundation blocks for the seven archway panels, plus border blocks for the reflecting pool.

Each ashler, weighing 225 pounds, was prepared with hand labor. The artist worked with the students every day as they pressed, pounded, and persuaded the grog-clay mixture into plaster negative molds of the original clay sculptures. They used fifteen

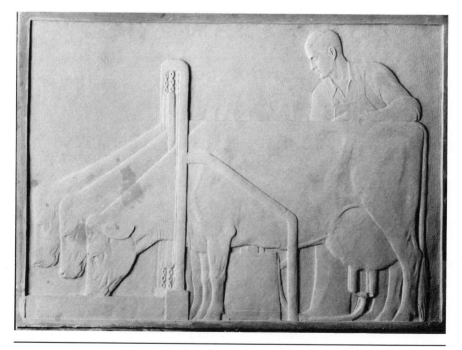

PANEL 4

tons of plaster in making the molds.

During each sixty-hour firing, temperatures were carefully maintained by student laborers. One of them slept on a cot by the kiln every night, insuring that the temperature held at 500 degrees the first day, 1850 on the second day, and 2050 degrees for the remainder of the burn. The process consumed consecutive weeks during the fall, winter, and spring. Although the exact number of kiln firings is not known, more than eighty burns would have been required to produce the sculptures, fountain, reflecting pool trim pieces, archway foundation blocks, and top sills.

Charlotte Petersen remembers that she and Christian "often went over to the lab in the middle of the night, to bring coffee and sandwiches to the student on duty at the kiln." She remembers, too, that "Christian worked day and night for months, helping the students form the plaster molds and pound the terra cotta mixture, or helping load or unload the kiln car."

An ancient sculpture material, terra cotta proved to be a difficult medium to produce. But it also represented an opportunity for an innovative combination of artistic skill, ceramics genius, and what Charlotte Petersen called fifty years later "sheer stubbornness and hard work for everyone concerned."

Some campus critics gossiped over the project, which many pre-

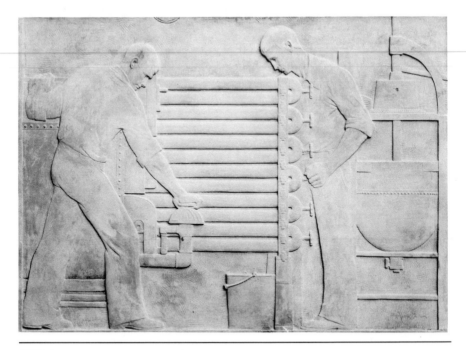

PANEL 5

dicted would be doomed to fail. Although they respected the abilities of Paul Cox, they speculated about the practicality of artist Christian Petersen, who dreamed up the idea of filling empty archways of the dairy building with sculptures, and the judgment of the college president who approved the project.

By mid-April, as Cox and Petersen were finishing production of the panels, they were hampered by repeated interference from an unnamed critic who apparently outranked and thoroughly vexed Cox. A "no-nonsense" pragmatist, Cox decided to defend himself and his friend Christian Petersen. He wrote a pointed letter to Dean Agg, reporting, "The Dairy In-

dustries building job has progressed to the point where all the problems are solved, provided the problem is not to be changed *after* the wares are all fired.

"Christian Petersen is not only a good sculptor but is a practical man who knows how to handle the mechanical portions of his work. He knows how to make terra cotta and knows its problems because he worked in a terra cotta plant for a long time. Had it not been for his very practical knowledge the job would have cost much more than it has."

A person Cox referred to only as "a critic" had constantly interfered, instructing him to saw off part of each panel section and install wider expan-

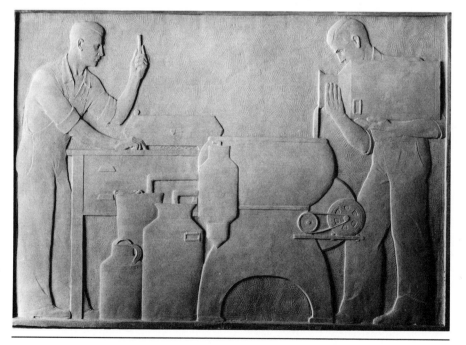

PANEL 6

sion joints. "This critic evidently is totally uninformed concerning the maximum coefficient expansion possible in the length of the work . . . " Cox wrote. He went on to explain that the orders from "this critic" caused extra cutting and grinding. "In order to please this critic the terra cotta for the first panel called for more cutting than the others will get or need. This is one of the annoyances we have had in setting this work." He added, "The critic then decided that the original plan was not correct. . . . The solution has been found in setting it as the sculptor planned it."

Professor Cox—never a man to shrink from giving a blunt opinion—wrote: "Anyhow we are entirely right and entirely correct in all the steps we took, and are in line with industrial practice. . . . I would appreciate it and Mr. Petersen would appreciate it if you would use your own tactful ability to just hold the critic off this job and permit the work to go on to completion as originally planned."

His final sentence was: "This note is written in case you find it necessary to help us. If nothing turns up further, forget it. Yours very truly, Paul E. Cox."[4]

A sculptural history of dairying in America

The results of the Cox-Petersen teamwork have remained astonishingly beautiful and proved to be amazingly durable despite the temperature and precipitation extremes of Iowa summers and winters. Although a few mortar joints were in need of repair in the fall of 1984, no cracks were evident on any of the terra cotta panels.

The dairy courtyard is seldom seen by today's students and faculty at Iowa State University, since it is far removed from the mainstream of campus pedestrian traffic. Many, if not most, recent Iowa State University graduates, former students, and faculty of the past two decades have been unaware that Christian Petersen's dairy sculptures exist.

Dairy industry education at Iowa State is now part of food technology, reflecting an expanded curriculum. The courtyard and sculptures remain, however, as unique symbols of agricultural and dairy technology in the United States. Christian Petersen's bas reliefs depict the history of dairying from ancient times until the "modern" era of fifty years ago, with emphasis on Iowa State's educational role in the industry.

The first three panels represent early American hand milking, the straining and butter churning process, and hauling milk to market by wagon. In the center, Christian Petersen's elegant high-relief panels feature three gentle Jersey cows drinking from a two-level, semicircular fountain that quietly overflows into a placid reflecting pool. In the background stands a Jersey bull proudly surveying his domain.

The second series of three panels begins at the far right, progressing toward the central figures. Modern dairy industry of 1934 is represented by mechanical milking machines, a "Babcock" testing machine and a power centrifugal separator, and equipment for pasteurizing, cooling, and cheesemaking in a dairy plant.

Bordering the reflecting pool is a graveled walkway leading west about fifty feet to a flight of wide stone

44

steps and a spacious flagstone patio. There, from 1934 to 1960, faculty and students enjoyed ice cream produced and sold by dairy industry students. One concrete table and two matching benches are reminders of what was once regarded as the most beautiful and enjoyable spot on the Iowa State campus on a warm spring or fall day.

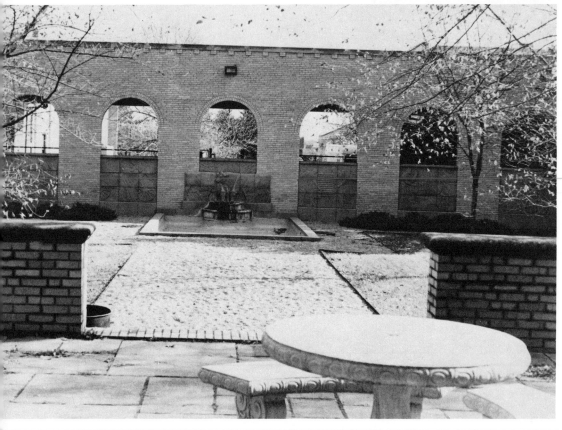

VIEW OF DAIRY INDUSTRY COURTYARD FROM THE PATIO. **AUTH**

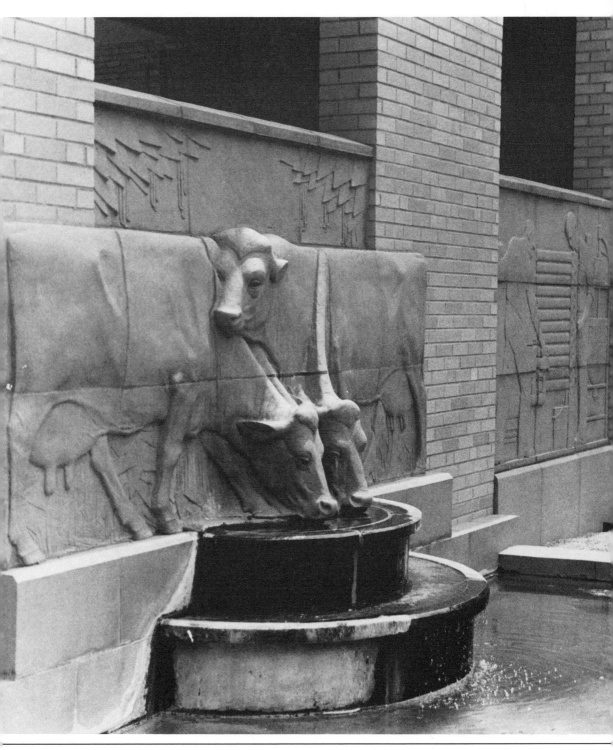

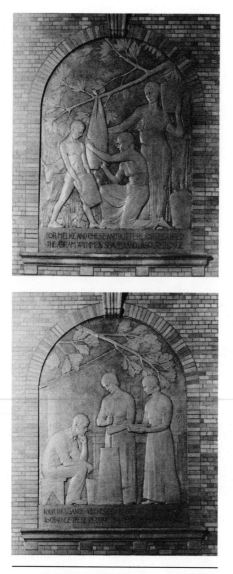

FOR MELKE AND CHESE AND BUTTER BE AS GUD FOR FED
THE ABRAM WYMMEN SO ABYDAND ABOUR EELS N.J.

FOUR THOUSAND YEIPRES PASSED BYTWENE
TO CHANGE THESE INDUSTRY...

INTERIOR PANELS. **CPP**

Interior panels: the story of ancient dairying

As the Petersen-Cox collaboration on the courtyard sculptures progressed over many months, the Danish sculptor was inspired to create two additional bas reliefs, which are spectacular for their beauty, immensity, and flawless casting in plaster. Probably his least-seen works on the Iowa State campus, the panels are inside the main foyer of the original dairy industry building.

Each bas relief is an astonishing eleven feet high by eight feet wide, designed by the artist to highlight a two-story staircase entryway. The reliefs represent ancient dairying in the time of Abraham (about 2000 B.C.) and the most important development in American dairy technology, circa 1850: the invention of the dash churn.

Four thousand years spanned the interval between the two modes of processing dairy products from milk. Christian and Charlotte Petersen spent considerable time studying dairy history in preparation for the courtyard sculptures; they both thought the contrast between ancient and modern times was so significant it deserved symbolic sculptures. Martin Mortensen, head of dairy industry, agreed and encouraged the sculptor to go ahead with the additional bas reliefs.

The two bas reliefs in the building foyer were overshadowed by the stunning courtyard sculpture panels after the initial festivities of Veishea and June commencement in 1935. "Veishea" is a student-sponsored spring festival at Iowa State University, originally named for the five undergraduate divisions of Iowa State College in 1922: Veterinary medicine,

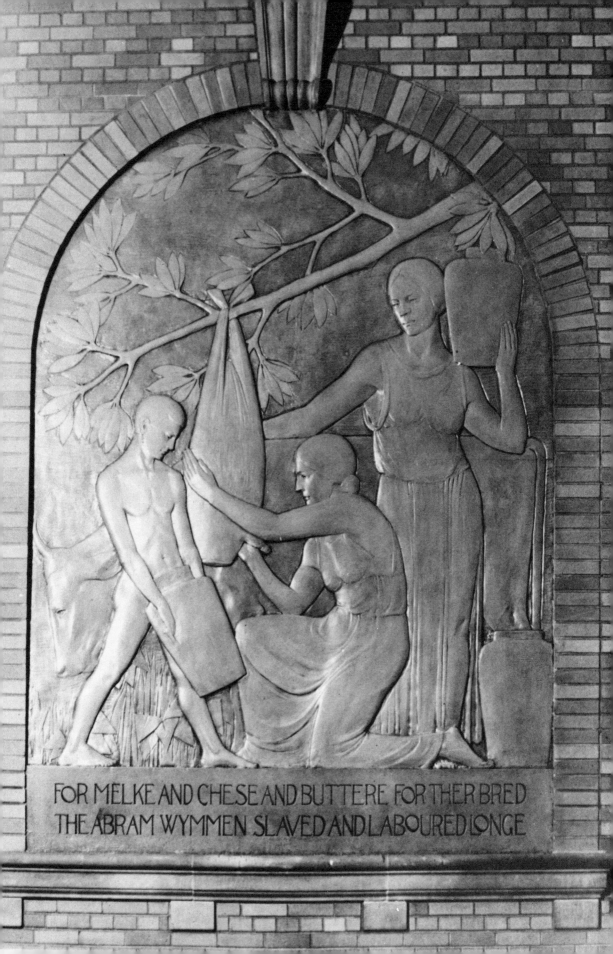

FOR MELKE AND CHESE AND BUTTERE FOR THER BRED
THE ABRAM WYMMEN SLAVED AND LABOURED LONGE

Engineering, Industrial education, Science, Home Economics, and Agriculture. It began in 1907 as a May Day pageant and gradually expanded into an all-college annual event.

Charlotte Petersen has always regarded the interior panels "magnificent in their beauty and size, but almost forgotten through the years. They deserve to be seen and appreciated."

The legend on the panels has, like each of Christian Petersen's works, an interesting story. By spring, 1935, the Petersens had become acquainted with a number of faculty, among whom was a likeable man named J. C. Cunningham, professor of corn genetics at the agricultural experiment station. Cunningham was a rare "renaissance man" at an agricultural college. He loved history, science, literature, poetry and drama, and the world around him. The Petersens had met J. C. and Alice Cunningham early in the fall of 1934 and became close friends in the ensuing years.

J. C. was facinated with Petersen's work on the dairy courtyard terra cotta bas reliefs, often dropping by the ceramics lab to check progress at every stage of the project. The two of them talked about art, history, people, agriculture, and the world. Charlotte Petersen explains Cunningham's role in the development of the interior bas reliefs:

"Christian asked J. C.'s opinion of preliminary sketches for the two interior bas reliefs. One was of beautiful women using a goatskin bag—hung from a tree—to churn butter in ancient times. The other showed pioneer American women churning butter with a dash churn.

"J. C. was enthusiastic about the sketches and told Christian he had an idea for something to add to the sculptures. He came back a day later with a legend he had written in Old English style, to accompnay the bas reliefs—if Christian liked it."

The agriculture professor wrote:

For Melke and Chese and Buttere for ther bred the Abram Wymen slaved and labored longe.

Four thousand yeres pass by before man thinks to change these plodding houres to houres of songe.

"Christian loved it, and so did I," Charlotte reported, "so he included J. C.'s legend in the sculptures."

Martin Mortensen was deeply impressed with his Danish compatriot. Mortensen's daughter, Edna Kiely, said her father "worked so hard to plan the dairy industry building, and when it was completed, I believe the thing he admired most was Christian Petersen's work. My father loved the sculptures and would go out to the dairy building many Sundays just to look at them. They were simply beautiful . . . and I believe for my father, they were a dream come true."[5]

The massive interior panels were finished and the courtyard landscaped in time for Veishea. Dairy industry students hosted an open house, and dignitaries and campus visitors toured the interior and courtyard sculptures. In June alumni viewed the new courtyard and building foyer art.

That fall President Hughes reported to his faculty that $25,000 would have been the cost in normal times for the new campus sculptures by artist Christian Petersen. With the

50

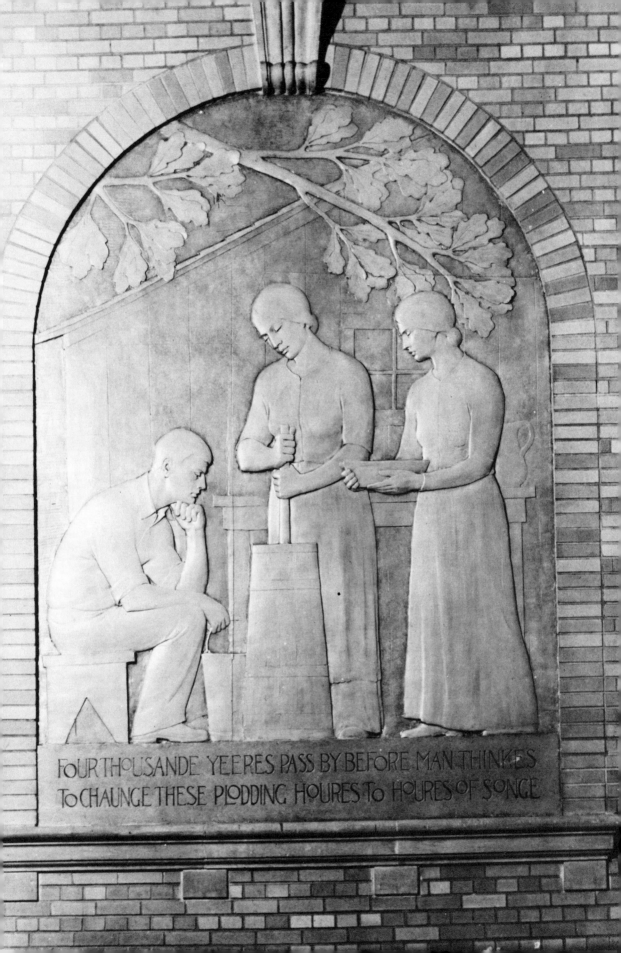

FOUR THOUSANDE YEERES PASS BY BEFORE MAN THINKES
TO CHAUNGE THESE PLODDING HOURES TO HOURES OF SONGE

federal student labor funding, donated clay and plaster, and Public Works of Art Project salary for the sculptor, however, the actual cost the the college was $1,750.[6]

Christian Petersen had earned $900 from Iowa State for consecutive three-month appointments during the school year. His Public Works of Art Project salary totaled $848 from January until September of 1934, totaling $1,748 for seventeen months of work.

Charlotte Petersen remembered that her husband put in many fifteen-hour days on his sculptures, but emphasized, "No one kept track of hours in those days—the important thing was doing the work, doing it right, and being glad to have the work you loved to do." They later figured—with laughter, not regret—that Christian had earned less than his student laborers for every hour he worked on the dairy project. They had earned thirty cents an hour.

Charlotte looked back on their first year at Iowa State College fondly, pointing out that they met "some wonderful people who became close friends." She saw a strong camaraderie develop between her husband and Paul Cox. "They accomplished something remarkable that few people realized then or later, and they both had a great sense of humor which helped them over the tough spots."

Typical of their humor was a practical joke they perpetrated on the State University of Iowa College of Fine Arts. When Cox was cleaning out a small pottery kiln, he found a large misshapen piece at the bottom of the kiln with an unusual blend of colors and textures. He gave it to Petersen, who mounted it on a handsome walnut base, then took it to Iowa City

MARTIN MORTENSEN,
HEAD OF DAIRY INDUSTRY, 1935. **CGP**

on a routine trip there, where he showed it to a professor of art and told him it was by a famous modern Russian sculptor. The art professor walked around it a number of times, inspecting it from every angle, and delivered his keen judgment: "Marvelous lines."

Charlotte described the moment when her husband showed Raymond Hughes the last few terra cotta pieces, ready for the kiln. Hughes asked, "Where is your signature?" Petersen retorted with a chuckle: "My sculptures should tell who did them. They don't need a signature." Hughes insisted that the artist sign his work, adding that he would not leave the lab

until he saw the signature in the terra cotta. Petersen reached down, picked up a nail from the kiln room floor, scratched his name in letters three-eighths of an inch high in a corner of the last terra cotta foundation block, added the word "sculptor" in small letters under it, and threw away the nail. Hughes laughed, they shook hands, and watched the drier cart as it was trundled into the kiln.

Fifty years later, the modest signature can be discovered on the lowest far right block of the seventy-five-foot panorama of superb sculptures.

Other than this small signature, none of Petersen's landmark works at Iowa State College bears his signature.

AUTH

Christian Petersen, college professor

Petersen's teaching career at Iowa State College did not begin until the winter quarter of 1934–1935, when he met his first class (all young women, as prescribed by the Home Economics Department) studying applied art. They reported to the artist's makeshift studio in one corner of the cluttered ceramics engineering lab.

President Hughes was anxious to acquaint his faculty with art and the new campus artist. Some time during that quarter, Petersen was assigned by President Hughes to lecture on art to a faculty convocation. He knew about the assignment in September and dreaded it, Charlotte explained, "be- cause he was not experienced in talking to an audience. He was terrified of the idea."

Hughes probably was unaware how difficult a lecture assignment would be for a man who had never been to college and who was a much more willing listener than he was a speaker. Charlotte, in her typical devotion to Christian and his work, persuaded him to "talk it out" at home while she transcribed his words in her practiced shorthand. She later transcribed her notes into a typewritten script, then rehearsed Christian for the lecture, which they revised many times.[7]

The sculptor realized he was at an agriculturally oriented college that included scientists, engineers, and a

technically minded faculty. Visual arts were taught only to women studying home economics and men studying architecture. The "aggies," scientists, and engineers had little exposure to the liberal arts, which were reserved by legislative mandate for the State University of Iowa in Iowa City. After all, Iowa State College was a land-grant college originally created to offer agriculture education.

So Christian and Charlotte decided the best thing to do was explain art and artists: to tell his audience why he came to the Midwest and why each of them was important to an emerging American art, which Christian believed could best flourish in the Midwest.

His lecture became a classic and was repeated many times for many groups. In it he entreated his audiences to "judge for yourselves what is good about art," and suggested that artists in America had been too dependent upon European training and trendsetting.

He warned them to be wary of what he called "fraudulent art," which he believed was being "foisted on a gullible public."

The most touching part of the lecture was his direct and humble appeal to his midwestern colleagues, asking them to understand who he was and what he did as an artist:

President Hughes has allowed me—an artist unknown to him and comparatively little mentioned nationally—to decorate one of your most important buildings. He had the courage of his own convictions.

I have been asked to talk about the sculptor's art . . . I am going to try to make plain to you that we artists are just like you are. We are doing our work in our way, just as you

are doing yours in your way. Your work calls for one type of expression, and ours for another. Our work, it is true, has been somewhat shrouded in a veil of mystery, but after all, there is no mystery to it. It's just the same as yours—it is plain hard work. But we love it.

He asked them to "Let your artists and sculptors work—make them work." He explained that the art of the past "is fine for us to study, to admire, to encourage us to go on. We can take its lesson, light our lamps there, and go on . . . "

And he informed his listeners that they were important to his work: "It is you who make your artists, and through them, you shall be remembered."[8]

Grant Wood inspects
Petersen's dairy sculptures

In late spring 1935, Grant Wood came to Ames to check on progress of his Works Project Administration mural painters, who were installing their finished canvases in the Iowa State library. Wood met Christian Petersen at the dairy courtyard to see the finished terra cotta panels, most of which were installed.

Charlotte described how Wood silently paced the length of the panels, stood back a distance to survey the entire wall, and finally commented: "You should have done a higher relief all the way through." Christian, who had expected verbal approval of the finished project, retorted: "You wouldn't want them so deep they'd reach out and hit the growing grass, would you?"

Charlotte Petersen explained in 1983 that Grant Wood "was trying to do too much running the Iowa City art

group" and added that Wood "kept going back and forth to Washington, trying to convince the WPA administrators to keep the program going. He just didn't have time to pay attention to what Christian was doing at Iowa State and he didn't know much about sculpture." She added: "Grant loved the national publicity about the murals. I think he took some bows for Christian's dairy sculptures, too."

Some writers attempted in the late 1930s to correct a widely held mistaken impression that Grant Wood personally did all of the mural designs and painting and contributed to the design of the dairy sculptures as well. Jessica Welbourn Smith (Mrs. Lewis Worthington Smith) of Des Moines wrote a story in 1935 for the Des Moines *Register* in which she carefully pointed out that although Wood was overseer of the art workshop in Iowa City, he did not paint the library murals, nor did he work on Christian Petersen's dairy sculptures.[9] A 1938 Federal Writers Project Iowa guidebook described the paintings: "Nine murals depicting phases of agriculture were designed by Grant Wood for the foyer of the library at Iowa State College and developed and executed by assistants under his direction."[10]

The names of the artists, most of whom Christian and Charlotte Petersen knew well, were not often listed in publicity regarding the project. Fifteen names are inscribed on a section of canvas in the center of the eight north staircase murals of the Iowa State Library: Bertrand Adams, Lee Allen, John Bloom, Dan Finch, G. E. Giles, Lowell Houser, A. G. Hull, Howard Johnson, Harry Jones, Francis McCray, Arthur Munch, Herman O.

Myre, Arnold Pyle, Tom Savage, and Jack Van Dyke.

The ninth mural is a triptych, completed in 1936 for the lobby below the staircase. Herman D. Myre and Francis McCray are listed in some documents as artists for both sets of murals. Working with them on the lobby mural were Holland Foster and Lynn Stacey. Records at the Iowa State University library and newspaper clippings from the Ames *Tribune-Times* conflict on data regarding which artists worked on the lobby murals. The names of Thealtus Alberts, William Bunn, Holland Foster, Richard Gates, John Hoaglund, Joseph Hunt, Howard James, and Joseph Swan are included in a catalog of mural projects in Iowa by Lea Rosson DeLong and Gregg R. Narber.[11]

In the mid-1930s Iowa State College, according to archive records, owned seventeen original oil paintings that were products of the workshop artists, but none of them, nor any of the artists' names, could be found in 1983. PWAP and WPA records were kept only casually in the 1930s; many were destroyed when programs were terminated.

Artist-in-residence, *in fact if not title*

Christian Petersen was unaware in 1935 that he was the only sculptor-in-residence at a public or private college or university in America. That distinction would not have paid the rent or bought a tub of clay. Petersen devoted his energies to his work, ignoring matters of status, prestige, or monetary rewards.

He was not listed on faculty

records or directories until 1937, when President Hughes was able to create a faculty appointment for him as instructor in applied art, division of home economics. Petersen was, in fact, an artist-in-residence from his first day on the Iowa State campus and remained so through the twenty-one years that followed. Journalism professor Charles Rogers declared in several articles and WOI broadcasts in the late 1930s that Christian Petersen was one of only three artists-in-residence at colleges or universities in the United States: Thomas Hart Benton, at the University of Missouri; John Steuart Curry, at the University of Wisconsin; and Petersen, at Iowa State College.[12]

Christian Petersen cared little about his title. He was anxious to get on with other projects after the dairy sculptures were finished. He had been appointed to a faculty art committee that prepared a list of suggestions for sculptures to beautify the campus. One was the idea of creating "a bird bath memorial" near the college cemetery.

Charlotte recalls her husband's wry comment, privately uttered at home: "A bird bath is not an appropriate memorial—for birds or people." That particular project was never mentioned to the committee by the sculptor.

The sculptor was not interested in personal publicity or public recognition of this work, to a degree that his friends often were compelled to remind him that indeed, he should identify his work and be proud to do so. He did occasionally add his signature to portrait plaques and busts, but never signed his Iowa State College sculptures—except for the tiny lines scratched inconspicuously on the dairy bas reliefs.

Petersen never looked on a past project with regret or outward pride; he was always looking forward to his next sculpture.

In the summer of 1935, he turned his attention to the projects suggested by the college art committee, one of which was a terra cotta mural that Dean Charles H. Stange wanted for the Division of Veterinary Medicine's unfinished outdoor quadrangle courtyard.

Paul Cox, who was by then a staunch friend and advocate of the sculptor, urged him to go ahead with the project for the veterinary division. The Cox kiln was ready to serve the creative talents of the sculptor again, and the ceramicist wanted more students to learn about kiln-firing terra cotta panels for another Petersen sculpture.

4 A Gentle Sculptor Creates *The Gentle Doctor, 1936*

"The Gentle Doctor and bas relief mural by Christian Petersen are international symbols of veterinary medicine."

—Dean of ISU Veterinary College PHILLIP PEARSON, 1976

DURING the summer of 1935, after seventeen months of intense effort on the dairy sculptures, Christian Petersen's temporary appointment ended, halting his $100-a-month salary for three months. He toiled all summer in the hot and dusty ceramics lab. No classes were in session, so he was alone every day sculpting studio pieces and portrait plaques or busts for private commissions, mostly for Des Moines people.

"We had a garden," Charlotte reminisced, "and there were no heating bills to pay, so we eked out a living for three months." The private commissions "helped us put groceries on the table that summer and for quite a few summers after that," she added, noting that "I'll never forget those Des Moines people. They kept us going."

In midsummer, Petersen was notified by college authorities that he was assigned space for the fall quarter in the basement of the home economics building, where he could set up his studio and teach sculpture classes to the women applied art students that fall.

In August he set up his studio-classroom in the southwest corner of the basement, building work tables and bins for clay and plaster supplies. When the quarter began he greeted the students and realized that he was surrounded all day by women, including students and faculty. Male students were not allowed to enroll in his sculpture classes. Because the well-mannered gentleman called Mr. Petersen treated his students with formal courtesy and kindness, he quickly gained their respect.

Harriet Allen, a native of Ames, was a graduate student in applied art that year. She later reflected how privileged she was to be in Petersen's class. Miss Allen still treasures a small and graceful horse sculpture she modeled in Christian Petersen's class; she echoes the universal opinion of his former students that "he made it look so easy when he modeled something in clay. We soon learned, as we strug-

gled with our small projects, that even the simplest sculpture demanded considerable talent and skill. That appreciation for all sculpture has lasted me through the years since."[1]

A second college landmark for the "vets"

The Division of Veterinary Medicine, guided by Dean Charles Henry Stange, was proud of its veterinary quadrangle building, constructed in 1912 as the most modern facility of its kind in America. Stange had become the dean in 1909 at the age of 28. He ably guided the division into a new era of veterinary education.

Traveling in Europe in the early 1930s, Stange saw that sculpture was an important element of college and university architecture. After Iowa State's veterinary quadrangle was built (in 1912), Stange had often mused about adding some kind of art to an unfinished courtyard area formed by the building walls and covered walkways. The area was dusty and unattractive, marked by animal hoofprints, rutted car tracks, and footprints of students. The area became a quagmire every spring.

Stange was therefore delighted when Christian Petersen came to the college in 1934. President Hughes promised the veterinary dean that after the artist finished the dairy sculptures and a number of small projects scheduled for 1935 and 1936, the veterinary project would begin.

After Christian visited with Dean Stange during the summer of 1935, he enlisted Charlotte's research abilities and enthusiasm for his work to help develop ideas for another bas relief wall mural. She spent hours at the library, digging out the history of veterinary medicine education in the United States as well as data on background of the Iowa State College vet education program, which had begun in 1879.

She learned that Stange and his colleagues established three science-oriented departments in the division by 1934: pathology, bacteriology, and physiology. A brilliant man, Stange foresaw the importance of applied science in veterinary medicine and was determined to bring the division into a new era of training for professional practice, teaching, and research.

Charlotte remembered that Dean Stange was "thrilled and delighted with Christian's first sketches for the mural." The artist designed a magnificent bas relief twenty-six feet wide, and six-and-a-half feet high for the east wall of the southwest corner of the veterinary quadrangle courtyard. Students and faculty would see the mural every day as they moved from one classroom area to another, reminded of the professional achievements and goals of their curriculum in veterinary medicine.

On the wall where the bas reliefs eventually would be installed was a horse watering trough which Mac Emmerson, retired professor of and head of obstetrics in veterinary medicine, remembered well in 1984. As a student in the 1920s, he often led horses to the trough. Emmerson recalled that one vet student in the mid-1920s neglected his professional image to the point where he very much needed a bath. "A group of his fellow students formed a committee—or maybe a

posse—and threw him in the horse trough. He needed a real bath after that."[2]

Stange and President Hughes were both impressed by Christian Petersen's artistic symbolism of research and development milestones in veterinary medicine. He portrayed major research advances, such as vaccines that protected humans and animals from contagious diseases. In a one-page proposal of her husband's concepts for the sculptures, Charlotte typed out a description of the proposed mural:

> The protection of human health by guarding animal health through the development of vaccines.

> . . . Men with cow. Protection of the food animal by inspection for the recognition of contagious diseases, specifically foot-and-mouth disease. Since this is a transmissible disease to humans it also shows human protection.
> . . . Kneeling figures working with a calf. The protection of the human from small-pox by vaccine prepared from the calf.
> . . . The protection of the human through the production of diphtheria and tetanus antitoxin through the blood of the horse.
> . . . Figure with hog—the protection of the food animal by vaccination against hog cholera.
> . . . The protection of both humans and animals with rabies vaccine prepared from the spinal cord of rabbits and sheep which have been inoculated with the brain tissue of infected dogs. The figure at extreme right is that of a scientist making microscopic examination of the brain tissue for rabies.[3]

Dean Charles H. Stange viewed the future of veterinary medicine as vitally important for animal and human health throughout the world; the theme of Christian Petersen's bas reliefs reflected that message, emphasizing the symbiotic relationship between man and animals. Each depended upon the other for survival; animal and human health were closely related through the food chain.

In 1984 Dr. Mac Emmerson looked back upon his veterinary education at Iowa State College in the early 1920s and explained, "Vets were regarded as cigar-smoking, foot-stomping, crude horse doctors back then. My own father did not want me to become a vet." Indeed, the public's image of veterinarians was neither urbane nor professional in those days. Working conditions, tools, and techniques were crude, and veterinary care for large animals has always been hard, dirty work.

Emmerson agrees that Charles Stange was a pioneer in developing education for a new kind of graduate in veterinary medicine who was trained in science and a rapidly emerging technology that applied to both human and veterinary medicine: radiology, animal nutrition, surgery, pathology, genetics, pharmacology. All those fields were rooted in the early education philosophy of Dean Charles Henry Stange.

Raymond Hughes takes a leave of absence

President Raymond Hughes, Christian Petersen's staunch advocate, coped with serious problems of his own in the fall of 1935. He had been pressured by factions of his faculty as well as discord in the state legislature concerning the future role of Iowa State College in higher education. Some elements wanted Iowa State maintained as an "ag college," dedicated to its original role in the land-grant charter. Others wanted wider

curricula in science and technology, regarding agriculture as only one essential facet of education for the 1930s and beyond. Budgets had been restricted and larger shares of legislative funding were sought by each of Iowa's two state colleges and one state university.

After the deaths of his wife and son occurred within several years, Hughes succumbed to a burden of emotional stress and took a leave of absence during winter quarter to recuperate in Florida. His leave eventually became permanent. In early December Hughes was named president-emeritus and Charles E. Friley, dean of the industrial science division, was named president.

Hughes had seemed an indefatigable man, devoted to excellence in education, and the Petersens were stunned by his emotional and physical exhaustion. He was their friend and they deeply admired and respected him. But they also knew that in college administrations, "new brooms sweep clean."

They had been reassured by Hughes, who told them in late October that he planned to resign, and Charles Friley would probably be named president. He also explained that Friley wanted Petersen to continue his sculpture work on campus. Hughes then sent a letter to Christian, putting in writing a proposal he made in a conversation with the artist a few days previously:

It occurred to me that it would be helpful to both of us if I had a record of our conversation the other day. I am very deeply interested in your success as a sculptor, and I believe you are approaching a point where you will receive more recognition than has hitherto been the case . . . without doubt your tenure of appoint-

ment . . . must remain very uncertain. This is not because you and your work are not appreciated by the administration, but because of the very nature of your work and the uncertainty of the college being able to finance it from quarter to quarter.

In order to give you a greater sense of security and to enable you to go ahead with more confidence in the work in which you are engaged I am willing to . . . pay you $100 a month for any month that you are not employed by the college, up to a total of twelve.

Their friend Raymond Hughes personally assured Christian and Charlotte Petersen of a year-around salary, because Iowa State College could not do so. Hughes knew the value of Petersen's accomplishments and felt responsible for bringing him to the campus. He pledged his personal integrity and funds because he wanted the Petersens to remain in Ames and because they were his friends. Hughes ended his letter: "I am not able to guarantee this in case of my death; otherwise, I think you can depend upon it."[4]

In December Christian wrote a letter to Hughes in Florida and enclosed photographs of a small model for the veterinary sculptures. Hughes replied:

I like the Veterinary Bas Relief very much indeed; the more I look at it . . . the better I like it. I hope you make this much bolder than the Dairy Panels. I am sure that is the only valid criticism on the latter. I hope that if anything you will err on the side of making the relief too bold. These outside things will always be seen from further off than inside panels such as you have worked on most.

By the way as I remember . . . the reliefs on the Parthenon were very bold, were they not?[5]

Christian Petersen rarely wrote

letters, let alone long ones—but he wrote a three-page reply in which he assured Hughes the advice would be heeded:

I am glad you like the designs for the vet panels. Please be at ease as to the relief—I hope it may be neither too bold nor too low—the architectural style of the Parthenon could countenance nothing but bold treatment in its sculptural embellishments—where a building the type of Dairy Industries does not call for such bold relief—I agree with you they should have been bolder. This situation will not occur on the vet panels.

May I say in our own defense that the others were kept so low under protest. That however does not constitute an excuse—but that "mistake" will not occur again.

Petersen went on to explain that Charles Friley and Dean Stange were "planning to get some Fed. funds reallocated from which to finance the converting into permanent form of the Vet panels . . . I think the estimates for terra cotta . . . are something over five thousand dollars."

The artist commented that he thought the dairy murals cost about $4,000, which conflicts with President Hughes's report to the faculty that fall, listing costs to the college at about $1,750.[6] The artist probably was estimating student labor as well as Paul Cox's time as direct costs on the dairy project, while Hughes did not. Petersen also was estimating commercial kiln charges for the veterinary panels. Anxious to keep expenses low for the panels, Petersen estimated: "I still think it can be kept around my original estimate of $2,000."

He also noted that Mabel Fisher, head of applied art in home economics, had recently informed him he had been retained on the college staff for winter and spring quarters,

"although she did not say at what figure." University records are somewhat lacking, but Hughes mentioned $150 a month as Petersen's salary for the nine-month school year of 1935–36, totaling $1,350. This, however, was still well below $1,520 paid the lowest-ranking teacher in applied art.

Finally, Christian Petersen told his friend Hughes that "the lumber for the panels and six tons of clay came today—so the track is clear and be assured I shall always be doing my best. Hoping the best shall merit your confidence in me, I am yours sincerely, Christian Petersen."[7]

The untimely death of Stange

The Petersens and everyone else connected with Iowa State were stunned in April 1936 by the sudden death of Dean of Veterinary Medicine Charles H. Stange, who died of a heart attack. Petersen was shaken by and deeply pensive about Stange's death. By late 1936, he had created a larger-than-life, half-figure bust of Stange for the veterinary division. For the next few months, he searched for another way to memorialize Stange. Some have since speculated that the statue titled *The Gentle Doctor* was modeled after the dean.

Charles Murray was appointed acting dean within weeks of Stange's death, serving in his new capacity from 1936 until he voluntarily returned to teaching in 1943. He immediately assured Christian Petersen that the murals must be finished, telling him that "They will be a splendid memorial to Dr. Stange and what he accomplished for veterinary medicine during his career." Murray also proceeded with plans for a new veterinary

DEAN CHARLES MURRAY,
CLAY VERSION FOR BRONZE BUST. **CGP**

clinic and endorsed a student proposal
that the building be named for Stange,
which it was.

Dean Murray became a close
friend and enthusiastic faculty propo-
nent of the Danish-born sculptor.
Charlotte remembers that when Mur-
ray first saw the sketches and models
for the bas reliefs he was astounded
by the artistic and thematic concepts
the artist had created. In a handwritten
essay prepared for publicity purposes
in 1936, Dr. Murray wrote:

> In collaboration, [Christian Petersen] and
> Dean Stange worked out the idea for a plaque
> which would depict the services the veterinary
> profession performs in conserving the life and
> health of domestic animals, thereby safeguard-
> ing the health of humans. When finished . . .
> [it] will be given a suitable setting on the east

wall of the clinic building which forms the west
side of the open court in the Veterinary Quad-
rangle. This court will be landscaped to make
a proper setting.

Members of the Veterinary Faculty and
other numerous friends of Dean Stange are
looking forward to the completion of this work
as a memorial to him and a testimonial of his
appreciation of the finer things of life.[8]

Working in his home economics
building studio, Petersen began the
carving for a revised version of the
veterinary bas reliefs in the spring of
1936, an effort that lasted many
months. He conferred with Paul Cox
about producing forty-four small sec-
tions in terra cotta, with a "graham
cracker," unglazed surface. Each was
sized to fit the Cox kiln, approxi-
mately twenty by thirty inches. Cox
wanted to incorporate the kiln work as
part of the ceramic engineering labora-
tory teaching, giving his students the
advantage of working on an important
project at a more leisurely pace than
for the dairy project. The first firings
would begin in the winter quarter of
1936–1937, continue through spring,
and be finished during winter quarter,
1937–1938. Because funding was de-
layed, the extended production
schedule allowed Christian Petersen
time to work on a series of small
sculptures for the college.

Charlotte Petersen always called
the finished mural "The Mighty
Panels," referring to them as such dur-
ing Christian's initial designs, through
every stage of production, and for de-
cades thereafter. She regarded them—
as do knowledgeable others—as "a
powerful, powerful statement about
man's dependence upon animals—and
their dependence upon him." In a
1983 interview, she explained her hus-
band's approach to the design:

The panels . . . were his expression of one thought: man's contribution to animals, and the contribution of animals to man. One without the other is nothing. And it's really a masterpiece. I still thrill when I see it, and I can't see it enough.

It's all about life with animals, and how important a relationship that is. And it was a fascinating thing to do. Christian felt a kinship with the vets, from the first moment he met Dean Stange. He loved people and animals, so he was close to the students and faculty. They were intelligent, practical people who worked with their hands and hearts. So was he.

The campus artist-in-residence was not able to devote most of his time to the veterinary project, as he had done during the first year of his work on the dairy sculptures. Because his sculpture students had told their friends about the quiet, kindly Danish artist teaching sculpture, his classes were overcrowded in his second year of teaching. During the school year of

1935–1936, he designed and fired terra cotta bas reliefs for the men's gymnasium and Roberts Hall dormitory, at least seven faculty portrait busts or plaques, the Marston Medal for Engineering, and an Alumni Association medal. All of these projects were assigned by the college administrators.

By June of 1937 Petersen was revising the clay carvings for the immense veterinary mural, and by October of that year the designs were approved and terra cotta production began in the ceramic engineering department. He then wrote another letter to Hughes in Florida, in which he reported progress on the murals and briefly mentioned that he was working on an idea for a central figure to enhance the theme of the bas reliefs. That mere mention was an understated indication that the artist was in the creative process for what became one

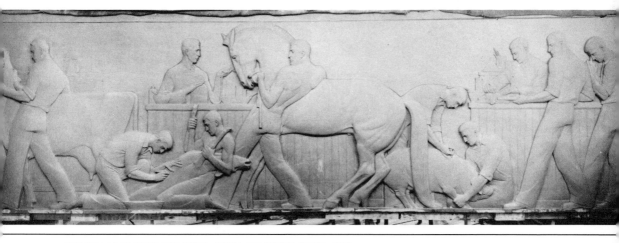

ORIGINAL CLAY PANEL FOR TERRA COTTA BAS RELIEF MURAL. **CGP**

of the most important, and certainly the most well-known, of his campus sculptures.

The gentle sculptor creates
The Gentle Doctor

Working at night in his studio in the fall of 1936, Petersen met a young man named L. M. Forland, a freshman pre-vet student who was earning his way through school by doing janitorial work for twenty-five cents an hour. The two often chatted while Petersen worked on his clay or stone and Forland attempted to sweep up the day's debris from the sculpture classes.

Forty-seven years later, Forland revealed that he unknowingly was the model who posed for what became known worldwide as *The Gentle Vet* or *Gentle Doctor*. A graduate in vet medicine, class of 1941, he explained in 1983 how his campus job introduced him to Christian Petersen:

> . . . It was the latter part of fall quarter '36 and the early part of winter quarter '37 that I modeled for Christian Petersen . . . Mr. Petersen often worked in the late afternoons and evenings when I was there and we became good friends. . . .

> Mr. Petersen's studio was on the ground floor of the home economics building. I remember too well how heavy his garbage cans were! If we had a few minutes' time, he would ask me to stand for him while he carved away at a small pile of clay. He had me hold a small pillow between my forearms in a position similar to that of a little pup.[9]

The "little pup" turned out to represent the bond between man and animal, symbolizing the essence of veterinary medical practice. The tall, cap-able doctor gently holds an injured or ill puppy, glancing down at the watchful gaze of the mother dog patiently sitting at the vet's feet, leaning against his knee.

Christian Petersen had developed the idea in a series of thoughtful sketches, which are preserved in the Christian Petersen Papers at the Iowa State University library department of special collections. The artist had rapidly sketched three initial ideas. The first is a little girl carrying her sick pup to a vet, who reaches down to retrieve the animal from her arms. The second is another little girl, this time holding what may be a kitten, while a kneeling vet examines the animal. The third shows a dog being carefully examined by the vet as it lies on the ground, the anxious little girl touching the animal reassuringly.

CPP

64

Rejecting these three ideas, Christian Petersen then turned to a fresh page of his sketchbook, quickly blocked out a series of a few bold lines, and left the remainder of the sketch unfinished. He undoubtedly had grasped the exact idea he wanted, and he probably dropped the sketchbook to pick up a handful of clay.

The unfinished sketch shows only the feet, legs, and long lab coat of a standing veterinarian and simple lines of a mother dog. There the lines end, but Christian Petersen knew that the mother dog's nose would be anxiously pointed upward at the vet, who held an ailing puppy.

L. M. Forland, the shy young student, happened to be working in Petersen's studio and was asked to hold the pillow "as if it were a puppy." Dr. Forland described himself as somewhat awed by the presence of a college professor who was an accomplished artist. He confessed, "I never asked him what the final product would be" as a result of the pillow-holding sessions.

CPP

CGP

A GENTLE SCULPTOR CREATES *THE GENTLE DOCTOR* 65

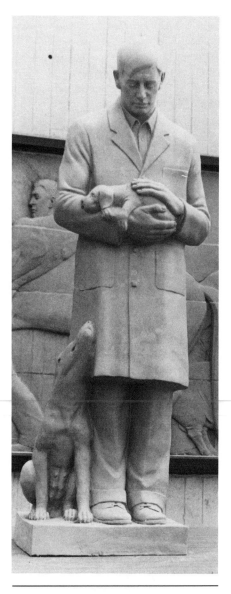

"THE GENTLE DOCTOR,"
BRONZE VERSION. AUTH

When the statue of *The Gentle Doctor* was installed in front of Petersen's bas relief murals in the fall of 1938, Forland realized he had unknowingly posed for the sculptor's initial concept of the sculpture.

Almost fifty years later Charlotte Petersen confirmed that the model for the gentle vet was, indeed, Forland. She admitted, however, that she was not able to follow the progress of this particular sculpture by her husband since "I was pretty occupied that winter—our daughter was born in November, and I just couldn't get over to Christian's studio that fall to see what he was working on."

Special recognition was accorded Dr. Forland at a 1983 Veterinary College homecoming reception for alumni. The "country vet," as he calls himself, had been so busy with his family and practice since graduation in 1941 that he had never previously attended the traditional homecoming festivities.

Other inspirations for the gentle vet

Through the years a campus legend says that Petersen fashioned the tall, powerfully built figure with Dean Charles H. Stange in mind, whether purposely or subconsciously. This can neither be proved nor disproved. However, another young man who graduated from veterinary medicine at Iowa State College in 1940 was certainly involved in a key role as an inspiration for the statue.

He was Dr. William R. Born, who practiced veterinary medicine in Story City, Iowa, until his untimely death in 1966. Dr. Born was a vet stu-

dent in 1937–38 when Petersen was carving the original clay version of the statue. By spring of 1938, the sculptor had been invited to move his studio to an empty equine ward in the southwest corner of the vet quadrangle, at the personal invitation of his friend, Dean Charles Murray.

Charlotte told the story in 1983:

Christian worked in the basement of the home economics building, but they didn't like having his studio there, and I can't blame them. There they were, trying to prepare appetizing food in their classes, with the smell of wet plaster and soaking clay coming from the basement studio.

His students tracked clay and plaster all over the stairs and halls, right into their cooking or sewing classes. It was a messy situation that no one liked.

But then a big thing happened. Charles Murray came over, saw the mess, and invited Christian to come over to the vet building and work there. They had one big vacant room which had been a horse hospital. Dean Murray offered it to Christian for a studio-classroom.

The area was on the southwest corner of the vet quad, with a concrete floor and nice west sunlight through the windows, plus its own outside entry. There was no phone, but there was running water and a bathroom nearby. The new Stange Memorial Clinic building had opened up the space, and Dean Murray gave Christian first chance at it. Of course he said "yes" immediately.

Christian was absolutely delighted to move back into the company of men. He loved talking sports and swapping stories—and the vets became his closest friends on the campus. The students and faculty often dropped in to chat; it was the only classroom that had a coffeepot always going and a radio, too. The students loved it; I can remember his sculpture classes always listened to Arthur Godfrey.

The vet quad area was to be Christian Petersen's studio for the remainder of his career and his life, the next twenty-three years. Charlotte told the veterinary faculty in 1972, "From the day that Christian entered the horse stalls and set up his studio, it was destined to become the rendezvous of students, professors, and town people. Christian was always pleased when the veterinary students came in to introduce themselves and stayed to watch him work and ask him questions. A rapport was there that was much appreciated and truly a delight."

It was here that a young vet student named William Born was asked to stand and hold a book several times, so that the gentle sculptor could model the capable hands of *The Gentle Doctor*. Marie Born Green of Lincoln, Nebraska, explained in 1984 that Dr. Born was her husband from 1941 until his death in 1966.[10]

Bill Born, like L. M. Forland, worked his way through Iowa State College tending furnaces and shoveling walks in exchange for a basement room in a private home, and working a board job in a dormitory for meals.

Mrs. Green described how Bill Born became acquainted with artist Christian Petersen: "He would finish his breakfast duties at the dorms quite early and then go over to the vet quad for some study before classes began. Nearly always, Christian Petersen would be in his studio . . . his open door emitted light, welcome, and a cup of coffee for whoever wished to stop in. It was during this period that the statue was 'being born.' "

Mrs. Green agrees that *The Gentle Doctor* is very probably a composite of the vet students and faculty Christian Petersen knew at Iowa State. But she is justifiably sure that Bill Born had a hand—or two of them—in the original modeling of the vet fig-

ure. When her husband brought her to Ames to meet Petersen she was heartily welcomed to Iowa and the campus by the sculptor and escorted to the courtyard of the veterinary quad, where he introduced Bill Born's bride to his "friend," the seven-foot-tall sculpture.

Undoubtedly, the hands of William Born, D.V.M., were the models for the large, gentle hands of *The Veterinarian,* as the statue was first called. It soon became popularly known as *The Gentle Vet* or *Gentle Doctor,* and has been called both ever since.

Through the years whenever Charlotte Petersen was asked why the statue has such large feet and hands, she always had a ready reply: "First of all, the statue is in heroic or larger-than-life proportions—it's seven feet tall. And a vet is on his feet all day, so the feet have to be big and strong. Finally, his most important examining tools are his hands. Christian wanted to emphasize that."

The gentle vet project moves to the vet quad

Petersen began sculpting the clay for the vet figure in his basement studio in the home economics building. Later the partly completed statue was moved to the artist's new quarters in the veterinary quadrangle, probably in late spring or early summer of 1938.

After considerable delays, the vet division and the college found a way to finance kiln firing of the terra cotta statue at a Chicago art foundry, since it was too large for the campus kiln. Apparently the firing was delayed for some months, because the vet figure was not installed in front of the "Mighty Panels" until fall. College masons had removed the ornate horse-watering trough in early 1938 and reworked the brick wall to receive the panels, which were installed in the spring.

When *The Gentle Doctor* was scheduled for installation, a conflict arose regarding the location the artist had selected for it. In May of 1938 Professor P. H. Elwood, head of the Department of Landscape Architecture, in a rather pointed letter to B. H. Platt, superintendent of the Department of Buildings and Grounds (with copies to Petersen and Friley) indicated that he had missed a group meeting to decide upon the location of the statue:

On Saturday last, I had an opportunity to visit with Dean Kelley of the Chicago Art Institute who is familiar with the work on the campus. In discussing the location of this statue with him, he seemed very much horrified at the thought of placing this statue below and directly in front of the fine large ceramic mural. He said I could quote him to that effect.

He [Kelley] explained there were many fundamental reasons why this statue did not belong in that location, and suggested that either a central or a location directly east near the wall would be preferable. Without much difficulty, it seems to me that by bricking in one window, or through the proper use of planting, adequate background could be provided for this statue on the east side of the court. Two compositions quite different in character could be created in this way. Otherwise, I feel the statue would tend to weaken the effectiveness of the fine, spirited, and vigorous wall decoration.[11]

The veterinarians apparently ignored Elwood's esthetic advice. They placed the sculpture exactly where Petersen designed it to be, directly in

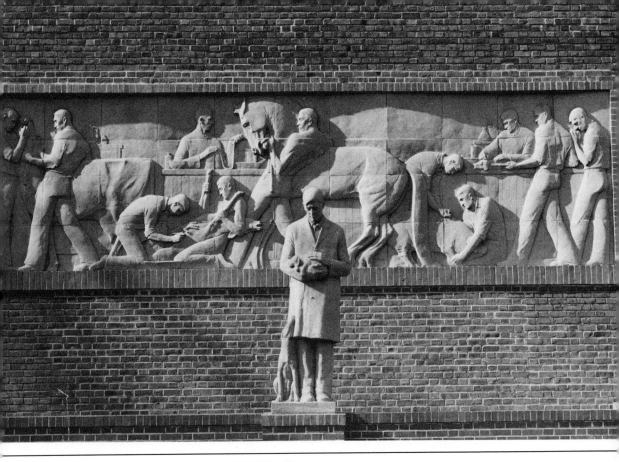

front of the bas reliefs depicting the history of veterinary medicine. "Christian wouldn't dream of telling Elwood where to plant his bushes, because Christian wasn't a landscape architect. But he did know something about sculpture. We were both glad the vets placed it where it should be," Charlotte commented.

The impact of Petersen's veterinary sculptures

The Gentle Doctor and veterinary bas reliefs have been recognized by veterinary schools throughout the United States and the world as "international symbols of veterinary medicine," declared Dean Phillip Pearson of the vet college in 1976. A letter from Dr. Richard Talbott, dean of the Virginia-Maryland Regional College of Veterinary Medicine, expressed Dr. Talbott's appreciation for permission to use photographs of the sculptures as permanent art for a college newsletter.[12]

Dr. Frank Ramsey, a professor emeritus of veterinary medicine, wrote Charlotte and Mary Petersen in 1985: *The Gentle Doctor* . . . reflects concern, affection, love, and the significance of life for all of God's crea-

tures—great and small. The memory of Christian Petersen will live forever in the minds of the veterinary profession."[13]

At Iowa State, small plaster replicas of the statue were created by Petersen late in his career, after numerous requests from his veterinary friends. "The veterinary profs constantly prodded him to make a statuette replica of *The Gentle Doctor*," said Charlotte, and he eventually did so. It has become a memento and a symbol of the veterinary profession.

The Veterinary College sold hundreds of eighteen-inch replicas from 1960 to 1980, but the mold eventually wore out. A new, nine-and-a-half-inch version was designed by artist Herman Deaton of Newton, Iowa, and produced in a bronze-resin process for sale as a scholarship fund project. Hundreds of statuettes have been purchased, many of them by foreign students in veterinary studies at Iowa State University. *The Gentle Doctor* is thus recognized throughout the world for its universal theme of man's care for animals.

Charlotte Petersen received a royalty for each *Gentle Vet* replica sold by the college; net proceeds fund the "Christian Petersen Memorial Scholarship," awarded annually to deserving veterinary students. Five students received $500 scholarships in 1984.[14]

In 1982, celebrating its centennial year, the Iowa Veterinary Medical Association commissioned a commemorative bronze medallion featuring the image of *The Gentle Doctor*. One of these, in a limited and numbered edition, was presented to Charlotte Petersen in behalf of Dr. and Mrs. Orin Emerson of Eagle Grove, Iowa. For many years, the college has

CHARLOTTE PETERSEN, HONORED GUEST AT "THE GENTLE DOCTOR" SOCIETY, MAY 1984. **CONT** *College of Veterinary Medicine.*

featured *The Gentle Doctor* in its promotional literature, on award and recognition plaques, or in special displays in the vet college building complex. The figure of the compassionate veterinarian has been carved in wood by artist Randy Harris of Nashua, Iowa, for "The Gentle Doctor Society" wall display of contributors to the Veterinary Challenge Fund. The image has also been recreated in an acrylic painting by Dean Biechler for the centennial of the vet college in 1979.

A bronze version of
The Gentle Doctor *cast in 1976*

When the vet college moved into its new $24 million building complex in 1976, a special setting had been designed by architects for Christian

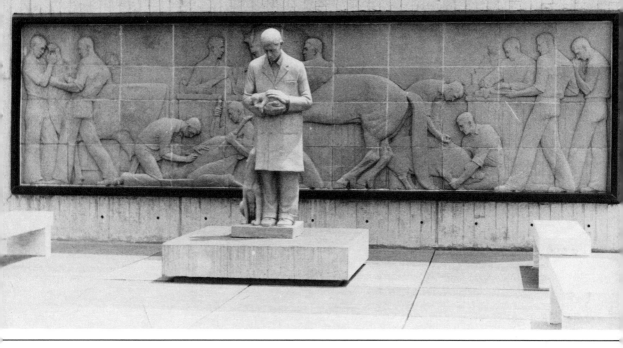

Petersen's bas reliefs and statue. They are now the esthetic focus of a pleasant plaza on the west side of the complex, occupying an entire wall near the entrance to the administration wing.

As the sculptures neared their fortieth anniversary in 1976, the original terra cotta panels were in excellent condition, but the veterinary figure was marred by decades of severe Iowa weather, cracking and flaking on much of its surface.

As a gift to the college from Dr. and Mrs. J. E. Salsbury, the statue was recast in bronze by Paul Shao, a talented architecture professor and sculptor on the faculty of Iowa State University's College of Design. Shao also refurbished the original terra cotta *Gentle Vet,* which was placed indoors on the main floor of the Scheman Building of the Iowa State Center.

The Ames *Daily Tribune* reported: "It is a source of pride at ISU that the international symbol of veterinarians originated on the campus of the nation's oldest college of veterinary medicine . . . for the more than 4,000 graduates of the college, the students and faculty, who have a sentimental attachment to the *Gentle Doctor,* Shao has some reassuring words: 'The bronze will last forever.' "[15]

The Gentle Doctor replicas are displayed in the offices of Iowa State veterinary graduates who are in practice or are faculty members of veterinary colleges throughout the United States and the world. Photographs or sketches of the figure have often been reproduced in literature sponsored by state, national, and international veterinary medical associations.

On both the original and bronze versions of *The Gentle Doctor*, the puppy noses have been worn smooth by thousands of persons who instinctively reach out to bestow a reassuring touch. Christian Petersen's sculpture evokes man's compassion for all animals, particularly those who are companions for humankind.

As he always did, J. C. Cunningham followed his friend's project closely, from start to finish. Just after the statue was installed in the veterinary quadrangle, Cunningham brought Petersen something he had written in tribute to the statue of *The Gentle Vet*. The poem was later included in a small book of poems, *From Dawn to Dusk*, printed in 1943 by a group of Cunningham's faculty friends:

FAITH

The mystery of suffering
She cannot understand,
Yet humbly at his feet she waits
To know his least command.

She cannot think her god is clay
Nor his neglect ill meant.
Waiting here she feels his touch
And is content.

Inside the main entryway of the ISU veterinary administration offices is the larger-than-life bust of Dean Charles H. Stange. The figure is oriented toward a view of a plaza, looking toward the murals and a symbolic sculpture of a gentle veterinarian he never lived long enough to see.

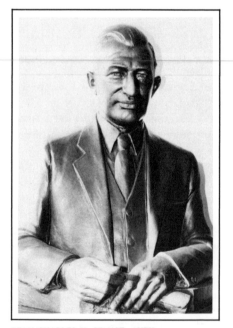

DEAN CHARLES H. STANGE. **AUTH**

5 Creating Campus Landmarks, *1938–1955*

"Lo, there is joy in my house."

—Osage Indian prayer of Thanksgiving,
Memorial Union fountain sculpture theme

THE campus artist-in-residence had completed two major projects for the dairy and veterinary medicine courtyards, a number of faculty portraits, and two bas relief sculptures for the men's gymnasium and Roberts Hall by spring of 1938. After four years at Iowa State, however, he was earning only $150 a month, on a nine-month basis.

Because the Petersen's daughter, Mary Charlotte, was almost two years old, Christian and Charlotte were concerned about their financial status and strongly tempted to seek better paying work elsewhere.

Although President Charles Friley had assured Petersen he wanted him to remain at Iowa State, the sculptor's faculty rank was only instructor and he was the lowest-paid member of the applied art teaching staff.

Charlotte looked back on the summer of 1938 as a "fork in the road" for her husband's career. They drove to Kentucky that summer, where Christian sketched the president of the University of Kentucky, Frank LeRonde McVey, in preparation for a commission to do a bronze portrait plaque. As they traveled through the Kentucky hill country, they were stunned to discover how floods had ravaged the small croplands and homesteads some weeks earlier, leaving the people of the area in even worse straits than the abject poverty they had endured for decades. It was a profound experience for both the Petersens.

They stopped often to visit with sharecroppers who mourned their dead or missing loved ones. They attended one simple funeral, sharing the grief of families in a little settlement near Wilhurst, Kentucky.

These Kentuckians knew that the Great Depression was something happening far away, to other people. Their economic depression was permanent; it was a way of life. Yet they all had unshakeable faith that somehow the Lord would lead them out of their misery, and things would get bet-

ter. Christian and Charlotte were moved by the simple faith and warm friendliness of these hill people. He filled his sketchbooks with superb impressions of people they met, each of whom they vowed never to forget.

By the time they returned to Ames, Charlotte and Christian felt they were lucky, indeed, to have some options for choosing their own lifestyle. They determined to explore the possibilities.

He considered resuming die cutting and engraving work on the West Coast. Charlotte related that "Dodge and Asher had been after him for several years, trying to get him to come out there and work in their West Coast office." She explained also that "Christian told me if he went back to die cutting, he could work at that the rest of his career and do some sculptures on the side. The pay would be fabulous, since die-cutter designers were in extremely short supply—and he was one of the best."

"He told me we'd never have to worry about money again. We could send Mary to the finest schools. And I could have a mink coat, if I wanted one," she added. Finally, Christian left the decision up to his devoted wife, who remembered well—many decades later—her reply to the question: "Do we stay, or do we go?"

She knew that Christian wanted to be a sculptor, not a die cutter, and she also knew that he had plans in mind for more landmark sculptures at Iowa State. Her answer: "I don't want a mink coat. I already have a coat. And you're a sculptor, not a die cutter. Let's stay, at least for another year or two."

She recalled that Christian heaved an audible sigh of relief, perched his battered felt hat on his head, and left home for his veterinary quadrangle studio whistling a whimsical tune.

He stayed on at Iowa State, unaware that his was a unique position, that of sculptor-in-residence at an American college.

In a feature story on Christian Petersen in the Ames *Tribune-Times* (January 1, 1938)—one of the best two profiles ever written about the sculptor—Virginia Cook asked him about regionalism in art:

"Regionalism is the bunk," Petersen said, laughter wrinkles around his eyes. "That is putting it crudely, perhaps. Of course my own work is regional in that it uses the material of the lives of Iowa and middlewestern people. It is natural that the artist uses the material around him. But I do not use a different style or work on eccentric principles because of the regional subject matter," he explained.

Petersen hopes to make his sculptures a part of student life on the campus. He feels that agricultural and science students need a knowledge of and appreciation of art. He hopes that his sculptures will become as much a part of the student's life after graduation as the campanile.[1]

Three bas reliefs of athletes, State Gymnasium, 1936

Petersen's second Iowa State project was designing terra cotta bas reliefs for a new masonry staircase at the men's gymnasium. Built in 1913 and named "State Gymnasium," the building was remodeled in 1935. A new outdoor staircase was added in order to accommodate basketball crowds more conveniently. Virginia Cook described the sculptures:

THREE ATHLETES, STATE GYMNASIUM. **CPP**

In a limited space the artist conveys a flowing movement which reaches its apex at the head of the central figure. Against the advice of experts who said it couldn't be done Petersen designed the panels for the full length of the kiln in which they were to be burned. The panels were successfully heated in spite of their large size.[2]

The inset terra cotta panels—fired in the Cox kiln—depict a football player carrying the ball and stiff-arm-ing a tackler; a basketball player poised shooting a free throw, and a track man sprinting. Each is designed in five horizontal panel sections, confining the figures in tall, slim rectangles. The high reliefs show small details—cleats on the football shoes and spikes on the track shoes, for example. Petersen sculpted superb detailing of muscle, bone, and tendon contours of athletes captured in mid-motion.

Roberts Hall fountain and bas reliefs, 1936

Christian Petersen designed two terra cotta bas reliefs that have become a rarity among his known works: nude female figures. Two exquisite young women were portrayed in graceful repose, their heads uplifted toward a small fountain. One of them languidly extends her upturned hands to catch the gentle water as the two appear to be contemplating their lives and futures.

Charlotte reminisced wistfully about the Roberts Hall sculpture:

They're two lovely young women, and they're nude, but you don't see the nudity, you see the beauty of youth. When Christian first thought up the idea for that bas relief, he came home with some preliminary sketches and showed them to me. I looked at them and remembered a poem with the line,

". . . no world more wide,
Since all her dreams start here or here abide."

He liked that thought so much he said, "We'll use that for the theme, and we'll put those words on the panels."

The sculptures were designed for a beautifully landscaped courtyard and double stairway of the new Roberts Hall, named for Maria Roberts, a mathematics teacher and dean of the junior college during her forty-year career at Iowa State College.

An idyllic courtyard with two graceful sculptures is now largely unnoticed by students hurrying by the stairway and veranda. The fountain was removed some years ago. Although the bas reliefs are intact, the supporting brickwork has been damaged by winter ice and frost, leaving crumbled and cracked mortar joints.

Both Christian and Charlotte wondered whether the artistic purity of nude figures would be acceptable to Iowa State College in 1936. At that staid institution in the late 1930s the elegant figures undoubtedly caused some lifted eyebrows. In a memo to college officials listing the costs for the sculpture—also fired in the Cox kiln—Petersen cryptically noted, in case anyone might inquire, "No models used."

One enduring campus legend is

ORIGINAL ROBERTS HALL FOUNTAIN AND BAS RELIEFS. **CPP**

that college officials quickly planted thick shrubbery to cover the sculptures, fearing accusations of indecent art on the campus. The story is probably apocryphal, however, since the brick courtyard surface shows no evidence of a planting area for shrubs.

After the Roberts Hall sculptures, Christian Petersen's rare nude works, including some exquisite figures in marble and Bedford stone, were reserved exclusively for private collectors.

In 1984 Charlotte Petersen rediscovered the poem from which the sculptured lines originated. Titled "Sancta Ursula," by William Aspenwald Bradley, the poem was published in the July 1917 *Century* magazine, a copy of which Charlotte Petersen found sixty-seven years later. "I remembered and loved that poem ever since I first read it, at the age of nineteen," she explained with considerable delight, "and when I recited it to Christian in 1936, he loved it, too. It reminded both of us of what life in a women's dormitory at a college might be like, and it tells of the hopes and dreams of a young woman—all young women, no matter what era they're in."

SANCTA URSULA[3]
(After Carpaccio)

This is her room; this is her narrow bed
Whereon each night her golden hair is spread.
This is her glass, wherein each morn she looks;
These are her pictures; these are all her books.
These are her trinkets, trophies girlish, gay;
These are the toys she touches every day.
This is her desk, whereat she sits to write
Letters that make the day that brings them
 bright.
These are her fish that swim in water clear;
This is her winged Love she holds most dear.
This is her rug her eager feet have pressed,

This is her chair, wherein she sinks to rest
When wearied with some simple task or
 pleasure.
This is her clock, whose hands her young hours
 measure.
These are her walls that hold her heart at home.
These are her windows, tempting her to roam.
This is in fine her world; no world more wide,
Since all her dreams start here or here abide.

Memorial Union Fountain of the Four Seasons, *1941*

After completing the massive terra cotta mural and *The Gentle Doctor* for the veterinary quadrangle in 1938, Christian Petersen found his sculpture classes so crowded that more sections had to be arranged every quarter at registration—and even those filled rapidly.

When he moved to the quadrangle in 1938, he unofficially allowed men students to attend his classes. But the word quickly spread—particularly among the architecture students—that Petersen's sculpture teaching was enjoyable and all students were welcome, regardless of their art ability or major areas of study. Furthermore the class was coed, one of the few informal ways men students could enjoy the classroom company of women, most of whom attended class in the home economics building where men seldom ventured.

A group of men students formed a committee in spring of 1939 requesting enrollment privileges in Petersen's sculpture classes. College officials, knowing full well Petersen had allowed men to enroll without credit, granted permission—with the proviso that the sculptor would have to make room, somehow, for all the extra students who wanted to be there.

Petersen managed it because he thoroughly enjoyed being among young people who responded with enthusiasm and enjoyment to his teaching. Most of them had discovered art as grade school pupils and never found an opportunity to explore it further; he gave them an art appreciation course with "hands-on" experience in a difficult, third-dimensional medium. Most of them have enjoyed that background all their lives.

Their mentor became a friend, a father-figure, or a Danish "Dutch" uncle. He never humiliated or belittled a student whose sculpting efforts were clumsy or unimaginative; he quietly suggested ideas or demonstrated how to improve a detail with a deft motion of his thumb on the yielding clay. One student remembered, forty years later, "Petersen's thumb had more talent in it than both my hands and all of my brain."

He also had a way of interspersing his teaching efforts with wry humor in the informal studio setting. For example, one rather attractive and flirtatious coed was escorted to and from class every day by a changing assortment of college boys who vied for the pleasure of her company. Attempting to finish a small clay portrait one day, she tried repeatedly and failed to model the eyes satisfactorily.

From her corner of the crowded studio, she appealed to her teacher in a coquettish voice: "Mr. Petersen— how do you make eyes?" From the other corner of the room he replied, "You are asking *me* how to 'make eyes'?"

Along with his crowded daytime classes, the sculptor had to work on dozens of portrait plaques and busts of faculty members in the late afternoons or evenings. He also did a number of studio pieces and private commissions at night, taking a few hours off for dinner with his family and returning to the studio to work from eight o'clock until midnight or later.

In early spring of 1940 a message was sent one afternoon from a veterinary department office to Petersen's studio. Since he had no telephone, the message requested him to call the president's office immediately. When Petersen reached President Charles Friley by phone, the latter gave the impression of being in a vexed mood. As Charlotte Petersen recounts, Friley sputtered an angry directive at the sculptor: "Petersen, I want you to do something about that terrible toilet situation we have over there at the Union fountain. They did it again. Think of something beautiful they can't make a joke out of." With that, Friley hung up.

Charlotte Petersen explained: "President Friley was tired of seeing the existing fountain there at the Union—it was just a little squirt, really—with either a toilet seat or even an old toilet fixture put there by students for a prank."

The Memorial Union fountain was a vertical water spout with a simple reflecting pool, a gift to the college in 1936 from the Veishea Central Committee. Every spring campus pranksters repeatedly found castoff toilets or toilet seats and perched them over the fountainhead late at night, causing chuckles among their peers and consternation in the highest offices of the administration the next morning. Friley wanted Christian Petersen to design sculptures for the fountain that would not tempt campus hijinks.

The sculptor welcomed the assignment because he particularly loved doing sketches for fountains. He mulled over various ideas for a few days, and then talked to his friend J. C. Cunningham, explaining the fountain situation, and adding that he would like to do something on an Iowa Indian theme. The sculptor had spent several weeks with the Mesquakies in Tama in the early 1930s, sketching their tribal symbols and lifestyle for a commission to illustrate a children's textbook, *Cha-Ki-Shi*. Cunningham dug into his voluminous files on American Indians—one of his many favorite intellectual pursuits— and came back to see his friend "Pete" the next day, bringing with him an ancient Osage legend, a chant or prayer of thanksgiving for maize.

Within a day or two, the sculptor brought sketches for Charlotte to see, asking her what she thought of them. "They were beautiful drawings," Charlotte described, "of four handsome Osage women facing North, South, East, and West. Each represented one line in the Osage chant. I loved it. The first plants the seed corn":

Lo, I come to the tender planting.

"The second bends close to the earth":

Lo, a tender shoot breaks forth.

"The third holds a harvest basket of maize":

Lo, I collect the golden harvest.

"And the fourth nurses her newborn babe":

Lo, there is joy in my house.

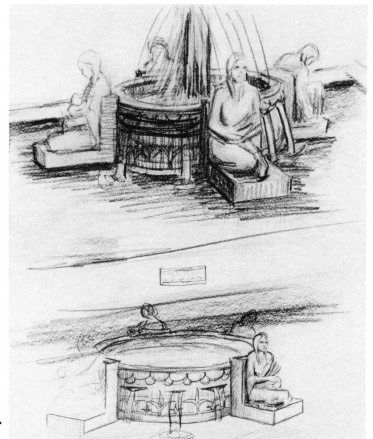

Petersen's handwritten notes reveal the effect he sought for the arching fountain jets:

Full water display symbolizes the fullness of the elements . . . the arch of the sky . . . the lifegiving rains . . . the calmness of the Indians in the face of the turbulence of the elements. . . . Tranquil water goes with the tranquility of the Indians. . . . Much water symbolizes elemental turbulence.[4]

Charlotte emphasized that the tranquility of the Indian women is enhanced by the strong arc of the water, and that the fountain spray pattern was designed as a significant part of the composition.

The artist set to work creating a small model of the fountain for Charles Friley's approval. One day during his late afternoon advanced sculpture class, Petersen retrieved the model from a cupboard just as his last student was leaving the studio. He set it on the worktable and asked, "What do you think of this?"

Lois LaBarr Moses was that student in 1940. A longtime resident of Ames, she later remembered that day vividly and recalled being astonished at the beautiful little clay model. "One day Christian Petersen showed me a small oval model with four kneeling figures of Indian women around it. He explained what it was to be, and the meaning of the four figures. It was a miniature of the fountain sculptures created for the Memorial Union. We were looking at it, and he asked, 'What do you think of this idea?' Imagine—Christian Petersen asking me!"[5] Petersen often asked his students for their reactions or suggestions regarding his sculpture projects. "He and his students had respect for each other. He valued their honest opinion

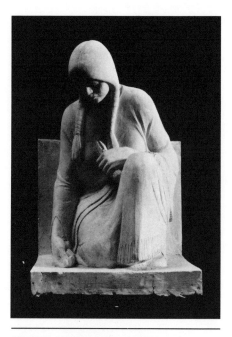

ORIGINAL PLASTER MODEL. **CGP**
Lo, I come to the tender planting.

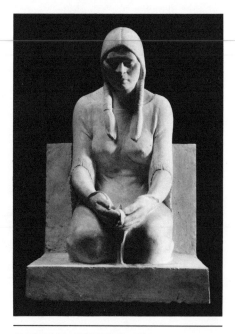

ORIGINAL PLASTER MODEL. **CGP**
Lo, a tender shoot breaks forth.

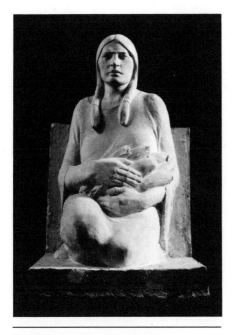

ORIGINAL PLASTER MODEL. **CGP**
Lo, I collect the golden harvest.

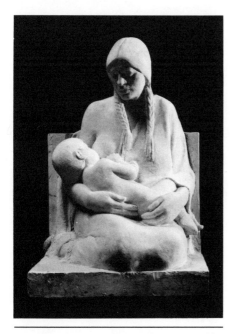

ORIGINAL PLASTER MODEL. **CGP**
Lo, there is joy in my house.

of his sculptures, because he wanted everyone to understand and enjoy them," said his widow.

Satisfied with Lois LaBarr's approval of his idea, he placed the model in a box and left for President Friley's office. The president liked the model but wanted full-scale versions for final consideration. Petersen went to work creating them in clay—a monumental effort, since each was larger-than-life size. After he cast them in plaster, Friley was so enthusiastic about them he ordered the four huge plaster castings trucked to the national cornhusking championships in Davenport, Iowa, that fall, where they were shown in a tent display area sponsored by Iowa State College. They were later stored in Ames and remain in storage.

Once approved, the four sculptures were to be carved from Bedford stone, a demanding task. Petersen tackled it with typical gusto in his quadrangle studio. By May 1941, the four statues were installed in the Union fountain, surrounding a new fountainhead. The artist had also designed terra cotta panels for the fountain basin perimeter, bas reliefs which were fired in the Cox kiln.

Friley was so pleased with Petersen's sculptures he arranged an unveiling presentation for them at Veishea. Charlotte Petersen remembered:

It was the only ceremony I can remember for any of Christian's work, probably because it meant so much to Dr. Friley. They scheduled a formal dedication, invited important people, and gave some speeches before the canvas was to be taken off for the unveiling. [Pranksters from Drake University, however, had planned a surprise for Friley and the College.] Iowa State and Drake had a great rivalry in those days in sports, and when the statues were un-

veiled, there were the beautiful Indian women, each with her face painted a bright red. There wasn't a sound from anyone in the crowd. No gasps, no remarks. There was dead silence because everyone was horrified at such a dumb stunt. They went right on with the ceremony.

Despite its inauspicious inaugural, the *Fountain of the Four Seasons* was well received by students and faculty. Petersen sent photographs of the finished work to his friend George Nerney in Attleboro, Massachusetts, and Nerney responded with a glowing letter of praise, in which he said:

I think you have handled the massing of the figures beautifully. The curving of the water jets complements everything just as one could wish, and I find much of harmonious relationship . . . the figures are so simple in their strength and beauty that I have enjoyed studying them, even down to the remarkably fine positioning of the little child's right foot as it fits so marvellously into the design . . . I like the design of the plant growth on the lower part of the fountain basin between the figures; but is it corn? I am inclined to believe it is, but still, I am not enough of a farmer to recognize it.[6]

In an interview with Martha Duncan on WOI radio in 1942, Professor of Journalism Charles Rogers commented on the *Four Seasons* fountain:

. . . The work took the best part of a year of Petersen's spare time—late at night, early in the morning, literally a whole year of time he could spare from his teaching duties . . . Petersen received much of the inspiration for these great figures from an old Indian song . . . Our campus authority on the history of corn, J. C. Cunningham, found it among his vast collection of corn lore . . . corn forms the economic basis of all cultural life in Iowa . . . [7]

August Bang, a writer for an American Danish language magazine, *Julegranen,* wrote a story about the sculptor, describing the Union fountain as "an epic poem hewed in stone—four full strong bars—rounded out of the joy of life." Bang, a poet and essayist who traveled to Ames specifically to see Petersen's work, wrote eloquently of *The Four Seasons:*

Here he has with his love of truth and aliveness and deep understanding given expression to the peace and happiness which Mother Earth gives to her children . . . Here he has with his love of truth and thoroughness in the project, illustrated the national American in the figures of the four Indian women which sit around the fountain. Three of them are working with the earth. They are planting maize, America's original bread corn . . . the fourth and last sits with her first born in her mother arms and her song is the full deep note "Lo, there is joy in my house."

A quiet, complete life cycle—tenderness, Godliness, work, and reward is here . . . there is a holy peace and quiet over these four figures; they listened, the two first to the heartbeat of the earth, they kneel as though in worship. The third sits with the harvest in her arms. What shall she do with more than enough for herself? Her glance takes on a dreamy look, whereas that of the young mother is introspective and rests on her child.[8]

The writer saluted Christian Petersen as a Dane, an American, and an Iowan: "He is home here in Iowa. Here he has found himself."

AUTH

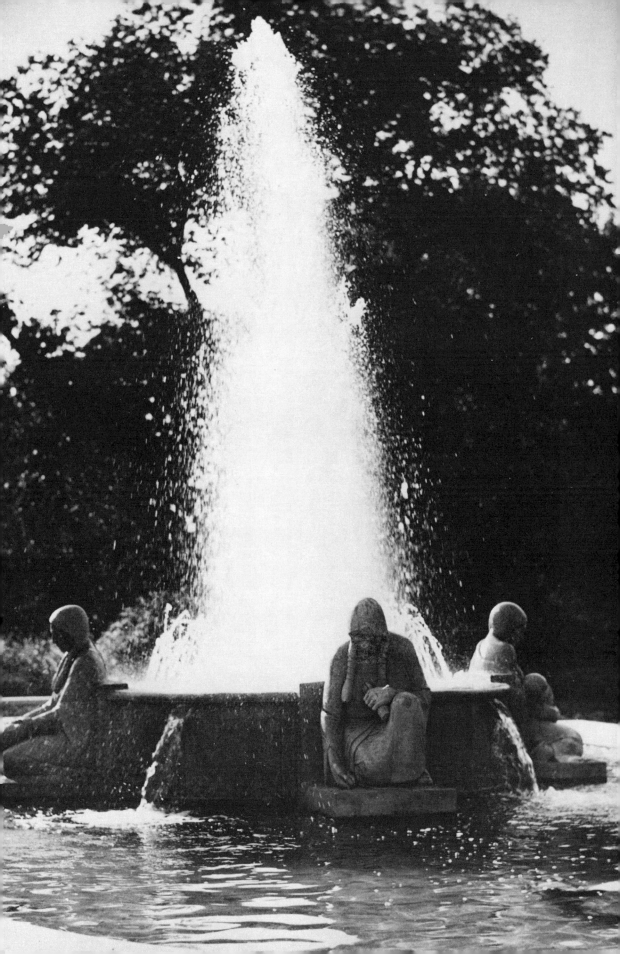

"THE MARRIAGE RING," COLLEGE OF HOME ECONOMICS. ORIGINAL LANDSCAPING. **CPP**

The Marriage Ring,
Home Economics building, 1942

Both Christian and Charlotte Petersen adored children. They noted that although the home economics curriculum at Iowa State was centered upon home and families, nothing in the building or its surroundings was visibly related to children. They were well aware that children were an important part of the child development curriculum and its laboratory nursery school program. And they agreed that children should be represented in a sculpture for the home economics division.

They searched for a whimsical fountain theme and discovered it together. Charlotte read aloud poems written for children while Christian laughed and sketched. The exact theme they sought was in James Whitcomb Riley's "The Hired Man's Faith in Children": "I believe all children's good, / if they're only understood, / even bad ones, seems to me, / 's jest as good as they can be."

The sculptor modeled three toddlers poised at the edge of a round fountain pool, intently studying a turtle, two frogs, a water lily, and a bubbling fountain, which represented a tiny brook. The perfectly round fountain basin represents *The Marriage Ring*. Charlotte fondly emphasizes

"the children are the precious gems of the wedding ring."

Dedicated in May 1942, at Veishea, the terra cotta fountain was a gift of the 1941 Veishea Central Committee.

Shortly after creating a small-scale model for the sculpture, Petersen was visited in his studio by Mr. and Mrs. Nile Kinnick, Sr. Frances Kinnick was the daughter of former Governor George W. Clarke of Iowa. During their Des Moines years the Petersens had spent many evenings with the Clarkes at their home in Adel. Christian had first met Governor Clarke while sculpting a bust of him for the State Historical, Memorial, and Art Department.

When the Kinnicks visited his studio, Petersen showed Mrs. Kinnick the small clay model for his latest project, the home economics sculpture. She was enchanted. As she admired it, he pulled the model off his studio shelf, placed it in a box, and handed it to her with his compliments.

Nile Kinnick, now of Omaha, Nebraska, recalled that his wife treasured the small sculpture all her life. Both Mr. Kinnick and his son, Ben, were Iowa State College graduates; the Kinnicks' other son, Nile, Jr., attended the University of Iowa and was an all-American quarterback on the 1939 Iowa football team and the Heisman Trophy winner for that year. Both sons were killed in action during World War II. After his wife died, Kinnick bequeathed Petersen's sculpture as a family heirloom to his daughter-in-law, the widow of Ben Kinnick.[9]

One day, with the Veishea deadline rapidly approaching, Petersen was working on the installation site of *The Marriage Ring*—just south of McKay Hall—helping workmen finish the landscape grading and install shrubbery enhancing the fountain. Clad in his usual clay-spattered smock and battered felt hat, he was shoveling dirt from a wheelbarrow when a committee from the faculty women's club arrived to inspect the sculpture project. One imposing woman, perhaps the tour leader for the group, motioned the sculptor aside, assuming he was one of the landscape workmen.

"My good man," she requested with considerable authority, "Would you please tell whoever is in charge that there's a spelling error on that legend over there . . . the word is j-u-s-t, not j-e-s-t." She had obviously never read the famous line from James Whitcomb Riley's poem. Petersen tipped his dusty fedora and courteously thanked her, assuring the woman that he would certainly inform the person in charge. He came home that night and regaled Charlotte with the story, commenting that maybe Riley's poem in rural dialect wasn't suited for the intellectual standards of the faculty women's club—of which Charlotte was an active member.

Regrettably, the beautifully sculptured child figures have been vandalized three times in recent years. Two of the heads were broken off during the decade of the 1970s and, fortunately, were later recovered from nearby shrubbery, where they had been thrown. In 1983 the same two figures were again beheaded. At that time university officials conducted a quiet search for the missing heads—an unsuccessful effort lasting from November until early spring. On a warm spring night, five months after they were broken off and apparently

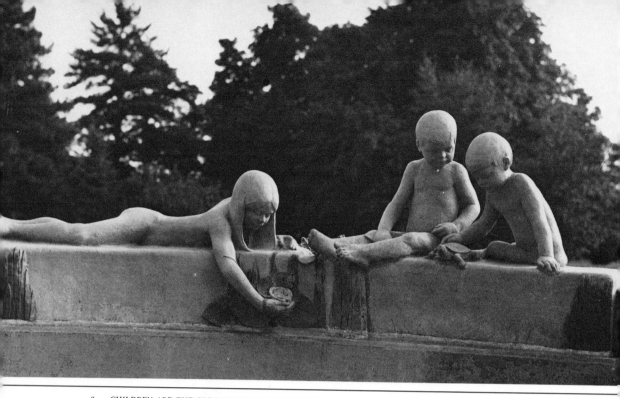

"... CHILDREN ARE THE PRECIOUS GEMS OF THE WEDDING RING." 1943. **CGP**

lost forever, the two missing pieces were left outside the front door of the campus security office, carefully packed in a box cushioned with newspapers. A conservator reinstalled the heads in 1984, but they were again damaged in fall of 1985.

Lynette Pohlman, director of the Brunnier Gallery and Museum at Iowa State, serves as the chairperson for the university museum committee, which has been responsible for maintaining and cataloguing all campus art works since 1983. When it appeared in 1983 as though the heads had been lost forever, and after conferring with Dean Ruth Deacon of the College of Home Economics and with the university administration, Ms. Pohlman, in behalf of the committee, hired an art conservator. The heads were installed and the terra cotta, which had badly

deteriorated from more than forty years of Iowa weather, was refurbished. Again in early 1986, plans were underway to repair the damaged sculptures.

Charlotte Petersen theorized shortly afterward that "some perfectly innocent person had probably found the missing heads, knew what they were, and wanted them safely returned with no questions asked." She regarded the reappearance of the heads as "a miracle. They might well have been thrown into Lake LaVerne, where they would never be found."

Back in 1942, Martha Duncan, who was for several decades a beloved broadcaster of women's programs on WOI radio, remarked in an interview:

Nothing could better symbolize home and the teaching of home economics than chil-

86

dren . . . In the group a little girl is lying on her stomach, her slender arms reaching over into the side of the pool . . . her fingers have cupped a lily . . .

The two other figures in the group are little boys . . . sitting at the edge of the pool . . . their interest is centered on a turtle . . . water comes out of the bank nearby . . . [10]

August Bang described the sculpture setting:

. . . Twenty-five feet from the home economics building, the whole background being grass framed in shrubbery and trees with the sky as canopy. The children in the group are done in approximately life size and the effect is so natural that if the children's figures were clothed one would at a short distance be unable to tell they were only terra cotta . . . the little girl . . . with her whole attention fixed on the marvel of the flower, the water lily. And the two boys—a turtle is doing slow leg gymnastics for their curious eyes. The turtle is just as alive as the flower is tender and beautiful, although both are in stone . . . the circular rim of the fountain as a ring laid on a green pillow of grass and the children as the precious jewels."

Commenting on the restoration of the sculptures in 1984, Dean Ruth Deacon summed up the importance of *The Marriage Ring* to more than four decades of students and faculty members at Iowa State: " . . . the sculpture has become a visual symbol of the college in much the way that Christian Petersen envisioned . . . we use sketches of the sculpture as a symbol of the college in our newsletter to alumni and for the Home Economics Development Fund stationery. A print of the commissioned sketch [of the sculpture] by John Huseby is given as a special acknowledgment to contributors to the development fund."[11]

The site for the refurbished *The Marriage Ring* sculpture was com-

pletely relandscaped in the fall of 1984, restoring it to the original concept created by the sculptor.

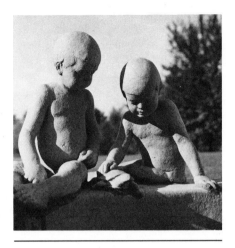

CGP

Boy and Girl, *Iowa State College library, 1944*

When the Iowa State College library was built in 1928, the architects designed two large stone pedestals flanking a wide staircase in the main lobby, specifying elaborate light fixtures for the pedestals. The lights were never installed, however. In 1943 Christian Petersen was assigned to create two appropriate sculptures for the long-vacant spaces.

Over a period of months he hand carved Bedford limestone into figures of a young college man and woman. The two figures epitomize the students he taught in his sculpture classes and the sturdy midwestern Americans he had observed on the campus for over a decade. The sculptor was very much aware that most of the young men he

had welcomed to his studio in previous years were then in uniform, scattered all over the globe during World War II.

The young man and woman symbolized for Christian Petersen the essence of hope for the future of America and freedom for all peoples of the world. Charlotte Petersen described her husband's whimsical poses of the two students, who are secretly admiring each other as they sit studying on opposite sides of the library staircase: "There's something electric going on between those two young people . . . Christian had a wonderful sense of humor. Anyone who has seen the two statues knows that.

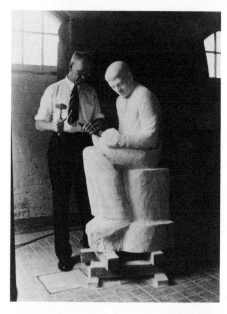

"The boy is seated—supposedly studying—and across the steps the girl is also supposed to be studying. Notice the boy's foot. He's nervous. You know how a boy jiggles his foot when he's ill at ease . . . that's Christian's sense of humor, right there."

Boy and Girl is the sculptor's enduring legacy to future generations of ISU students, his successful effort to capture their youth and vigor in Bedford stone. Many of today's students, of course, may have no idea who sculpted the two figures, or who Christian Petersen was. Although the murals in the library lobby and those above the staircase landing are signed with the names of the artists, no marker indicates that Petersen spent a year of his life carving stone into a lasting tribute to all Iowa State students.

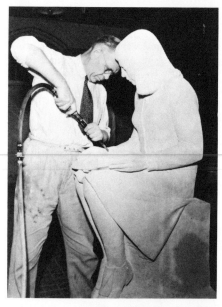

The remodeled lobby was named the "Grant Wood Heritage Room" in 1984–85 by library officials after a fundraising drive among alumni to provide new study desks and equipment for the area.

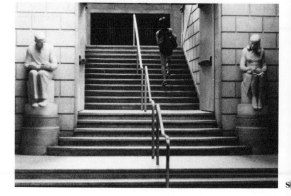

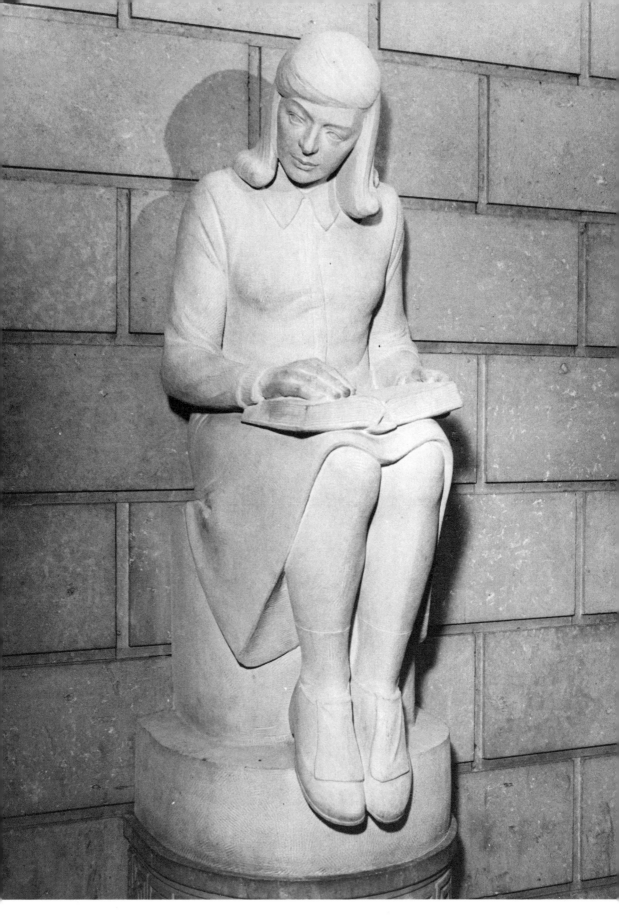

Sculptures in campus buildings, 1943–1983

In the foyer of Carver Hall stands a one-third-size model, a clay study of a man Petersen greatly admired: George Washington Carver. The class of 1968 purchased the sculpture for $500 from Charlotte Petersen seven years after her husband's death in 1961.

Carver Hall was named to honor a remarkable scientist who earned both bachelor's and master's degrees from Iowa State College. Studying botany, horticulture, and sciences from 1891 to 1896, George Washington Carver went on to serve a long and dedicated career as a professor at Tuskeegee Institute in Tuskeegee, Alabama. He achieved notable breakthroughs in plant breeding and industrial applications for agriculture products, particularly the southern-grown peanut and the common sweet potato.

The figure study by Christian Petersen shows Dr. Carver thoughtfully holding and contemplating one lowly peanut, for which he discovered dozens of industrial processing products. The sculptor created the figure after Carver's death in 1942, proposing it as a full-size bronze memorial to the institute. His proposed work was never commissioned, however.

August Bang commented on the Carver sculpture:

[Petersen's] studio teems with works. He is often there long before and long after his teaching duties are done. There stands an unfinished statue of George Washington Carver . . . "When I look upon Carver as you have him here," I said, "the words which were written at his death came to my mind . . . he wandered with God." "That is just what I have tried to say," answered the artist.

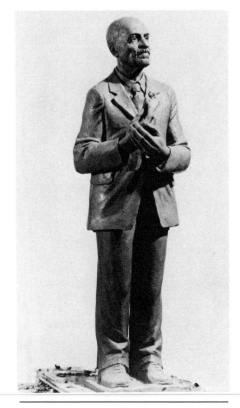

GEORGE WASHINGTON CARVER, ORIGINAL CLAY FIGURE. **CPP**

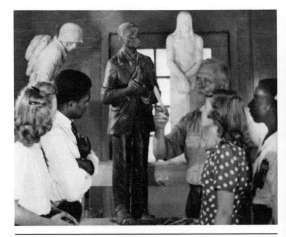

CHRISTIAN PETERSEN WITH STUDENTS AND CARVER FIGURE, IN STUDIO. **CGP**

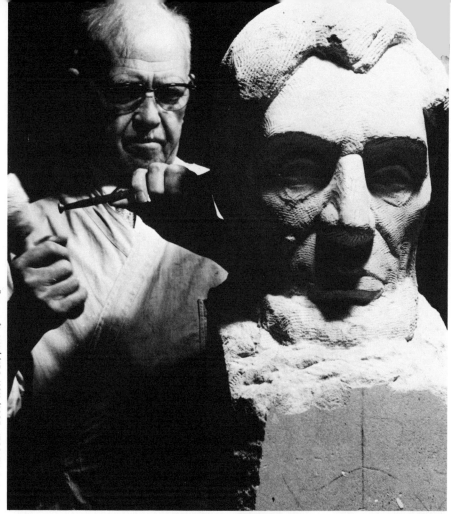

CARVING LINCOLN BUST, 1950. **CGP**, photo by Fr. Roger Sullivan.

ABRAHAM LINCOLN, A BUST CARVED IN BEDFORD STONE. A magnificent sculpture—one of Christian Petersen's strongest, most dynamic studio pieces—is spotlighted in the foyer-reception area of the Communications Building at the WOI radio and television center on the ISU campus. One of many studies done of Lincoln by the sculptor, this is carved in Bedford stone, with vivid lines and a dramatic characterization of Lincoln. Purchased by WOI-TV from Charlotte Petersen in about 1962, it was the only campus work in 1984 marked with a permanent plaque honoring the artist: "Christian Petersen, sculptor and artist-in-residence at Iowa State, 1934–1955."

ABRAHAM LINCOLN,
WOI-TV FOYER, 1984. **AUTH**

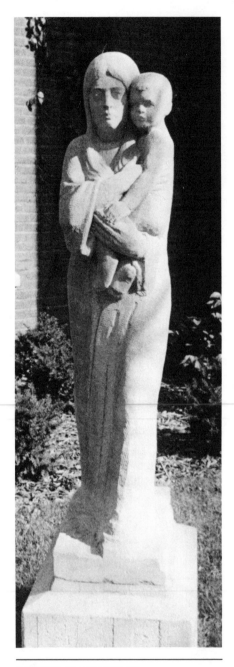

"MADONNA OF THE PRAIRIE,"
COLLEGE OF EDUCATION. **AUTH**

MADONNA OF THE PRAIRIE, COLLEGE OF EDUCATION. Sculpted circa 1940 as a studio piece, *Madonna of the Prairie* is Christian Petersen's eloquent tribute to American pioneer women. The Bedford stone full figure, in life size, portrays a young pioneer mother tenderly carrying a small child in her arms. Both are gazing out on the tallgrass prairie where their homestead will be established. The striking beauty of the woman and the bright, innocent vigor of the child form a composition that symbolizes the strength of the immigrants and settlers who came to find their futures in the rich prairie loam.

Christian Petersen was fascinated with the vastness of America, particularly the Midwest. He was also intrigued with the settlers, who came to the prairie equipped with little more than enduring courage and tenacious determination.

Madonna of the Prairie, the artist's memorial to pioneer women, was purchased by the College of Education in 1982 and placed in the courtyard of the remodeled quadrangle, which had formerly housed the veterinary medicine complex. The sculpture is placed on the east side of the courtyard—across from the site where the *Gentle Doctor* and veterinary murals stood for more than forty years.

AUTH

92

"OLD WOMAN IN PRAYER,"
PARKS LIBRARY, 1984. **SVO**

OLD WOMAN IN PRAYER, 1984 ISU LIBRARY
ADDITION. Christian Petersen was a
compassionate man with a profound
sense of empathy for the weak or
handicapped, and the innocent victims
of wars. His deep emotions concern-
ing World War II were the inspiration
for *Old Woman in Prayer,* a superb
Bedford stone studio piece he carved
circa 1940.

The Petersens often went to
movies, where they saw graphic news-
reel films of civilian refugees during
Hitler's opening conquest of Europe.
"Christian was deeply moved by the
barbarism of the pogroms and the
bombings. We were stunned by the
tragic suffering of innocent civilians
during World War II—he brooded
about it."

He translated his emotions into
Bedford stone in *Old Woman in
Prayer,* which is also known as *The*

Refugee. It is a starkly dramatic por-
trayal of an aged woman refugee, her
hands placed together in plaintive
prayer, eyes cast upward in a dazed
search for refuge from terror. The
sculpture is the artist's memorial to
civilian refugees and concentration
camp victims during the global second
World War—and in all wars in the
history of man's inhumanity to man.
It was purchased by the ISU library
from Charlotte Petersen in 1983 and is
located on the new main floor, west
wing.

AGRONOMY BUILDING FACADE, 1952. The
carved limestone Iowa farmland motif
on the Agronomy building is a rarity
in Christian Petersen's campus sculp-
tures: the only itaglio stone carving
done by the artist during his long ca-
reer at Iowa State. The work was com-
missioned when the building was
under construction in 1951.

HEAD OF A YOUNG GIRL, BRUNNIER
GALLERY AND MUSEUM. Marjorie Gar-
field, head of applied art in home
economics at Iowa State for many
years, purchased *Head of a Young
Girl* as a gift to the department upon
her retirement. The sculpture was
added in 1984 to the permanent col-
lection of the Brunnier Gallery and
Museum, Iowa State Center.

The fired-clay study of a young
woman is a studio piece that was
probably created by the artist as a
demonstration for his sculpture class-
es.

BUST OF JENS JENSEN, COLLEGE OF DE-
SIGN. One of two known (identical)
busts of landscape architect Jens Jen-
sen was purchased by students for the
Department of Landscape Architecture

"HEAD OF A YOUNG GIRL,"
CLAY STUDY, BRUNNIER MUSEUM. **SVO**

JENS JENSEN,
COLLEGE OF DESIGN, 1984. **CGP**

CLIFFORD GREGORY,
PROFESSOR OF JOURNALISM, 1940. **CGP**

after Christian Petersen's death in 1961. The other bust of Jensen was purchased for the Chicago Conservatory in the early 1930s, honoring him as the landscape architect for the Chicago parks system.

A notation in Petersen's handwriting (in his papers at the ISU library) captured an aspect of the architect's personality: "Jensen—a satyr . . . sly humor." That characterization is evident in the excellent portrait bust of Petersen's fellow Dane: a distinctive and jaunty handlebar moustache, a leonine mane of hair, a mischievous twinkle in his eye, and the hint of a suppressed smile.

BUST OF LOUIS PAMMEL, BOTANY DEPARTMENT. The bronze bust of Louis Pammel—which was approved by a faculty committee in 1933, thereby winning Christian Petersen his first appointment as artist-in-residence at Iowa State—was displayed in 1984 at the botany department offices in Bessey Hall.

An excellent example of the sculptor's consummate skill in portraiture, this bust is one of only a few faculty portraits remaining in the university collection. Most college-owned busts and plaques were cast in plaster—an economy measure—and were eventually sold to heirs or descendants of the subjects in recent decades.

BLAIR CONVERSE, CLIFFORD GREGORY, AND FREDERICK BECKMAN. In the Press Building (renamed Hamilton Hall in 1985) on the Iowa State University campus are three of Petersen's portrait

94

busts: Blair Converse and Frederick Beckman, in bronze; and Clifford Gregory, in fired terra cotta. Converse was the head of the journalism department for many years; Beckman was a journalism professor and founded the Iowa State College Press in 1934, and Gregory was a journalism professor. These sculptures and the bronze of Louis Pammel represent the excellence in style and technique of Petersen's portraiture; they were the only remaining faculty portraits in the university collection as of 1985.

CONVERSATIONS, OAK-ELM DORMITORY CAMPUS. By far the most monumental campus work by Christian Petersen— in terms of prodigious effort over a period of years—is a grouping of student figures at the Oak-Elm dormitory campus near Lincoln Way and Beach Avenue.

Both Charlotte and Christian were keen and appreciative observers of college students, who were "growing, changing, and finding themselves during their years on the campus," Charlotte reflected in 1983. Their home was always open to young people who came for advice, friendship, an interesting conversation, advice to the lovelorn, or perhaps a temporary place to stay. "We loved them," Charlotte declared, with her ebullient good humor, "and they kept us young."

The students they so enjoyed are symbolized in *Conversations*. Begun in 1947, the three groupings of six Bedford stone figures were carved from forty tons of Bedford limestone over a period of eight years. Petersen finished the work shortly before his mandatory retirement in 1955. Using his architectural drafting training of the 1920s, Petersen carefully planned the sculpture groupings for an entry wall to the campus at the northwest corner of Lincoln Way (old Highway 30) and Beach, the gateway to the campus.

His excellent technical drawings and specifications for the masonry wall setting show careful computation of the tonnage of the finished Bedford stone statues. Petersen planned the concrete footings, foundation, and brick structure to enhance the student figures as a welcoming scene to visitors traveling the only east-west route through Ames, bordering the south edge of the campus.

As the student sculptures neared completion, a newspaper story by Don Smith recorded the event.

Chip by chip, work is progressing on the statues which will form the proposed Beech [sic] Avenue entrance to the Iowa State campus.

Prof. Christian Petersen of the Department of Applied Art is designing the groups of figures and also is wielding the mallet and chisel to create them from big blocks of Bedford limestone. He has completed three of six statues . . . they will be placed along a low red brick wall . . . the figures will be one and a half times life-size.

A second group of figures will have an agricultural motif and is planned for the east side of Beech. Thus an informal entrance to the campus will be formed which the sculptor thinks will be more inviting than a conventional gate or the often proposed neon sign.

[Smith wrote that artist Petersen had been ill for two weeks, but planned to resume work on the sculptures after another week of rest.]

Then he will take up his tools—a compressed air chisel for roughing out the forms and a hand mallet and chisel for more precise cutting—and go on with the present project.

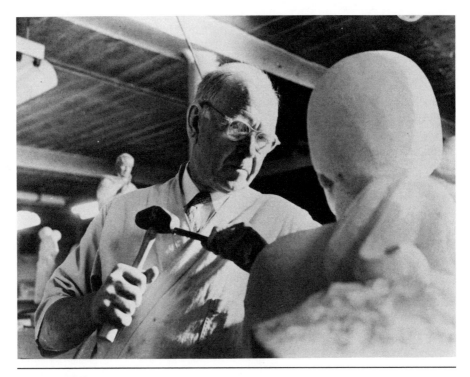

CARVING "CONVERSATIONS." **CPP**

The figures completed are three girls. They strike the kind of informal poses one sees somewhat book-weary students assume on sunny afternoons on the campus. Two other figures in the group, now roughed out of the stone, are of a boy and a girl, reading a paper. The third is another coed, seated and apparently finding enjoyment in one of those fleeting in-between-class intervals.[12]

Dycie Stough Madson was a student of Petersen's at the time he was carving the huge Bedford stone figures. She recalled, "I'd come to class and he'd be singing at the top of his lungs, in Danish, over the scream of the jackhammer. By spring, the doctors insisted he wear a mask while carving the stone . . . it was hard for him to carve and not sing."[13]

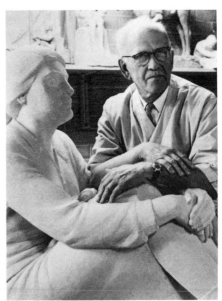

CPP

His plans for the second grouping of figures on the northeast corner of the intersection were never completed. The Lincoln Way–Beach site was rejected as the location for the sculptures because of heavy highway traffic and dormitory construction during the post–World War II enrollment expansion.

The school changed to university status in 1956, broadening its curriculum to include plans for new colleges within the university structure. President James H. Hilton began serious planning for a vast new complex of buildings incorporating an auditorium, a small theater, a huge coliseum, and a center for continuing education. Called "Hilton's Dream" by campus critics, the Iowa State Center became a reality over the next two decades. By comparison, Christian Petersen's longtime "dream" for an outdoor amphitheater representing five divisions of the college was obsolete by the mid-1950s.

University officials were beleaguered by the demands of expanding enrollments and curriculum, attempting to preserve the open green areas of the campus while building new classrooms and dormitories to accommodate the expansion. And, federal highway improvements were being programmed for the corner of Lincoln Way and Beach. The sculptures of the students were "temporarily" stored in an outdoor covered walkway in the veterinary quadrangle for eight years, pending land developments for the proposed Iowa State Center, widening of the Lincoln Highway to four lanes, and the building of a new dormitory on the corner where Petersen's sculptural welcome originally was to be. Not until two years after Peter-sen's death in 1961 was an alternate site finally designated for the sculptures, a location the artist had approved during his first year of retirement in 1955.

A story in a student magazine, the *Iowa State Scientist* (December 1953), explained his original plans for two sculptured walls and his idea for an amphitheater:

> Petersen is planning another sequence of figures to be grouped on the opposite corner when the completed statues are put in place. The figures located on this side will depict such disciplines as science, engineering and agriculture.

> Work on the entrance project began in 1947. . . . In Petersen's studio there is a small-scale model of an amphitheater with statues spaced around the back of it in a semi-circle. This is a model of his dream to provide the college with an amphitheater. It would be located by the walk going from Curtiss Hall to the Botany Building. The five sculptured groups around the back would picture the five divisions of the college.

That longtime dream appeared in several of Petersen's sketches. A 1959 editorial in the campus newspaper, signed only by the name "Klopf," asked:

> In years to come, the University family will realize what a cultural contribution this artist has created at Iowa State. Why not do it now? Why not erect this project as a tribute to a man who had an idea and the faith and steadfastness to follow through with it?[14]

A story in the Ames *Tribune* on February 7, 1961, quoted James Hilton: "Two alumni have agreed to contribute as necessary to a fund for erecting several figures by the Danish-American sculptor." The story noted that "students and staff of ISU have contributed a total of $2,070.59 to-

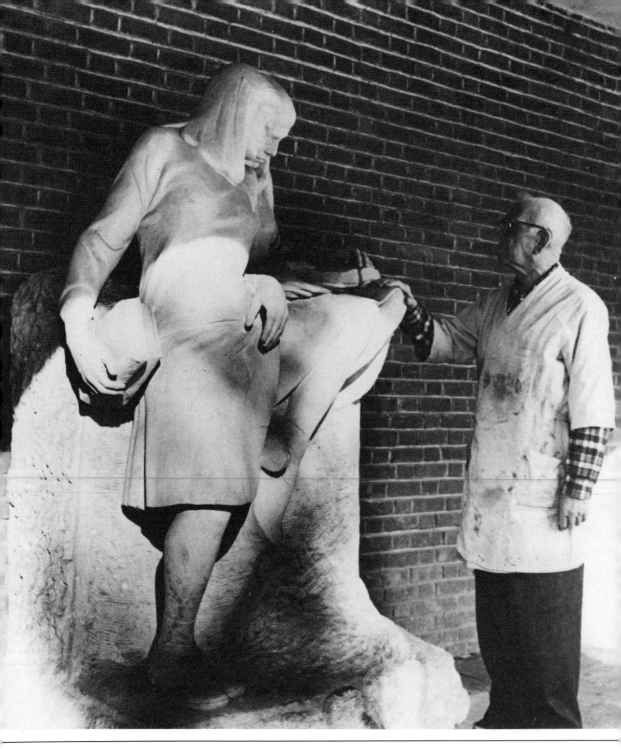

CHRISTIAN PETERSEN WITH FIGURES IN STORAGE AREA. **CPP**

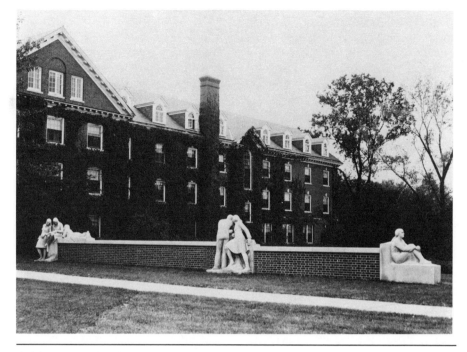

ELM-OAK CAMPUS SETTING FOR "CONVERSATIONS." **CPP**

ward erection of the figures . . . the cost . . . has been estimated at between $5,000 and $6,000. An earlier agreement between the University and student groups provided for matching funds.'' Several campus organizations were cited for conducting campaigns to finance installation of the sculptures, including the *Iowa Homemaker* (home economics publication), Phi Kappa Theta fraternity, the Faculty Women's Club, and the Alumni Achievement Fund. Two months before Christian Petersen died he chose the alternate site for the sculptures. "John Fitzimmons, head of landscape architecture, said today the site plans had been completed and submitted to the university planning committee. 'Dwight Kirsch and I submitted a list

of possible sites to Christian Petersen, and he made the final selection,' Fitzimmons said."[15] Dwight Kirsch, painter, was artist-in-residence at Iowa State for a brief period of time after Christian Petersen's retirement.

Because the sculptor was hospitalized at that time, too ill for an interview, he could be quoted only once in the story regarding his reaction to the chosen site: "It's quiet there," he said. Charlotte Petersen explained that her husband "was glad that the sculptures would be installed, but keenly aware he wouldn't live to see them as he'd planned for so long."

Charlotte named the six-student sculpture grouping. "When different people ask me the name of the Oak-Elm sculptures, I tell them: *Conversa-*

tions. I think they have much meaning to young people. The first three young women are sharing; the second is a boy and girl, trying to understand—they're in love and caring. And the last figure is a young woman taking time to contemplate her world."

The sculpture wall is a favorite gathering place for visiting families and friends during Veishea or homecoming festivities at Iowa State. Many snapshot albums include photographs of relatives and friends grouped around Petersen's larger-than-life sculptured representations of students—and their real-life counterparts.

In January 1954, the Des Moines Sunday *Register* featured the sculptures in its rotogravure section. "The co-eds in the group will wear short skirts, about knee length, as that was the style seven years ago when the work was begun. Since fashion follows a cycle that takes hemlines up one year and down another year, it ac-tually makes little difference in a permanent work what the skirt length is. Over a long period of years sometimes it will be in style and sometimes it won't. At any rate, this is a problem about which Christian Petersen is not worrying at all."[16]

Seventeen years after his death, a *Daily* story carried the headline: "Moo U.'s Beefy Babes." The story summed up Iowa State student opinions about the sculptures created: "After all, if you were 180 centimeters (6 feet) tall and you and your friends weighed over 2.7 metric tons (3 tons) each, you'd probably be 'beefy,' too."[17]

Charlotte Petersen loved the student-written story, which praised her husband's artistry and referred to "our sculptures." "They knew those sculptures belonged to them," Charlotte said after the story appeared. "And so they do. For all time. After all those years, I'm so glad Christian Petersen was remembered."

6 Imagery in Clay and Stone, *1934–1961*

*"Christian was a superb portraitist—
probably one of the best in America."*

—CHARLOTTE PETERSEN

CHRISTIAN PETERSEN was honored in November of 1942 by his colleagues at a reception and dinner preceding an exhibition of his works in the Memorial Union at Iowa State College. A special guest on that occasion was George Nerney, who had journeyed from Attleboro, Massachusetts, to honor his longtime friend. He spoke appreciatively of Petersen's talents at the recognition dinner, citing the sculptor's background and achievements during the early phase of his career.

The tribute was well deserved. The magnificent dairy industry and veterinary projects had firmly established Petersen's talents in his first few years at Iowa State, and the elegant new Memorial Union *Fountain of the Four Seasons* was well received by alumni, students, and faculty members. When plans for the home economics *Marriage Ring* sculptures were well under way in late 1941, a group of faculty friends began planning special honors for the sculptor for

the fall of the following year, including an exhibition of his portraits and studio works.

Many committee people had been subjects of portrait busts or bas reliefs commissioned by the college or various campus organizations. Others were proud parents whose children had been sculpted in bas relief plaques by the artist, portraits that became instant family heirlooms. In many cases, Petersen enjoyed doing a child's likeness so much that he gave the finished portrait to a faculty friend and never asked a fee. Charlotte commented about this: "Christian would often make a plaque or clay sketch while we were visiting with friends. He loved doing that; he said it was relaxing and fun for him. When he was finished, he'd simply hand the portrait to that friend. We kept no records of these, really."

Charles Rogers told Martha Duncan during her interview with him in 1942 that he guessed Petersen had created more than a hundred portrait

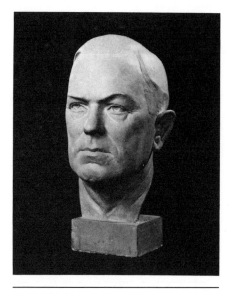

CHARLES FRILEY,
ISC PRESIDENT, 1937. **CGP**

R. K. BLISS,
DIRECTOR OF EXTENSION, ISC, 1950. **AUTH**

plaques and busts of Iowans—"so many that he's lost count."[1]

Even when he could not model a subject from life, the artist was exceptionally talented at capturing a likeness from photographs. His training with Henry Hudson Kitson in the 1920s sharpened his inborn talent for capturing facial characteristics of young and old in portraits. He was unexcelled in both forms, deserving to be ranked among the best American portrait sculptors. "Very few artists can do likenesses well," says Charlotte Petersen, "but Christian was gifted at it. He could carve the shape of the skull, the tiniest contours of a jawline, the exact placement of the features—and the fine wrinkles or character marks of a person."

His portraiture ability had been the deciding factor in launching Petersen's career at Iowa State. After a test likeness of Louis Pammel was enthusiastically approved by a faculty committee and purchased by the college in 1933, Petersen received a second assignment: to capture the likeness of Professor Martin Mortensen, a fellow Dane who was head of the dairy industry department. Mortensen's daughter, Edna Mortensen Kiely, wrote: "The bust is simply wonderful, so real it is almost as though my father were here."[2] When Mrs. Kiely was asked by university officials in the 1950s whether she would like to purchase the bust, she was pleased to do so. (This courtesy was extended a number of descendants of faculty members whose likenesses had been modeled by Petersen for the college.)

Although no official university records exist of these commissioned portraits, the Christian Petersen Papers

at Iowa State University library include references to the following:

T. R. Agg, dean of engineering; Frederick Beckman, journalism; Ralph K. Bliss, director of agriculture extension; Carrie Chapman Catt, woman suffrage leader and graduate of Iowa State College; Blair Converse, journalism; J. C. Cunningham, agriculture; Charles F. Curtiss, dean of agriculture; Sara Porter Ellis, director of home economics extension; Genevieve Fisher, dean of home economics; Charles Friley, president; Clifford Gregory, journalism; A. Maurice Hanson, landscape architecture; Richard B. Hull, WOI radio and television director; H. H. Kildee, head of animal science; Neale Knowles, home economics extension dean; Ernest N. Lindstrom, genetics; Anson Marston, dean of engineering; Martin Mortensen, head of dairy industry; Charles F. Murray, dean of veterinary medicine; Louis Pammel, botany; Charles Rogers, journalism; Charles H. Stange, dean of veterinary medicine; O. R. Sweeney, head of chemical engineering.

Most faculty portraits were created in the decade between 1934 and 1944 as projects assigned to Christian Petersen by college officials.

A bronze bust of WOI television producer Richard B. Hull is displayed in the Richard B. Hull Television Center building at The Ohio State University in Columbus, Ohio. Hull and his wife Dorothy were close friends of Christian and Charlotte during the postwar years at Iowa State. WOI was the first educational television facility in the United States; Hull pioneered in its inaugural and development in the mid-1950s and left the college for a successful career in tele-

vision management at Ohio State.

In addition to the above known works, the sculptor also created busts of three members of the State Board of Education in the late 1940s, probably as gifts of the college. They were Anna Lawther, George Shull, and Dorothy (Mrs. Hiram) Houghton.

The Lincoln sculptures

When Charlotte Petersen looked back on her husband's productive career, she recalled his seemingly inexhaustible supply of energy. His overloaded sculpture classes left little

AN UNUSUAL LINCOLN MASK, BRONZE VERSION. **AUTH**

time for working on college-assigned pieces during the day, so the "gentle sculptor" usually worked on those in the late afternoons or at night, particularly if a completion deadline was near. Such efforts permitted few opportunities to create his own studio pieces—sculptures of his own choosing, for which there was no commission—but he managed to model in clay, cast in plaster, or carve in stone a number of studio sculptures he was inspired to do. The major work among these was the excellent head of Abraham Lincoln, carved in 1948 of Bedford stone. During his twenty-one-year career at Iowa State, he also created a small plaster bust of Lincoln which he gave to President Charles Friley in the late 1930s.

The artist modeled an unusual small "mask" sculpture interpretation of Lincoln in about 1936, which was cast in plaster. Designed as a wall-hung piece, it is a striking study of a beardless Lincoln in a remarkably unusual form unlike any other work known to have been created by the sculptor.

Petersen's fascination for the personage of Lincoln was a lifelong interest. Early in his career he created a young Lincoln titled *The Frontiersman* while another, later version portrayed a seated president in an informal, relaxed pose. This small model was submitted to the Milwaukee Lincoln sculpture competition in the early 1930s, receiving an honorable mention among 48 entries. It was purchased from Charlotte Petersen in the mid-1960s by the public school parents' association in Gilbert, Iowa, and has been displayed there ever since.

Charlotte explained that "a seated Lincoln—in a full-size sculpture—would allow the children to look directly in Lincoln's eyes, to understand him as a person, not a towering figure standing high above them. That was what Christian had in mind."

Major studio sculptures, 1934–1955

Although his Iowa State career left little time or funds for studio sculptures, Petersen managed to create an astounding number of superb studio works. Many of them were on a much smaller scale than he would have liked; all were either fired clay or plaster castings of the original clay versions. He would have preferred fine marble, bronze, or stone for his studio works, but economy was paramount.

When the artist died in 1961, his veterinary quadrangle studio was filled with unsold models and sculptures created over a period of twenty-seven years. The studio stood undisturbed until 1964, when university officials found a pressing need for laboratory space in the veterinary anatomy department and requested Charlotte Petersen to move Christian's sculptures and tools from the area. Faced with expensive storage costs, she authorized a sale of remaining studio pieces.

Friends volunteered to catalog the works and conduct the sale for her. They put days of dedicated effort into the project, setting a desired minimum bid price on each piece and attempting to publicize it on a statewide basis through a story in the Des Moines *Register*. Unfortunately, however, bid-

ders were scarce and rarely offered the price asked. Most pieces were sold at considerably less than the requested minimum bid. The net proceeds from the sale were $3,401.[3]

Among the eighty works listed, a number of pieces were unsold. These were stored for more than twenty years, pending disposition by Charlotte and Mary Petersen.

The following list of major studio works includes all data available in 1985.

BUFFALOES, 1934. A handsome fired clay study of three American plains bison, fourteen inches long, eight inches high, and six inches deep, this plaster casting was the only small sculpture Christian Petersen created at the federal PWAP workshop in Iowa City. It was a preliminary model for a proposed bridgehead sculpture in Des Moines that was never authorized. The department of special collections of the Iowa State University library purchased this sculpture in 1985.

THE IMMIGRANTS, 1934. A photograph is all that remains of this sculpture. It depicts a man, woman, and two children attired in foreign clothing, which is perhaps Danish.

COUNTRY DOCTOR, 1936. Christian Petersen had many heroes during his lifetime, most of them great poets, writers, statesmen, or explorers. This sculpture was his tribute to family doctors of the 1930s, for whom he had tremendous respect and admiration. Dr. and Mrs. Charles Ryan of Des Moines were close friends of Charlotte and Christian during the middle 1930s. Dr. Ryan treated both of them for illnesses during their two sojourns in Des Moines.

"THE IMMIGRANTS." **CPP**

Another physician, Dr. A. I. Haugen of Ames, performed emergency surgery on Charlotte in 1935 when she suffered an embolism—a life-threatening blood clot. Charlotte noted without reservation that "Dr. Haugen saved my life." It is not surprising, therefore, that Christian felt inspired to pay sculptural tribute to the medical profession in general and the two physicians in particular. *Country Doctor* was a studio piece he created of a small-town practitioner, a determined figure hunched against the cold, carrying his medical bag on the way to see a patient. Petersen wrote of this sculpture:

The sculptor . . . must place in a single figure all of the self sacrifice, kindly good will,

dependable patience, gentle gruffness, and shrewdness of insight into human nature which have made the American country doctor an institution as well known, as greatly respected, and as highly esteemed as any other institution on earth. . . . No matter what the weather, the time, no matter how fatigued they may be, they are always at beck and call, and they can be depended upon to arrive in time. . . .

For he is not a specialist; his work is more varied and all-inclusive than any other on earth. . . . My figure is the portrayal of an institution, not a man. . . . I have tried to call up in the imagination of those who see the piece the untiring dependability, the confidence, the universality and all the rest of the characteristics which make up that great institution we have come to designate as THE COUNTRY DOCTOR.[4]

Perhaps Petersen hoped to create in this work a sculptural equivalent for human medicine similar to his *Gentle Doctor* figure for veterinary medicine. The only known plaster casting of this twenty-inch piece was purchased by a private collector from Charlotte Petersen at the 1964 studio sale.

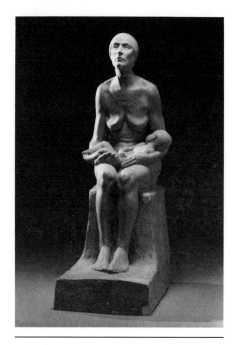

"DROUGHT," 1985. **BRUN**

DROUGHT, CIRCA 1938. This is a white plaster casting, Petersen's interpretation of a destitute young mother holding her emaciated infant. Her breasts are devoid of milk; resignation and hopelessness are conveyed in every angle and contour of her wasted body. This poignant sculpture was the inspiration for a poem by J. C. Cunningham, which was later included in his privately published *From Dawn to Dusk*.

The brave child Hope
Lies starving on the mother's knees.
Her shrunken breasts have failed
When empty skies
Mocked back the cry for rain.

Both day and night
The cattle moan

For drink and parceled forks of hay.
High poised the ugly buzzards circle slow
To drop like plummets when some beast
Staggering falls to rise no more.
The dried up corn breaks from its roots
And burning winds suck added heat
From pastures dry as parchment from a desert
 tomb.

The Pueblo calls his clans
And hour by hour
And day on day
Repeats his chants
And thinks by agony and dance
To draw from gods displeased
The blessing of the rain.
The Pale-face knows no chant,
No dance.
He cannot think that God
Would change his laws for one small place,
He cannot pray for rain;
He can but dumbly stare
While Hope lies dying
On the mother's knees.

A commentary (author unknown) in *From Dawn to Dusk* explains: "J. C. and his family experienced many hardships in his boyhood because of drought and the loss of crops. This was written for Christian Petersen's *Drought*. It was very difficult to express the hopeless watching for a cloud with the strength of restrained lines. It was two years before J. C. was satisfied—if a poet is ever satisfied with his lines."

The Petersens witnessed drought across the Midwest in the middle 1930s, when they saw withered crops, scorched pastures, and dustbowls in Kansas. This sculpture and its companion piece *Flood* reflect the artist's firsthand experience with the extremes of American weather—which could include an overabundance of rain or a scarcity of it. The piece was purchased for the permanent collection of the Brunnier Museum and Gallery at Iowa State in 1985.

FLOOD, 1938. Cast in plaster and based on sketches in Mississippi and Kentucky during the Petersen's travels, this sculpture combines tenderness, strength, and terror: a mother carrying her infant child, fleeing from rising floodwaters that submerge her trailing foot. The work was also purchased by the Brunnier in 1985.

MOTHER EARTH, 1938. This, said Charlotte Petersen in 1983, "was a beautiful life-size stone piece of a pioneer woman—an expectant mother." She adds that "it was a sculpture, full of life and the hope of the future for a young, strong woman." The stone sculpture was stolen from Christian Petersen's studio in the summer of 1939 when the Petersens were on an out-of-town trip.

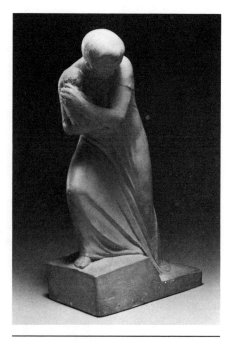

"FLOOD," 1985. **BRUN**

PIONEER WOMAN, 1938. Inspired by a cemetery burial he saw that year, Christian Petersen was moved to create a solitary figure of an American pioneer woman standing resolutely at the graveside of her husband, clad in a long prairie dress. At the Iowa State College cemetery in the late 1930s, the artist saw a widow standing in sorrow; Charlotte explained that her husband "shared the woman's grief and couldn't get that image out of his mind." She adds, "It's a very old cemetery and includes a number of simple gravestones from days of early Iowa settlers." The work was purchased by a private collector in 1985.

LAURA AND WALLACE, 1938. These are a pair of sculptured heads of a hand-

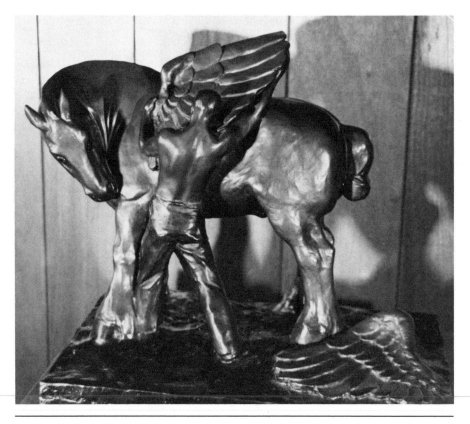

"PEGASUS," BRONZE STUDIO PIECE,
VET COLLEGE LIBRARY. **CGP**

some couple—black sharecroppers—
whom Christian and Charlotte met in
Kentucky hill country, near August,
Kentucky, in 1938. The plaster cast-
ings were sold at the 1964 sale.

PEGASUS, 1938. The winged horse of
Greek and Roman mythology was the
subject of a whimsical interpretation
by Christian Petersen in 1938, a
sculpture created for his own personal
amusement and enjoyment. The plas-
ter casting of the piece stood in his vet
quad studio until the artist's death.
After that it was in Charlotte's home.

Pegasus depicts a hardworking
farmhand struggling to follow orders
and install the first of two wings on
an obedient, proud Percheron—typical
of the champion Percheron breeding
stock owned by Iowa State College in
the 1930s. The message of this studio
piece might well be a spoof on
mythology and midwestern practical-
ity, combined with Danish humor:
"Don't try to make a Pegasus out of
a plowhorse."

In 1984, a limited edition in
bronze of this sculpture was offered in
behalf of Charlotte Petersen by
Pegasus Productions, sponsored by
two of her friends. The first of thirty-

five pieces was purchased by the Veterinary College at Iowa State University, funded by a gift from Dr. and Mrs. John E. Salsbury, and is permanently displayed in the Veterinary College library.

CHILDREN'S FOUNTAIN, 1938. This is a drum-shaped fountain piece, thirty inches high and thirty inches in diameter, with bas reliefs of children at play on the periphery of the plaster-cement casting. Christian Petersen designed it for Brookside Park in Ames, but funding for a bronze casting of the sculpture was not available during the late Depression years. The work has been in storage in Ames since 1964.

SOON AFTER FLOOD, 1939. Charlotte regarded this as a compassionate effort by her husband to capture an unforgettable image of three wistful children riding bareback on a mule among hill-country refugees from the 1938 floods in Kentucky. The work was purchased previous to the 1964 sale. In 1985 it was presented as a gift to the Brunnier Museum and Gallery.

MOUNTAIN MOTHER, 1939. A graceful, small (eighteen inches high) Bedford stone sculpture of a mother and two small children, this piece is owned by the Fisher Community Center in Marshalltown, Iowa, and is described in Chapter 10.

STEPHEN VINCENT BENET, 1939. Author Benet visited the campus in 1943 and spent several hours in Christian Petersen's studio, where the artist modeled a portrait bust. The piece was sold to the Sioux Center, Iowa, schools in 1964.

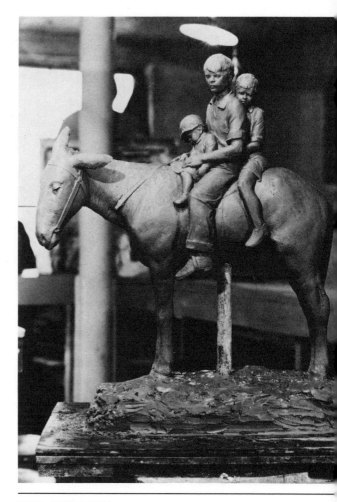

"SOON AFTER FLOOD,"
GIFT TO BRUNNIER, 1985. **CGP**

GRATEFUL FARMER, 1939. This was probably a portrait of one of Charlotte Petersen's relatives in Cherry Valley, Illinois. A notation on a handwritten list of sculptures in the Petersen Papers indicates the theme of the piece was the bountiful harvest time in the midwestern farm belt. It was purchased by a service club as a gift to the Mason City public schools in 1964.

IMAGERY IN CLAY AND STONE **109**

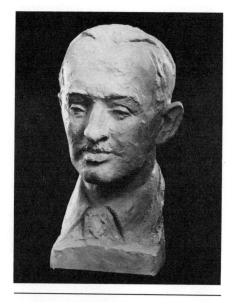

STEPHEN VINCENT BENET,
ISC CAMPUS VISITOR,
SIOUX CENTER (IOWA) LIBRARY, 1964. **CGP**

OLD WOMAN IN PRAYER, 1940. One of the artist's best stone sculptures, this Bedford limestone work is owned by the Iowa State University library and is described in Chapter 5.

MADONNA OF THE PRAIRIE, 1940. Purchased by the College of Education at Iowa State University in 1982, the life-size stone sculpture of a mother and child is described in Chapter 5.

A clay study model for the work was sold in 1964 to a private collector.

AFTER THE BLITZ-WAR, 1940. A half-figure in Bedford stone, this life-size sculpture was purchased in 1961 by Martha Ellen Fisher Tye for the Central Iowa Art Association, Marshalltown, Iowa. See Chapter 9 for a description of the work.

THE CORNHUSKER, 1941. Petersen's tribute to a uniquely midwestern type of athlete in the premechanized farm era, this piece was inspired by Marion Link, a handsome young Nevada, Iowa, man who placed second in the national cornhusking championships in Davenport, Iowa, in 1940 while 125,000 spectators watched. He had won the county, district, and state husking championships to qualify at the national level. In 1941, he again won the Iowa championships.

Petersen had noticed the powerfully built youth at a district cornhusking competition in central Iowa and was fascinated by his strength, speed, and coordination as he hand picked and husked 46 bushels of Iowa field corn in 80 minutes. The sculptor was sent to the national championships to accompany his four life-size plaster castings of Indian women that were displayed by Iowa State College during the championships. These were models for the Bedford stone carved figures the artist created for the Memorial Union in 1941, *The Fountain of the Four Seasons*.

Marion Link recalled in 1984 that Christian Petersen asked him to visit his studio on several occasions in late fall of 1940 to model for sketches. The two visited while the artist finished his preliminary version of the work and they became well acquainted.[5]

When Link returned to Nevada on leave from the navy in 1942, he visited Petersen and saw the finished *Cornhusker* sculpture, cast in plaster, for the first time. He described the Danish sculptor as "a quiet, friendly man who cared about everyone he met." The sculpture was commissioned for the lobby of Hotel Sheldon

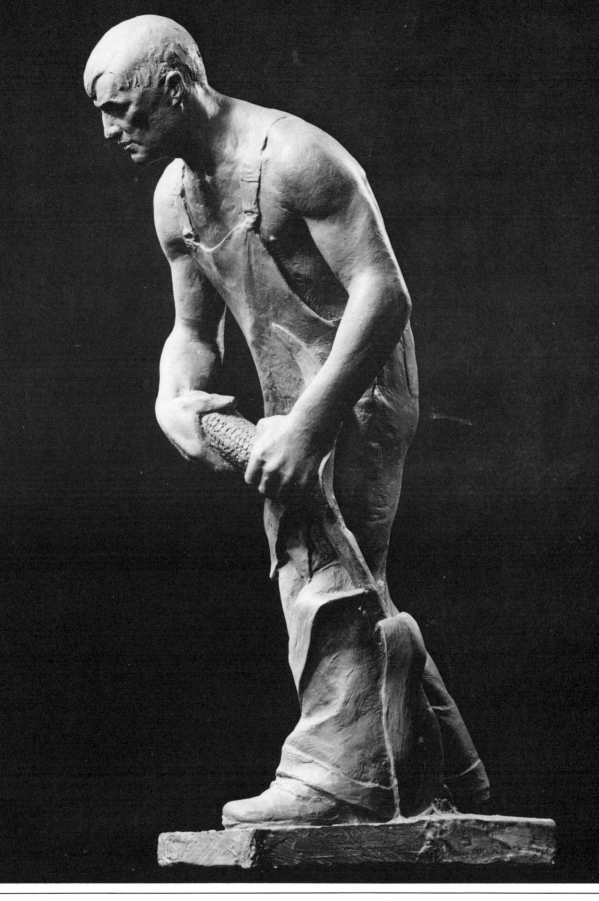

"THE CORNHUSKER," MARION LINK OF NEVADA. **CGP**

Munn in Ames, along with *Four-H Calf*. Both works were later moved to Madison, Wisconsin, when the hotel chain sold the Ames hotel and acquired motel property in Madison.

FOUR-H CALF, 1941. Both this piece and *The Cornhusker* represent relative rarities in American art: sculptures based on an agricultural theme. This work depicted a young 4-H boy with his calf, struggling to bring the animal into a show ring. Christian Petersen conducted sculpture demonstrations at the Iowa State Fair for a number of summers. He particularly enjoyed watching the young farm boys and girls showing their livestock in 4-H competition. This piece was also cast in plaster.

MEN OF TWO WARS, 1942. The outbreak of World War II inspired Petersen to create a half-size sculpture of two soldiers—from both World Wars—approximately fifty-five inches long, twenty-nine inches deep, and thirty-three inches high. He intended the sculpture as a proposed war memorial; the unfinished plaster casting was stored in Ames in 1964. The artist proposed this work in heroic-size bronze as a war memorial to be sponsored by the American Legion of Iowa in the late 1940s, but the project was never commissioned. The work was purchased by the Memorial Union at Iowa State University in 1985.

THE PRICE OF VICTORY, 1944. Of all the sculptures created from the deep wellsprings of Petersen's mind, this work stands alone because it depicts a violent, ugly, revolting event. *The*

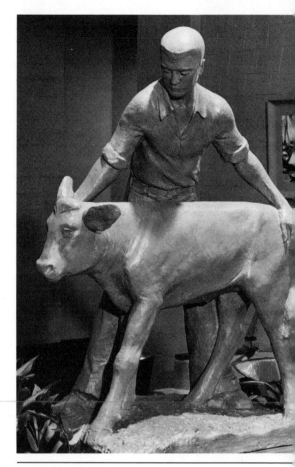

"FOUR-H CALF," **CGP**

Price of Victory is aptly named, for it conveys the jarring visual impact of an American soldier being fatally hit by enemy fire. The agony of his death is reflected in his half-fallen figure.

During World War II, when most of his former men students were serving in the armed forces, the artist often listened to war news on the radio in his studio. Shortly after the allied invasion of Europe, he felt deeply moved to work clay into a powerful, emotional symbol of the

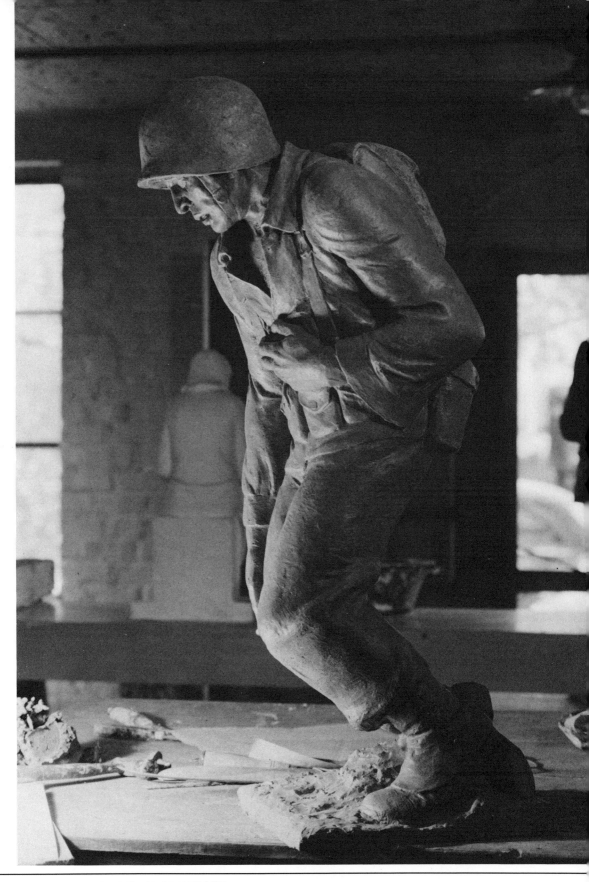

"PRICE OF VICTORY," PARKS LIBRARY VAULT. **CGP**

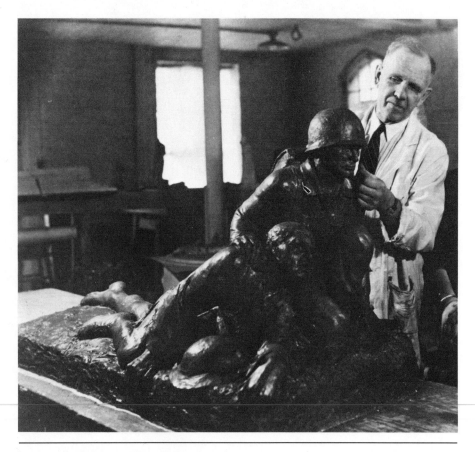

"MEN OF TWO WARS," MEMORIAL UNION, 1985. **CGP**

sacrifices American men were giving for their country.

This sculpture was created not to glorify or glamorize war; Petersen had done his share of monuments honoring war heroes in earlier decades. This memorial was starkly different from all the others.

It reflected his grief for every fallen soldier, his deep feeling that every battle death was a profound loss. He wanted the sculpture to memorialize those losses when peace arrived.

The half-size plaster casting was displayed for several days in Gold Star Hall of the Memorial Union after World War II ended, but it was quickly removed by college officials in response to complaints from viewers. The statue apparently had created too much grief for those who had seen it, particularly persons who had lost a loved one in combat.

When the statue was removed, Petersen said: "It is the greatest compliment ever paid to my work." The piece was shown briefly in the 1960s during anti-Vietnam war demonstra-

tions and has been stored in the Iowa State University library vault since then.

CHARLOTTE AND MARY, 1946. A beautiful terra cotta bas relief, this portrait of his wife and ten-year-old daughter typifies Christian Petersen's superb skill in creating likenesses. The piece is sixteen by twenty inches and is owned by a private collector.

MADONNA OF THE SCHOOLS, 1946. See Chapter 8 for a description of this unusual multiple-figure terra cotta sculpture grouping, created for St. Cecilia's Catholic school in Ames, Iowa.

VIKING, 1946. Petersen was commissioned by the Ventura, Iowa, public school board to create a Viking figure in bas relief for the main lobby of a new high school building. He also carved a bas relief panel of a basketball player for the school gymnasium.

HEAD OF CHRIST, 1949. In his latter years, the artist was repeatedly inspired to create sculptures of the figure of Christ. This superb Bedford stone studio piece was purchased after the artist's death in 1961 by St. Thomas Aquinas Catholic Church and student center, Ames. See Chapter 8.

CHRIST WITH BOUND HANDS, 1950. Another studio piece of deep religious significance to the artist, this work is also described in Chapter 8.

"TWO CHILDREN," BRONZE. **AUTH**

Small studio sculptures and models, 1934–1961

Among the eighty works in the 1964 sale of Christian Petersen's studio pieces were a number of small clay studies or plaster castings of studio pieces.[6] The following are descriptions of works for which information was available in 1985.

Charlotte is a fired clay sculpture modeled in 1938 by the artist on a family picnic in Ames. Charlotte sat on a fallen tree trunk, dressed in her new hat and coat, while Christian worked on the small sculpture, eight inches high by ten inches long and five inches deep.

Two Children, two charming figure studies of a boy and girl, ages three and four, was sculpted by the artist one afternoon in 1939. The little girl was Mary Petersen, who often

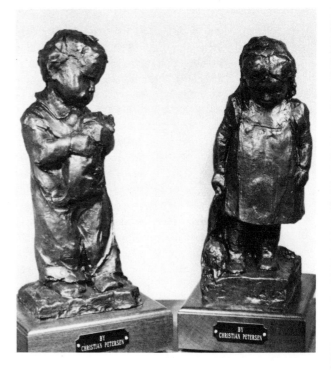

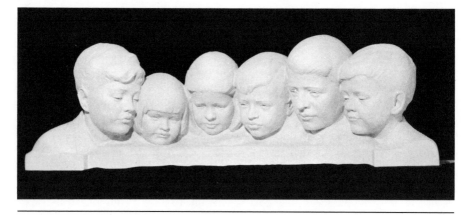

HAUGEN CHILDREN, 1936. **CGP**

carried her favorite doll everywhere. On one warm spring day, she encountered the little boy next door, who bragged "I have a puppy—and you can't play with it." He proudly held the puppy while the little girl looked on, head cast downwards, her beloved doll dragging on the ground. The figures were reproduced in plaster and sold by Charlotte Petersen for about a decade in the mid-1960s. The original pair of sculptures was purchased by a private collector in 1985.

Mrs. Christian Petersen Washing Her Hair, a spoof on an abstract sculpture of the 1930s, is a small piece that was done in 1939 and presented by the artist as a gift to his wife. Charlotte explained, "A famous sculptor was fussed over in New York because he did something called *Girl Washing Her Hair.* Christian thought that was amusing because the subject had been done several times by sculptors on the East Coast. So he did one of me washing my hair, with my head upside down over the sink."

She was referring to a work by Hugo Robus in 1933. Robus had also attracted considerable acclaim for a small sculpture in 1927 titled *Woman Combing Her Hair.* In 1915, Alexander Archipenko had also won plaudits for a freeform modern sculpture titled *Woman Combing Her Hair.*

Siesta, a rare nude piece completed in 1939, was shown in Mason City, Iowa, in 1958 and later purchased by a private collector.

The Princess and the Pea, 1939, based on a story by Hans Christian Andersen, beloved Danish writer, is the sculptor's whimsical fired clay interpretation of the princess, sitting atop stacks of mattresses on her bed, complaining of her discomfort over a tiny lump many layers down.

Dmitri Mitropoulos, 1940, is a likeness of the conductor of the New York Philharmonic. When Mitropoulos was in Ames for a concert, Christian Petersen spent an afternoon sketching him. Petersen later created an excellent bas relief, which was cast in bronze and presented to Mitropoulos as a gift from Iowa State College. A

plaster casting of the sculpture was sold in 1964.

About fifty other small studio pieces were created by Petersen during his career, many of which were shown at Younker's Department Store gallery in Des Moines in 1933 and at a Memorial Union exhibition in 1942.

Private Portrait Commissions, 1934–1961

During his long career Christian Petersen created hundreds of bas relief or in-the-round portraits. The early commissions from his East Coast years are discussed in Chapter 1. The following are the known portraits sculpted from 1934 to 1961.

CHILDREN OF IOWA STATE COLLEGE FACULTY OR STAFF: Bas relief of three children (Dave, Jean, and John) for Dr. and Mrs. William G. Murray; Michael, son of Mr. and Mrs. Ira Schroeder; John and Betty, children of Mr. and Mrs. William Schrampfer; Bruce, Bill, and Beth, sons and daughter of Mr. and Mrs. D. L. Holl; Carol and Janet, daughters of Mr. and Mrs. A. L. Wilcke; Edward R., son of Florence Walls; Helen Cunningham, daughter of Mr. and Mrs. J. C. Cunningham.

AMES AREA TOWNSPEOPLE OR CHILDREN: A. H. Munn, Ann Munn, Mary Jean Stoddard Fowler, children of Mr. and Mrs. Walter Goeppinger of Boone, six children of Mr. and Mrs. A. I. Haugen, M.D., Mildred Finnegan, Dorothy Beemer, William F. Peet, Steven Lofgren Memorial at Roosevelt elementary school.

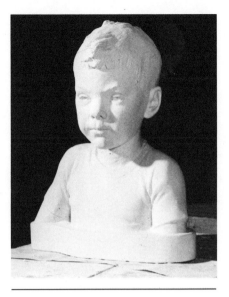

KEVIN FITZPATRICK. **CGP**

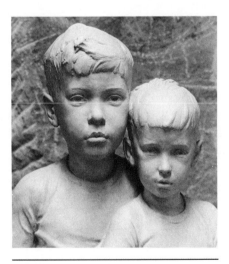

GOEPPINGER CHILDREN, 1948. **CGP**

CLOSE FRIENDS OR THEIR CHILDREN: Richard B. Hull; Jack Beckemeyer, son of Louise and Harry Beckemeyer; Martin Fritz; Gary and Sandy Weiss, son and daughter of Mr. and Mrs. Martin Weiss.

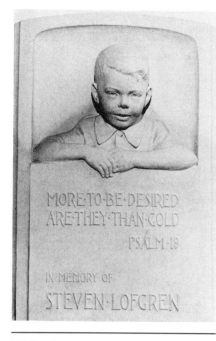

STEVEN LOFGREN MEMORIAL,
ROOSEVELT SCHOOL, AMES. **SVO**

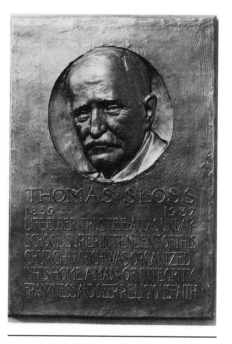

THOMAS SLOSS, BRONZE BAS RELIEF,
COLLEGIATE PRESBYTERIAN CHURCH, AMES. **SVO**

SCULPTURE DEMONSTRATIONS: For Ro-
tary Club or Kiwanis: Don Reynolds,
Lloyd Hedrick.

PORTRAITS FOR AMES CHURCHES: The
Rev. Walter Barlow, Thomas Sloss,
the Rev. L. Myron Boozer, bronze
bas relief portraits for Collegiate
Presbyterian church, Ames; the Rev.
Sam Nichols, bas relief portrait in
terra cotta for Collegiate Methodist
Church, Ames.

Sculpture competitions,
circa 1938–1940

Primarily at the urging of his
friend George Nerney, Petersen en-
tered at least two competitions for
sculpture commissions in the late
1930s. He sketched designs and sub-
mitted specifications for a heroic-sized

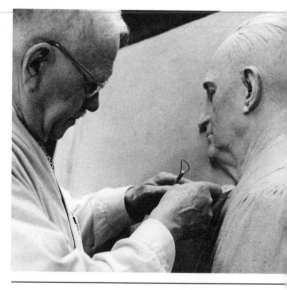

WORKING ON TERRA COTTA BAS RELIEF OF
DR. SAM NICHOLS, COLLEGIATE METHODIST
CHURCH, AMES. **CGP**

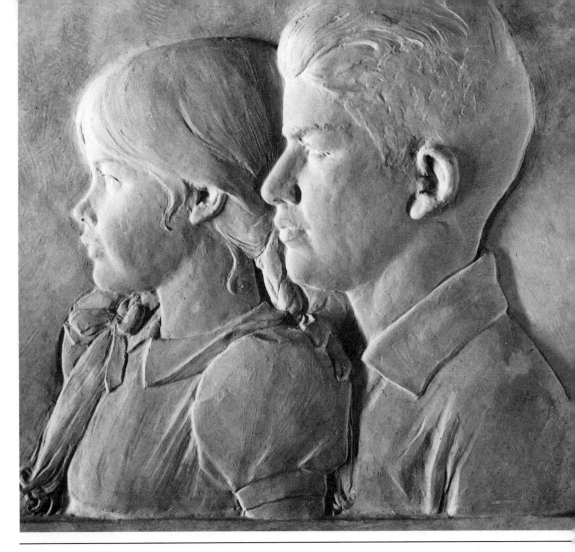

MOYER CHILDREN. **CGP**

monument to pioneer women in Denton, Texas, as part of a Texas memorial program. His unsuccessful bid was for $25,000; the proposal submitted by Petersen described a bronze sculpture of horse and rider, thirteen feet long by thirteen feet high, with the pioneer woman "the indefatigable home builder . . . the personification of calm strength in the face of often overwhelming odds. . . . She symbolized quiet determination and resolute self confidence. Burned by the shadeless Texas sun, she looked ever ahead to the future, never back on the conveniences, companionship, and safety she left behind. . . . Without her, this country could never have been."[7]

The sculptor also interpreted this thematic tribute to pioneer women in his Bedford stone sculpture of *Prairie Madonna*. (See Chapter 5.)

He also created a small model for a proposed memorial to William Holmes McGuffey, famous for the *McGuffey Readers* written for school children late in the last century, but was chagrined to discover later that his proposal was never considered by the McGuffey committee.[8]

Commercial medal and portrait commissions

In the early 1940s Petersen completed four medallion designs for Josten's fraternal jewelry manufacturers in Owatonna, Minnesota: the Alumni Medal and the Marston Medal for engineering at Iowa State College, and two medallions titled "Steer" and "Gerber Baby." The latter two were apparently commercial commissions, but no records could be found by Josten's in 1984.

The Eli Lilly biochemistry award medal was a medallion commission arranged by Christian Petersen's friend John Pusey. This medal has been awarded annually since 1936. Petersen also designed a safety award medallion for the Quaker Oats Company in Cedar Rapids, Iowa. In the late 1930s, the artist designed a medallion award for the Equitable Life Insurance Company of Des Moines and created bronze portrait plaques of prominent business and civic leaders Frederick M. Hubbell, Frederick C. Hubbell, Frederick W. Hubbell, Henry S. Nollen, Hoyt Sherman, Benjamin F. Allen, Phineas Casady, Cyrus Kirk, and James C. Cummins. In 1985, these were in the main floor lobby area of the Equitable building in Des Moines.

Bronze plaques of publisher

ISC ALUMNI MEDAL, 1940, **CGP**
MARSTON ENGINEERING MEDALLION, 1938, **CGP**
ELI LILLY BIOCHEMISTRY MEDALLION, **CGP**

Gardner Cowles and his son, Gardner Cowles, Jr., of the Des Moines *Register and Tribune* Co. were displayed in the lobby of the building in 1985.

Petersen carved a portrait bust in 1930 and a commemorative bas relief in 1959 of James C. Edmundson of Des Moines. The bas relief is installed on a memorial at the Des Moines Art Center, a facility funded by a bequest from the Edmundson estate.

A bronze plaque of Arthur E.

120

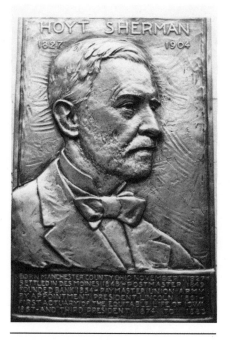

HOYT SHERMAN, BRONZE,
EQUITABLE BUILDING, DES MOINES. **SVO**

Many of the busts or plaques were shown at Younker's gallery in 1933, along with portraits of Des Moines civic and business community leaders: E. B. Bieghler, head of Des Moines City Railway Co.; Mr. and Mrs. A. H. Blank, owners of Tri-States Theaters; Johnson Brigham, State of Iowa librarian; Robert Cook, principal of Roosevelt High School; Jay N. ("Ding") Darling, editorial cartoonist for the Des Moines Register; George C. Duffield, president of Duffield Motor Co.; George Dumphy, Jr.; Amos Emery, architect; Mr. and Mrs. Amos Emery; Mrs. Amos Emery; Clyde Beals Fletcher, founder of Home Federal Savings and Loan; Kirk Fox, editor of *Successful Farming* magazine.

Billie George; Colonel W. F. Godson of Fort Des Moines army post; Benjamin F. Hadley, second

Thomas, director of the Des Moines municipal airport, was displayed on the main concourse of the airport in 1985.

Private portrait commissions in Iowa, 1928–1956

DES MOINES. In the early 1930s Petersen was commissioned for a number of portraits in Des Moines. During the following decade he sculpted portraits of children for Mr. and Mrs. Harlan Miller, Dr. and Mrs. William Ryan, Mr. and Mrs. Johannes DeJong, Mr. and Mrs. George Kuhn, Mr. and Mrs. Joseph Lorentzen, Rabbi and Mrs. Eugene Mannheimer, Dr. and Mrs. Charles Ryan, Mr. and Mrs. Max Schloss, and Mr. and Mrs. Ted Stuart.

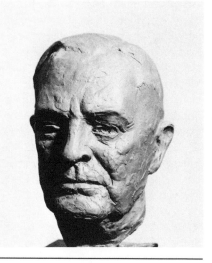

GARDNER COWLES, SR.,
COWLES LIBRARY, DRAKE UNIVERSITY. **CGP**

ANNA AND A. H. BLANK,
PLASTER CAST FOR BRONZE BAS RELIEF. DES MOINES BLANK CHILDREN'S HOSPITAL. CGP

vice-president of Equitable Life Insurance Co.; Kenneth Haines; Edgar R. Harlan; Emmett Hasty, principal of Roosevelt High School; George Kuhn, president of Bankers Life Insurance Co.; Rabbi Eugene Mannheimer, temple B'nai Jeshurun; Julia Bloom Meyer; Ellis Newsome, owner of Hotel Elliott; Lewis Worthington Smith, English department, Drake University; Forrest Spaulding, director of Des Moines Public Library; Mrs. Forrest Spaulding; Mark Thornburg; Dr. Nelson Voldeng; Eastman Weaver; and James B. Weaver.

PORTRAITS OF IOWANS: Ole Nelsen, Story City, National Commander of the Grand Army of the Republic; Francis McCray, Iowa City, who was one of the artists for the Iowa State College library murals, 1934, and later a member of the University of Iowa

art department; John Pusey, Sioux City, who was a painter in the Iowa City federal art workshop and a close friend of the Petersens; Grant Wood, bust for McKinley Junior High School, now displayed at the Cedar Rapids Art Center; J. W. ("Bill") Fisher, Marshalltown; Megan Norris, Marshalltown.

PORTRAITS OF RESIDENTS OF OTHER STATES. Frank Luther Mott bust (1936) at University of Missouri, Columbia. Mott was on the faculty at the University of Iowa School of Journalism in the 1930s and later headed journalism at the University of Missouri.

Knute Rockne medal and portrait bust (circa 1933). Rockne was football coach at Notre Dame University, South Bend, Indiana.

Gutzon Borglum, sculptor; Alfred Caldwell, architect in Chicago, Il-

122

FRANK McVEY, PRESIDENT,
UNIVERSITY OF KENTUCKY,
BRONZE MEMORIAL PLAQUE, 1938, **CGP**

ROBERT R. COOK, PRINCIPAL,
ROOSEVELT HIGH SCHOOL, DES MOINES,
PLASTER CAST FOR BRONZE PLAQUE. **CGP**

CREATING PORTRAIT OF DEAN HELEN BENITEZ,
PHILIPPINE WOMEN'S UNIVERSITY. **CGP**

IMAGERY IN CLAY AND STONE **123**

linois; Carroll Caldwell, daughter of Alfred Caldwell; Edward and David Rall, sons of Dr. Edward E. Rall, president of North Central College, Naperville, Illinois; Dr. Albert Goldspohn of North Central College, Naperville, Illinois; George Nerney, lifelong friend of Petersen's, from Attleboro, Massachusetts.

RESIDENTS OF FOREIGN COUNTRIES: August Bang, Danish writer; Consul-General Baumann of Denmark; Neils Bukh, gynmnastics educator in Denmark; Dean Helen Benitez of Women's University, the Philippines (a duplicate of this sculpture in plaster is in storage in Ames); Don Ricardo Jiminez, faculty member of the University of Costa Rica, San Jose, Costa Rica; Phillip Lyendecker, Department of Botany, Veracruz University, Veracruz, Mexico.

Portraits of Christian Petersen

Petersen created only one self-portrait during his long career as a sculptor, a rapidly sketched caricature of himself in pastels. Two 1940 oil portraits of the artist—both by Frank Johnson, a friend of the Petersens from Rockford, Illinois—are known to exist. One of them was purchased by Charlotte Petersen's "Playmakers" drama group and presented as a gift to Iowa State College in about 1943.

The other Johnson painting, an informal likeness, was a gift to Charlotte from the artist, who was a houseguest of the Petersens while he was in Ames doing other faculty portraits in 1940. Christian Petersen created a portrait bust of Johnson, which he presented as a gift to the painter.

Although the sculptor spent much of his life creating images of other people, he was reluctant to pose for photographs, preferring that his sculptures be emphasized rather than the artist who created them. The best studio portrait of Petersen was by professional photographer John Barry of Cedar Rapids in 1937.

Word portraits by friends of the artist

Perhaps the best likeness of Christian Petersen emerges from word portraits of him by those who knew him best: his former students, neighbors, friends, and his widow. Glimpses of the persona of the man emerge from the memories of people who knew the "gentle sculptor" as "artist, teacher, friend."

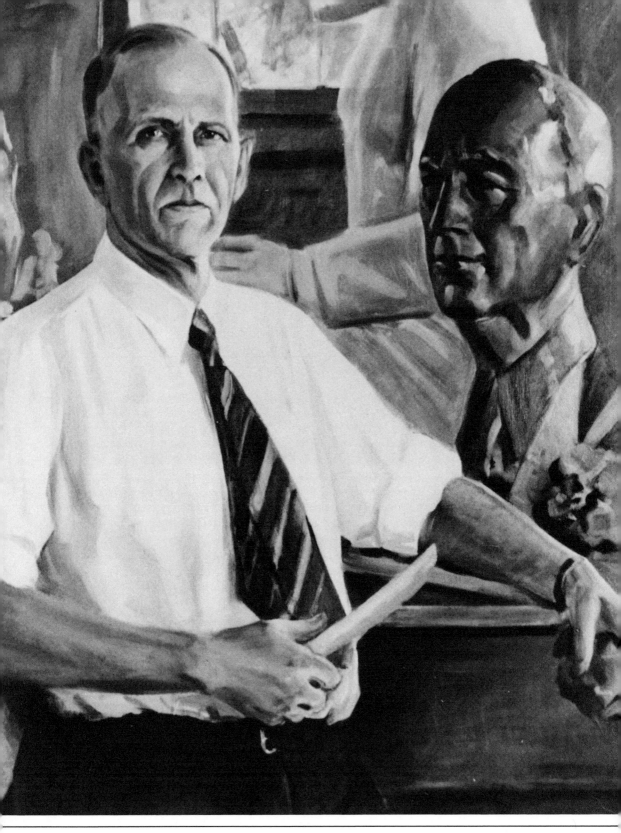

PORTRAIT OF CHRISTIAN PETERSEN BY FRANK JOHNSON, ROCKFORD, ILL. **ISU**

7 Christian Petersen Remembered

". . . to Christian Petersen, artist, teacher, friend we dedicate this 1957 Veishea parade."

—VEISHEA CENTRAL COMMITTEE

FEW are the college professors who are revered by their students twenty, thirty, or even forty years later, but Christian Petersen was one of them. In response to an alumni newsletter story about him in 1983—twenty-two years after his death—more than forty of his former students, Iowa State faculty and staff colleagues, and friends and neighbors from past decades recalled their memories of the Danish sculptor.

Decades after they struggled with clay, plaster, and terra cotta in his sculpturing classes, these former students took time to look back and say he was an unforgettable teacher and friend. Many reported that the sculptures they created in Petersen's class are treasured mementoes of a person they often remembered.

They characterized him as an infinitely patient, kind, and gentle man who cared deeply about every individual in his sculpture classes, not only the talented ones. "He never belittled or embarrassed anyone, no matter how clumsy they were with a lump of clay. He made each of us feel special," one of them wrote.

They were taught by distinguished professors in architecture, veterinary medicine, engineering, the sciences, agriculture, or home economics, and still a number of them regarded Christian Petersen as the best teacher of their college years.

How did this quiet man—who had no formal college degree—teach sculpture and art appreciation to students of home economics, science, and technology? What did he hope to accomplish?

Petersen knew that art was available as a course only for young women students studying home economics. They could elect "applied art," which meant ladylike weaving, home decoration, or perhaps genteel watercolor or oil painting. But messy clay and stone carving? And no men allowed in his sculpture classes?

For a working sculptor, the chal-

126

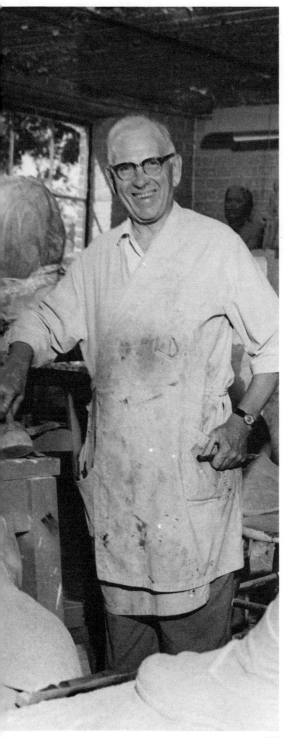

to young women who had never worked in sculptural media, and a small budget for classroom materials, Petersen resolved to fulfill his assignment.

President Hughes had also assigned Christian Petersen to lecture on art appreciation to both students and faculty, many of whom had never seen a gallery or an original work of art, let alone a working sculptor. "Very well then," he decided, "I'll just be who I am and give them my very best efforts. We'll figure it out as we go along."

And, with Charlotte's help, Christian did just that. They worked together to find ways of relating his sculpture experience and abilities to the lives of these practical-minded midwesterners, most of whom had little background or preconceived notions about art.

It turned out to be a satisfying and inspiring challenge for Christian, who understood and enjoyed the students and faculty who wanted to learn about art. Charlotte found illustrations and reference materials in magazines

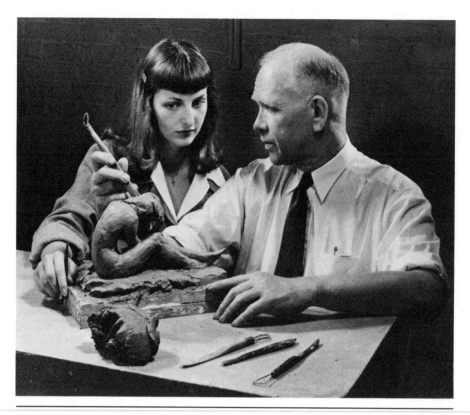

CHRISTIAN PETERSEN AND A SCULPTURE STUDENT. **CPP**

or at the library. Christian soon realized that his faculty lectures were well received and his students were enthusiastic workers in class. "His studio was the only classroom on the campus with a coffeepot always going and a radio playing in the background," Charlotte emphasizes. "It was a relaxed, comfortable kind of laboratory where the students could enjoy themselves and the professor enjoyed the students. Various faculty people—especially the vets—often dropped in to visit a working artist.

In September 1950 the Ames *Daily Tribune* carried a story by War-

ren Gore with the headline: "Science, Agricultural Students Take Interest in Art—That Pleases Petersen." The story explained, "Petersen . . . teaches students of landscape architecture or home economics majors fundamentals of form through his art courses. He gives them work with clay 'to help them know and see things in the third dimension.' "[1]

When the artist moved to studio space in the veterinary quadrangle, men students began unofficially attending his sculpture classes, although enrollment was still limited to women applied art students. "First came the

architecture boys,'' Charlotte Petersen recounted, "then other men students heard about the class and began asking if they could attend, too. Christian always found room for one more student."

After receiving college permission to enroll any student who wanted to elect sculpture, Petersen found himself with a full day of teaching and a waiting list at every registration for those who had scheduling difficulties and wanted to try a later quarter. Charlotte recalled:

He loved it, because he loved young people. Most of them were studying all kinds of difficult science and technical subjects, and his class was an enjoyable change-of-pace for each of them.

He would teach all day. But he'd put the kids to work and do what he could with his own projects. Of course he couldn't carve limestone when the students were there—too much dust and chips of stone flying around. But they enjoyed one another in those classes. There was a lot of philosophy talked over between Christian and his students. He was really among them as they worked, not off in a corner.

Architect Leo Peiffer of Cedar Rapids was enrolled in Petersen's sculpture classes for two years in the mid-1950s.

I'm sure the vet quadrangle was a good place for a sculpture studio, but a vivid memory was the first day of class, where I was introduced—as an architecture student—to animals the veterinarians had dissembled for their anatomy studies . . . quite a shock, and if you could imagine the pungent odors Mr. Petersen and the students had to put up with . . . whew!

For two years I enjoyed the leadership of Mr. Petersen and I took all the sculpture classes I could from him. One of my most vivid memories was helping him carry the quantities of heavy clay up the scaffold when he was preparing the clay model of a large statue . . . I believe it was almost fifteen feet in height. After many months of labor and when it was

finished, I also aided him in cutting the carefully planned pieces to send to the bronze foundry for casting.

Like many other former students of Christian Petersen, Leo Peiffer said, "I have typical pieces I did while under his guidance, such as a horse, a crouching leopard, a cowboy with arms and eyes lifted skyward, all mine, but each with a part of Mr. Petersen's personality and fine details."[2]

Maggie Kolvenbach, an Iowa State College graduate of 1954, now lives in Mt. Kisco, New York. She describes the vet quad studio atmosphere: "Another vivid memory is of the nightmarish pig noises we heard during class. Some said they were slaughtering the animals in the next room. Some of us didn't believe it, but we never knew—one way or the other."

She remembered her first day of class:

. . . The room was two stories high and drafty. About fifteen girls stood at two long, crude tables. The room was full of statues in all stages; broken pieces and hardened clay were everywhere. There was a foolish moment when we realized that class had begun . . . Mr. Petersen was 69 years old that year. College students don't know how old anyone is, especially if they're over 22, but I don't remember any signs of age. He had sufficient white hair and his coloring suggested he loved being outdoors . . . he moved eagerly about the room during the whole class.

If you have three fine teachers in your life, you're lucky. Mr. Petersen was one of my three. He was calm, he was gently encouraging, but he didn't give you a false sense of accomplishment. He was so patient and never seemed bored with what his students were doing. We were treated as adults; we could do as little or as much work as we wanted. He didn't profess to know the one right way to approach sculpting—and he was always available.[3]

SCULPTURE BY MAGGIE KOLVENBACH, STUDENT.
CONT *Maggie Kolvenbach.*

James Dixon of Wilmington, Ohio, rated his sculpture teacher as a special person in his life.

I took a couple of courses under him in about 1948–1949 and of all the profs I had, he is the most remembered. . . . As a student in architecture, I selected sculpturing as an elective subject. . . . I had seen an exciting drawing of a cavalier on a horse, which had about as much action in it as you could get . . . and decided that would be my project. Prof. Petersen advised that the subject was probably too difficult for a first project, but when I registered my disappointment he gave the OK.

Of course he helped whenever I asked, and occasionally when I didn't . . . the fun started in taking the mold off the [plaster] casting. I remember chipping away at it, making very slow progress. He stopped to watch me and probably suggested I take bigger chunks. When my progress didn't satisfy him, he took over. The way the plaster was flying, I knew he was going to ruin my piece.

But of course he didn't. He showed me how it should be done, and from that point on, my progress greatly improved. I shall always be grateful to Christian Petersen for helping me

with that small achievement—the horse and rider.[4]

Viola Kietzke Barger (Mrs. Howard C., Jr.) of Sidon, Mississippi, reminisced about her 1949 sculpture class:

I remember him as a very astute observer—walking the aisle behind the workbench of students—not offering suggestions unless solicited or a student indicated he or she was having an execution problem. I was doing a head of my future husband and was having trouble doing the eyes. I told Mr. Petersen that I couldn't seem to "get the eyes." He picked up the wire-loop tool, deftly made three marks for each eye, and they were perfect. Needless to say, I never touched the eyes again.

She adds that she finished and cast the statue with Christian Petersen's contribution of the perfectly modeled eyes.[5]

Glen Jensen, a landscape architect living in Carmel, Indiana, remembers Christian Petersen "as a warm, friendly fatherly person with a very modest opinion of his own tremendous talent. I think he had the ability to make a student feel that he or she was someone special." Jensen enjoyed two quarters of sculpture class in 1949 and 1950:

In my case, the emphasis was on the Danish connection. This began on the first day of class when he looked over the roster and read aloud only three names—"Feddersen," "Jensen," and another obviously Danish name. Then he said, "Well, I see we have three 'A' students."

Jensen recollects that the sculptor told him he was from Dybbol, Denmark, "the same town in Denmark as the late Jens Jensen, a famous landscape architect in the Chicago area. I mentioned one time that it might be helpful to me if I were related to Jens because I was majoring

in landscape architecture . . . Christian said, 'Don't you know, Glen, that all of us Danes are related?''

Petersen often reported Danish news items to his young friend, among which was, ''Glen, you should have been at our house last night. The Bishop of Denmark stopped overnight in Ames and we sat up and talked half the night.'' On another occasion, he told Jensen ''the whole Danish gymnastic team'' was at the Petersen home the previous weekend.

When Glen Jensen and his wife later lived in Indiana and became parents of a son in the mid-1950s, they named him Christian Peter Jensen and wrote to Petersen to tell him so. ''He replied that he was pleased and flattered because no one had ever honored him like that before,'' Glen Jensen recalls.

Jensen described ''the morning he called me aside in the studio to show me the clay relief of the Mutual of Omaha Indian chief.'' The company had sent a sketch of the proposed corporate symbol to the artist, commissioning him to do a relief sculpture. ''Christian used the basic idea, but created his own version of the Indian chief . . . the Mutual of Omaha representative was coming to Ames that day to pick up the sculpture.''[6]

Robert Copenhaver, vice-president of the Omaha insurance company confirmed in 1984 that the corporate symbol was developed in the late 1940s. However, company records of Christian Petersen's design could not be found in 1983. Copenhaver explained that a number of preliminary designs were submitted through the company's advertising agency; Christian Petersen's original concept may well have been the basis for the adver-tising art later developed for the corporate symbol.[7]

In 1983 Glen Jensen went to considerable effort in contacting officials of Mishawaka, Indiana, regarding a sculpture that had been proposed by Christian for the city's centennial in 1933. (See Chapter 6 for the story of ''Princess Mishawaka.'') Petersen was never allowed to complete the work—through no fault of his own—but rumors had circulated fifty years previously hinting that he was at fault for failing to complete the sculpture. As a result of Jensen's concern for the reputation of his friend and teacher, official civic records were corrected during Mishawaka's sesquicentennial celebration in 1983.

Another former student, Lois LaBarr Moses of Ames, remembered the following about the 1939 class.

. . . about 20 of us were seated on stools at a high table or shelf and watched as this sandy-haired, rather studious looking man used one of the girls as a model and very quickly and expertly executed a perfect likeness of her head. He talked and explained as he worked. I was simply amazed at how he never made a wrong motion with those hands. Every twirl of a thumb at the eye socket, or pressure of fingertips modeling the nose accomplished exactly what was needed to get the proper result. The clay took form in a matter of minutes.

He gave each of us a chunk of clay and told us to do whatever we liked with it. Most of us had never done anything with clay except to make ''snakes'' and tiny baskets in grade school. Since I'd had sketching of faces and figures in applied art, I decided to do a little bas-relief picture. . . .

He chose two of us to take a course in the spring quarter . . . When he discovered I liked to draw figures and liked to read, he suggested combining the two ideas. It took me most of the quarter to do my clay piece. I still have it. It's called *Barefoot Girl—Reading*. It's a piece on a flat platform, of a girl lying prone, upper

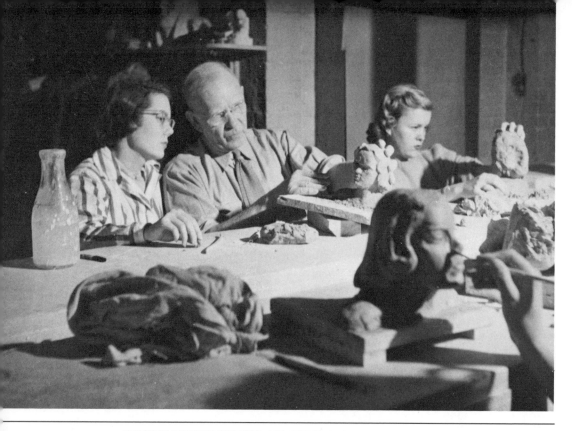

CHRISTIAN PETERSEN, STUDENTS, AND CHUNKS OF CLAY. **CGP**

body raised on her elbows, reading a book. I wanted her to be barefoot, so my twinkle-eyed instructor said, "Let's cross one foot over the other, just for fun." And we did.

The studio was on the southwest side of the building and the afternoon sun would shine in the west windows—the door was always open. He had many models of his works scattered here and there throughout the studio . . . We students never felt any pressure to get things done quickly. He seemed to want us to just work, dream, and enjoy. My greatest impression of those three months was how modest our instructor was. He was confident of his abilities, of course, or he couldn't possibly have done the work he created.

I was fascinated by one sculpture of a young farm boy attempting to put wings on a big, sturdy plow horse. I knew all about Pegasus and Bellerophon, and I loved horses and fantasy, but it took me a few years to understand that sculpture. . . .

Christian Petersen loved realism in a world that was turning to "modern" art—or whatever it's called. He remained his own person in that world. Perhaps that is one reason his work is respected.[8]

A young veterinary student who elected Petersen's sculpture class during the winter and spring quarters of 1953 was Dale Welbourn, DVM, of Neola, Iowa. He explained why he wanted to enroll in the class:

I had a heavy workload and was carrying about 18 credit hours at the time, but felt I also needed a change of pace and I was fascinated with Christian Petersen's work and had always wanted to try my hand at sculpture. So I went over to see him and told him I would like to take the course. Mr. Petersen looked me straight in the eye and said, "Did you come here to sculpt or to meet girls?" "Sculpt," I said, and he said, "OK" and grinned.

He asked me what I wanted to sculpt and I said "animals." He said, "Well, you should know your animal anatomy and muscles, since you're a junior in vet med."

On occasion he would walk past and check everyone's work. He kept after me not to smooth my work so much and leave a rough texture, otherwise I would have had them looking like ceramics. . .During the two quarters I sculpted a horse, bull, fox, and a dog. The horse I gave to a good friend and I kept the other three pieces. I still remember, after thirty years, that I spent fifty-two hours sculpting the dog.

. . . One day I was having trouble getting the eyes right on my dog. Mr. Petersen let me struggle for an hour, and then came over and with five or six deft movements of the stick did what I couldn't do in an hour . . . He wanted you to do your own work but he added little touches to all my animals and they mean so much more to me because of it.[9]

Three artists honor their former teacher

Three of Christian Petersen's sculpture students later became professional artists. Each began her career at Iowa State College and remembers well the talents and teaching abilities of the Danish sculptor.

Dycie Stough Madson of Godfrey, Illinois, wanted to enroll at the Chicago Art Institute, but came to Ames because "my parents had been sold on Iowa State as an all-around school for a proper young lady in 1944." She took every sculpture class available from Petersen and hoped to study for a master's degree in sculpture, but no such program was available. Madson became an accomplished ceramic artist and illustrator for her husband John's books and articles on wildlife and natural history.

This is her account of the first day in sculpture class:

It was a big sunny stone stall, designed for twenty horses . . . There were good, solid-looking work tables arranged in a U and a few girls standing around looking confused and a great, barrel-chested, grizzled man wearing a blue and white striped shirt, tie, and sagging grey pants.

Christian Petersen was my friend . . . from the instant I saw him. He showed us where the tub full of stinky clay was, under the homemade wooden lid. It was full of goo, twigs, and leaves—and it smelled. Christian said it made the clay more plastic.

He indicated that we could start at anything we wanted, but that we ought to remember simplicity. Past student work was out in the courtyard. He once grinned and said it was a test of the durability of the terra cotta and pointed out the year each piece had been made.

In the window was the model of George Washington Carver and the study of a soldier. Christian was working on a bas relief of a child, one of many that he did in the next three years. We worked up our clay and began—he'd look over our shoulders and do a couple of quick little things and it suddenly made sense. But that wasn't all. He loved each stroke and curve in the clay, he loved living things, and loved the material into being more than just clay.

He taught me that anything you can do little, you can do big . . . I measure everything I do against an artistic and a human standard that I was privileged to know.[10]

Mary Jean Stoddard Fowler grew up in Ames, and played with the Petersen's daughter when the families were neighbors. She now lives in Houston, Texas, and is a weaver and designer of tapestry wall hangings, many of which are landscape themes based on the Texas hill country. She is also owner of an art gallery and custom design firm of painters, sculptors, and textile artists. Her applied art studies at Iowa State began

in sculpture class in the early 1940s. "I remember Chris's class as one of the highlights of my schedule. It was so real. Other labs were obviously for students to work only in theories. Here, in the studio, one felt the reality of the working artist—the creativity taking form." She recalls, "The awe, the fascination of seeing his work in progress, of just being there as it developed . . . I felt included in something very private, very special. Working there was a wonderful experience and he was so patient with us, so encouraging, so kind."

Of Petersen's sculptures, she commented: "I remember his presence in so many places around the campus—a dear part of growing up richer for his works. I cannot imagine growing up without their company. Solid, basic, simple, fine, strong; I can see their influence in my own work today."[11]

George-Ann Tognoni of Phoenix, Arizona, brought thirty of her western-theme bronze sculptures to Ames in June 1983 for exhibit in the ISU College of Design gallery.

Tognoni showed her work in trib-

GEORGE-ANN TOGNONI
photo by Markow.

ute to her sculpture teacher. As George-Ann Neudeck of Fort Dodge, Iowa, she came to Iowa State in 1943 and again in 1946 expressly to study sculpture under Petersen, whom she remembers as "a gentle person and sort of father-figure to his students—a lot of us confided in him."

Having grown up with horses on her family's farm, she determined to sculpt them. She began introductory sculpture studies at the University of New Mexico in 1942, then came to Iowa State, where Christian Petersen "taught me a lot about patience. I was struggling one day with a clay model of a cowboy figure riding his horse into a blizzard. Christian saw I was just fiddling away at getting the details right. He took his tools, obliterated the clay, and told me, 'Start over.'"

She recalls that Petersen "wanted me to get the basics, to understand anatomy, and to do an honest job of sculpture." The first day she reported to Petersen's veterinary quadrangle studio, he sent her out with a sketchpad to the vet barns to study the living models which were so conveniently near. One of the sculptures she completed during her study with the Danish artist was of a beloved old mare named "Old Bessie," a horse boarded in the veterinary college as a living anatomy model for the freshman students. Tognoni and Bessie became well acquainted, she remembers, "and I soon knew the contours of every rib and bone on her elderly frame."[12] The Arizona artist later created a limited edition in bronze of the horse who helped teach veterinary anatomy at Iowa State College.

Tognoni has specialized in sculptures based on early mining days, Old West themes, and handsome Ara-

bian horses during the latter part of her career. Many of her early works were based on the sturdy draft horses she remembers from her Iowa farm days. *The Yearlings,* her magnificent trio of life-size bronze mustangs, was purchased in 1985 for the Scottsdale (Arizona) Civic Center plaza.

Tributes from other former students

Marian Moine Beach of Lakewood, Colorado, was a student in 1940. She recalls that the artist appeared in a *National Art Week* feature film in 1941 which was distributed to theaters by RKO studios in Hollywood:

> One day in class . . . he came to me and told me that a film company (RKO, I think) was coming from Hollywood to make a short film of him working on a piece of sculpture. They wanted it to show across the United States during National Art Week. He asked me if I could stay after class and be his model. I was flattered and agreed to stay.

She added, "I never got to see the film, but I had letters from friends in three states telling me they had seen me in the movies."[13] Petersen gave her a plaster casting of the portrait bust he sculpted that day, but some years later it was badly damaged by moisture while in storage. Like many other Iowa State graduates, she mourns the loss of that special memento. Because of the high mobility of Americans in the 1940s and 1950s, a number of Christian Petersen's former students lost the small sculptures they created in his vet quad studio, either by breakage or deterioration of plaster during their many moves throughout the United States.

One student who did not lose a Christian Petersen original sculpture is Sheila Dunagan Sidles (Mrs. Harry A.) of Centerville, Iowa. She explained that in 1947, "As a demonstration project, he did my head from clay, working on it at the start of each class period. He was never satisfied with it as he claimed I looked different each day. The head is now a prized possession in my home and it looks more like me now than it did then!"[14]

Margaret Leonard of Chariton and James Buck of Ames shared enjoyment of Petersen's class together in the late 1940s, during the "going steady" phase of their college romance. They have been Dr. and Mrs. James Buck since their Iowa State College years. The small sculptures they both created in the vet quad studio occupy special places in their Ames home. A stone carved squirrel is part of their summer and winter patio decor; Jim sculpted it in Petersen's class. "Margie" Buck created two small child-figure bookends which now occupy a shelf in their den. Both the Bucks regarded Petersen's class as something they particularly enjoyed sharing as undergraduates. "It was the only class we could enroll in together," Margie Buck explains, "and Christian Petersen taught all of us to understand and appreciate craftsmanship and design in professional art."[15]

AUTH

Barbara Taylor Davidson is a native of Ames and another former student of Christian Petersen. On her bookshelves are a pair of unusual bookends "Of two chubby babies in different poses," she explains, "and I remember how Christian kept telling me to make them fatter. He said there was no such thing as a skinny baby."[16]

Other bookshelves and curio cabinets all over the United States are undoubtedly special places for hundreds of small sculptures created by Petersen's students over two decades at Iowa State College. Although most of them were not applied art majors, Petersen's students gained a firsthand appreciation and enjoyment of visual art from their experience in his classes, something which they value as a plus in their lifetimes. As former students at a technically oriented college, they fully realize in retrospect how fortunate they were to have been enrolled in "beginning sculpture" at Iowa State College.

Dori Bleam Witte of Sedona, Arizona, was a textiles and clothing graduate in 1949. She sums up her experience as a student in Petersen's class: "Christian Petersen was one of my favorite instructors at Iowa State. His patience and kind attitude made sculpturing a real joy. Isn't it wonderful that his many sculptures at Iowa State will keep his memory alive?"[17]

Other Iowa State students who remember Christian Petersen

Not surprisingly, other Iowa State College students who never enrolled in Christian Petersen's sculpture classes also have warm memories of the likeable Danish-American sculptor. He was always willing to help with a student project and never too busy to welcome any student to his vet quad studio.

Herb Pownall, a 1951 graduate of the college, was editor of the campus yearbook that year. Now chief clerk of the House of Representatives of the Wyoming legislature, Pownall wrote his tribute to Christian Petersen: "I knew and admired Christian Petersen. His work with its clean strength and poetic rhythm is a delight to me."

Pownall and the 1951 *Bomb* editorial board unanimously agreed that Petersen deserved a special honor that year: the yearbook was dedicated to the artist and featured an eleven-page opening section of his campus landmark sculptures and a biography of the artist. The dedication reads: "To Christian Petersen, whose sculptures add beauty to our campus."[18] Pownall adds that the yearbook dedication " . . . was an opportunity to say 'We love your work' in a very public way."[19]

In 1950 Petersen was named an honorary faculty member of Cardinal Key, the top all-college senior men's honorary group. John Edenburn, a senior in veterinary medicine that year and president of the senior class, proposed Petersen's name for the coveted faculty honor and it was unanimously approved by the fraternity. Edenburn was one of many vet students who often dropped in to visit with Petersen.

As a graduation present for Edenburn, Christian Petersen created a small sculpture of a rider on a cutting horse, separating two polled Herefords from a run of cattle. Today Dr. Eden-

burn treasures the Petersen fired clay sculpture, which is now displayed in his home in Dell Rapids, South Dakota. The Petersen original has moved many times with him during his career as a veterinarian with the United States Department of Agriculture.[20]

Charlotte explained that "Christian never could turn down a student who asked for his help. They came from all over the campus—he did a wood sculpture trophy for the Veishea Varieties committee one year, and they still award that trophy to the winners of their show. He felt that the campus existed for the students, not for the faculty. Those young people were the reason why the college functioned."

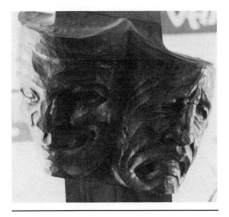

SVO

The 1957 Veishea Central Committee honored Petersen for his long career as artist-in-residence at Iowa State. The official Veishea program included this dedication:

Yes, in Christian Petersen, the students of Iowa State have found an artist, teacher and friend.

Ever since 1934 when Petersen joined the staff at Iowa State, he has added beauty and

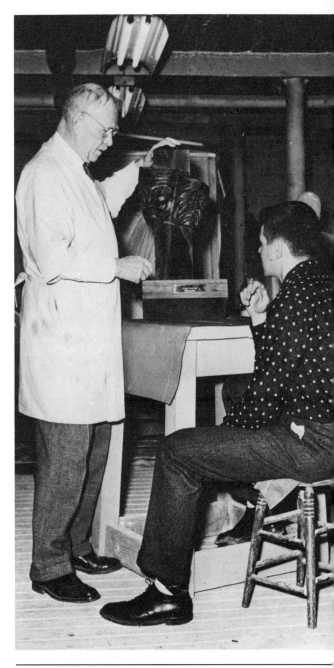

CHRISTIAN PETERSEN WITH VEISHEA VARIETIES TROPHY AND STUDENT. **CPP**

culture to the campus. . . . The many students who have worked with Mr. Petersen through the years have found in him the kindness and understanding desirable in a teacher. He has served Veishea many years by acting as a parade judge. . . . To you, Christian Petersen, we dedicate this, the 1957 Veishea parade.[21]

Iowa State students also elected Christian Petersen to Delta Phi Delta art fraternity (1950), Tau Sigma Delta, architectural and allied arts fraternity, and Phi Kappa Theta, Catholic men's social fraternity. The architecture faculty successfully nominated the sculptor as an honorary associate of the American Institute of Architects in 1959.

Christian Petersen remembered by faculty and townspeople

Marjorie Garfield was head of the applied art department from 1948 until her retirement in 1969. Now a resident of Marco Island, Florida, she wrote the author: "My office door was seldom closed and thus I often looked up from desk work to see Chris standing in the door (nearly filling it with his tall, strong frame) and always with his infectious smile. Usually he came to ask me to order clay or other needed supplies for his teaching, never to ask for personal favors. . . .When preclassification filled his classes to overflowing, Chris would invariably say 'Yes' to enrolling yet another student in a class already too large. Probably my most vivid memory of Christian is the love and admiration of him held by students, colleagues, and all who knew him."[22]

Ann Munn McCormack, formerly a longtime resident of Ames, also wrote from Marco Island that Christian Petersen did a demonstration bust of her father-in-law, A. H. Munn, for the Ames Rotary Club in the mid-1940s. When her husband insisted that Christian Petersen should do a portrait bust of her, she finally agreed. "It was a rare privilege. At that time he had his studio in the old vet med building and I went many times. He was never satisfied and would make many starts. . . . It is larger than life size."[23]

Mrs. Bayard Holt of Ellsworth, Iowa, looked back in 1983 on her family's friendship with Christian and Charlotte Petersen in the 1950s:

We aren't former students, faculty or staff, but we as a family knew Christian and Charlotte while our two daughters and our boy were growing up, and until Chris passed away. All three children dearly loved the Petersens We live on a farm about a half hour's drive from Ames, and it was a time of great joy when we would see Christian and Charlotte drive into the yard to visit.

The children were always excited when we would visit them in their interesting old home in Gilbert, or would go to Christian's studio at the college. The Petersens were always thoughtful of the children, treating them with love and respect, never "speaking down" to them. At the studio we were always intrigued by the . . . sight of the models, big and small . . . [24]

Martin Fritz, professor emeritus of psychology and counseling at Iowa State, is now retired and living in Madison, Wisconsin.

My wife, Mildred, and I knew Christian and Charlotte very well, visited often in each other's homes. . . . Some time during the early '40s, Christian and Charlotte came over to our house bringing a "tub of mud" (potter's clay which came from near Fort Dodge—Christian considered it good) and a number of people were there to serve as subjects. He modeled small heads, about six inches high, of a number of us. . . . These heads were later fired by Christian and returned to each person.

138

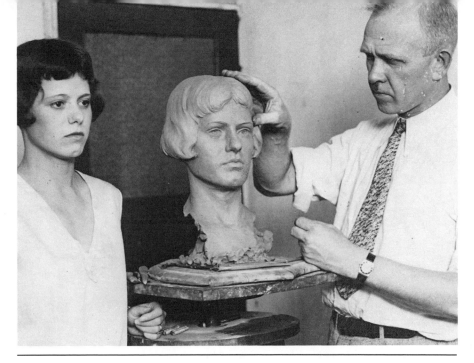

MODELING PORTRAIT OF HELEN GILKEY, AMES. **CGP**

Dr. Fritz recalled an art display at Memorial Union on the Iowa State campus. " . . . Christian and I were wandering about, from painting to painting, when we came upon one of a tenement building in an obviously rundown area. We both agreed that this was not art—that art should appeal to the beautiful, not the sordid, however realistic it might be. And I think Christian's sculptures showed this.[25]

A home for the Petersens in Gilbert, Iowa

Charlotte fondly remembered the friendly townspeople and neighbors in the rural community of Gilbert, a few miles north of Ames. The Petersens bought a rambling old farmhouse on the edge of the town in 1947. There they enjoyed a garden, flowers, and a beloved border collie named "Tink,"

who was Mary Petersen's constant companion and Charlotte's guard dog when Christian worked late at night. Charlotte treasured her memories of the wide-open horizons of Iowa cornfields and pastures and the quiet charm of a rural setting.

Until they purchased their Gilbert home, the Petersens rented a series of houses in Ames. Their first residence was Coburn house, owned by the college. This temporary home was arranged for them by their friend Raymond Hughes, the president of the college. They lived there until 1936, when they rented a house at 1221 Kellogg, on the east side of Ames. In 1938 they rented another house at 2324 Knapp, a quiet street south of the campus and "dogtown," the college student designation for the college-area business district.

The Petersens had placed an ad in the campus newspaper for a live-in helper. Charlotte remembered a red-

CHARLOTTE AND MARY WITH "TINK" IN GILBERT. **CGP**

headed young student who came to the Knapp street house in the fall of 1938 and applied for the job as a "student-girl" combination household helper and babysitter. When the young man answered the ad, he told them he had a large number of brothers and sisters and needed a place to live. They hired him on the spot. "He was a marvelous, shy, capable young man," Charlotte fondly recalled, "who could iron a shirt better than I could. He stayed with us all that year."

In 1943 the Petersens moved again to a rented house at 400 Ash Avenue. "We had really arrived. It was in one of the nicest faculty neighborhoods. I told Martha Duncan in a radio interview that I *knew* we had really arrived!"

When the house was sold in 1947—an era of scarce housing—the Petersens searched for something they might be able to buy. They were overjoyed to find a rundown, boxy farmhouse for sale in Gilbert. "We loved it," Charlotte happily recounted, "and no one else even looked twice at it, but it was perfect for us. Christian liked to fix things and knew how to do carpentry, plumbing, painting, or whatever else was needed."

Someone who remembers well what delightful Gilbert neighbors Christian and Charlotte Petersen were is Martin Weiss of Beltsville, Maryland. Weiss returned to Ames after military service in World War II to

140

finish college. Like many other veterans with a wife and children, he found housing scarce.

> . . . We found a large, old house in Gilbert . . . Charlotte and Christian lived across the street . . . the renovation required on our houses was largely conducted by ourselves.

> He would come home dressed in a suit. I've seen him—without changing clothes or even taking his coat off—open a can of paint and paint the interior of windows in their home. He was the most exacting and precise person I've ever known. Never a drop of paint on his suit or on the carpet . . .

> He was one of the most genuine friends I have ever had. He did not know the meaning of deceit or arrogance. He was proud but also humble. He was genuine.

> . . . Christian told us he would like to make a bas relief of our children—he had become very much attached to them. We were amazed but ever so grateful. It's a perfect image of our kids.

Mr. and Mrs. Martin Weiss thus acquired a family heirloom portrait (1948) of their children Sandra and Gary, then eight and two.

Martin Weiss remembered something he was pleased to do in return for the portrait of his two children:

> Christian was a proud man. . . . He loved to wear a suit; but frankly, his suits were somewhat shabby. My father-in-law, a businessman in Minneapolis, had a yen to buy expensive clothes but would soon tire of them. He accumulated a closet full of slightly used, beautiful suits.

> He asked if I could alter them—no. I wasn't of the proper build. But his build closely resembled Christian's. So, on returning from a visit, we brought two suits. But Christian was proud, would he take offense? My wife consulted Charlotte. She thought it was a splendid idea. She brought Christian over to try them on and they fit perfectly. He was delighted . . . the next time we went to Minneapolis we brought six more for Christian!

GARY AND SANDY WEISS, BAS RELIEF PLAQUE. **CONT** *Martin Weiss.*

Weiss also remembered that "salary scales at Iowa State were nominal . . . I took a one-third cut in salary from my basic salary as a battalion commander with the rank of Lt. Colonel . . . I gathered his salary was lower than mine."[26]

Louise Beckemeyer of Shaker Heights, Ohio, was a brand-new bride in August 1942, when her husband Harry introduced her to Christian Petersen. Harry Beckemeyer was a student in ceramic engineering, assigned to help the sculptor arrange kiln firing of terra cotta panels for the Memorial Union fountain basin in 1941.

She describes her impressions of Petersen in 1942: " . . . a tall, rugged, handsome man, accompanied by a short, dark-haired woman and a beautiful child with long, blonde braids." The Beckemeyers left Ames in 1943

when Harry went on active Navy duty. Three years later—in 1946—they returned to the campus and soon reestablished their acquaintance with Christian and Charlotte. Along with Andy and Virginia Johnson and Dick and Dorothy Hull, the Beckemeyers enjoyed a close and memorable friendship with the Petersens.

"We were quite a group," Charlotte fondly apprised. "Because the Johnsons lived next door, there were many impromptu potlucks and get togethers at our house or theirs, some of them in the wee hours of the morning."

Louise Beckemeyer warmly remembers the old farmhouse Christian was remodeling for his family:

> When the Petersens moved in, Harry, Andy, Christian, and perhaps others rewired the house and remodeled the kitchen . . . the Petersen welcome mat was well-trampled as their many friends drove up to Gilbert to see how things were going. . . . We really got to know Frank and Laura Brandt, Joe North, Joann Hansen, Lenore Sullivan, and others. What interesting arguments and discussions took place all hours of the day and night.[27]

Social life for Christian and Charlotte in the postwar era included a marvelous assortment of six bright young people, plus a number of faculty, staff, and townspeople—all brought together by the Petersens' hospitality. Both Harry Beckemeyer and Andy Johnson were teaching in the ceramic engineering department; Joann Hansen was teaching in applied art. "Everyone called her 'Auntie Jo,'" Charlotte reminisced in 1983. "She was a delightful woman who did exquisite watercolors, and who tended to be absent-minded. Sometimes she put her dress on backwards when she dressed for the day, never noticing it

until she arrived in class and one of her students would tactfully tell her. . . . "

Charlotte also treasured her memories of Frederica Shattuck, a beloved speech teacher at Iowa State. "Freddie Shattuck was a very dear, close friend of ours. She and Christian really hit it off, arguing a lot, but getting along beautifully. She had an office in the browsing library at the Union during the 1950s, so Christian would stop in to see her. They'd stand there and talk about art, music, and the theater."

On any given evening, someone was likely to drop in at the Petersen household unannounced, for Charlotte and Christian had an ongoing open house—no matter what the hour of the day or night—and always extended a warm welcome for friends. "They all knew they could find a place to sleep, a meal, or some laughter," said Charlotte, "and there was no formality or invitation needed."

One of their friends from that era thoughtfully commented:

> The Petersens attracted bright, interesting, enjoyable people like a flame attracts moths on a summer night. They had open hearts and open minds and they loved people who were genuine. They didn't care what your rank or status was; it was a matter of whether you, too, loved life and people and laughter. At the Petersens, you might run into President-emeritus Raymond Hughes, along with one of Christian's friends who worked as a handyman on the college dairy farm, one of Charlotte's pals who was the lead actress in a "Playmakers" production, a visiting painter from Iowa City, or a Danish writer who was doing a story on Christian—all on the same occasion, all happenstance. It was a fascinating place to be, because they attracted wonderful people from all walks of life.

> Some professors on any campus can be pompous bores and some of their wives can be relentless social climbers . . . the Petersens

142

would have none of that . . . they chose not to participate in campus "status games" or politics. Their friendships were based on who you were, not who you thought you should be.

Charlotte believed that the straight-laced element in Ames regarded their lifestyle as somewhat "out of step" with the social order of the faculty community, but said, "We had known some famous people in life—the bigwigs—and a lot of 'little people' like us, and we always looked for friends who brought us joy, not status."

J. C. and Alice Cunningham were close friends of the Petersens from their earliest years in Ames. Charlotte remembered warmly:

The Cunninghams were marvelous people. They talked about literature, about the world, about the future. They were *alive*. J. C. wrote some lovely poetry.

One summer J. C. built a homemade boat and wanted to take Christian on a camping trip, on the Marquette and Joliet route. Christian told me, "Well, I'd better go with him, just to make sure nothing happens if the boat doesn't float." They had a wonderful time, with the wind blowing sand into their pancake batter, J. C. singing all the time. Christian came back relaxed, happy, and full of mosquito bites.

Charlotte also remembered J. C.'s interest in waterfowl migration: "Somewhere in the late 1930s, the Cunninghams took us over to see the annual migration in western Iowa. We couldn't believe it—thousands of ducks and geese, stretched out on the horizon. It took us a whole day to get there and back, but it was worth it."

Charlotte Petersen always was delightfully disdainful of pomposity and pretense in people. She looked upon life as an enjoyable journey, and her fine sense of high comedy always served her well—an attribute she traced to her Irish ancestry. "What is there to be serious about," she asked, "except for faith and love?" Consequently, she reserved seriousness for only two subjects: Christian Petersen and her Roman Catholic faith. "With both," she said, "my life has been full to overflowing with joy."

Summing up her years as Petersen's wife, she said, "It was joy, all of it. I wouldn't change a minute of it . . . our life together was a time for learning, sharing, and growing—along with some wonderful friends I'll never forget."

Charlotte Petersen: a devoted helpmate

For all the thirty years she and Christian were married and for the decades after his death, Charlotte Petersen continued to be her husband's helpmate. In 1984, at the age of eighty-five, she was living in a small Ames apartment overlooking the campus they discovered together fifty years before.

Christian's beloved art books, sketches, and small sculptures crowded the walls and shelves; his favorite sculpting tools occupied a place of honor across from her favorite chair so that she could see them every day.

Charlotte was always known as a blithe spirit and a delight to her friends. Only four feet eleven inches tall, she was very grand in spirit and endowed with a perpetual supply of Irish charm.

She gave loving humor, a keen intellect, and an enduring sense of joy to her partnership with Christian Petersen. He thrived on Charlotte's love of

people, devotion to his well-being, and ability to always see the comedy in life, not the tragedy.

In her senior years Charlotte enjoyed looking back on the past, never being dull or maudlin about it, never discussing sorrows, preferring always to emphasize the achievements of Christian's career at Iowa State and how she loved sharing it with him and their daughter Mary.

His sketchbooks are filled with examples of husbandly and fatherly devotion to Charlotte and Mary. Likenesses of his daughter appear at every age and stage of childhood—and in many of his landmark sculptures—and his rollicking sense of humor surfaces in caricatures, sketches, or small sculptures of Charlotte. She remembered:

Christian loved people, like I do, but we ran different steps. I entertained him, really, although I didn't know it right away . . . I'll tell you what kind of a person he was: Christian always picked the very first violets of spring and brought them to me. He did that every year. And the only thing we promised each other when we decided to get married was that he would buy me the first watermelon of the season and I'd buy him the first box of ripe strawberries. So we did that every year.

He was a quiet man. He didn't like to speak before an audience. But he was not a shy man. He was made of stern stuff. Few people knew he had a quiet, violent temper—but he learned to control it. He always had a string on it. He had a lot of patience. The patience moderated his temper.

He was a very serious man; he always read a book before going to bed. He had a very deep intellect, but he loved to read the "funnies" in the Sunday paper, too.

He had both physical and inner strength. He did hard, physical work and had strong shoulders and arms—when he was so ill, trying to finish his last sculpture, he lifted himself with just his arms, up to the top of the scaffolding. His legs were too weak to climb the ladder.

He was a big eater, and he enjoyed his food. I was a pretty good cook . . . we liked lots of cream and butter . . . and he loved pie. All the time we lived in Gilbert, he came home every day in the middle of the afternoon—an eight mile trip—to take me downtown for pie and coffee.

She spoke of his total generosity to family, friends, and students.

It was impossible to keep up with sculptures Christian created and simply gave away, unbeknownst to me. They were his to give, of course . . . I wasn't in his studio every day; that was his domain. He never mentioned a lot of things he did for people or honors that came his way. He'd rather come home and tell me about his students and the big events in their lives.

Christian's sense of humor was the panacea of our lives. I still find little reminders of it tucked away, here and there: sketches of our dog occupying my brand-new chair; a cartoon of me reading a book on WOI radio; sketches of me trying out a new vacuum cleaner and then going back to a broom. He had a way of leaving those little drawings at my place on the kitchen table, so I'd discover them later in the day.

There's one titled "He can read, but he can't spell." That one shows me reading the morning paper, with the cat perched on my shoulder, just as if he were reading the paper, too. One afternoon I had let the cat out just as Christian came home, and I spotted a baby rabbit hopping around, right where the cat would be. I shrieked, "Christian—call the cat and get him in—I see a R-A-B-B-I-T out there!"

Christian really guffawed over that. He scooped up the cat and pointed out that maybe the cat could read, but he certainly couldn't spell.

The next morning the cartoon was beside my breakfast plate on the table.

Another cartoon is titled "Mama didn't think she'd look like this." One morning I was sitting in my favorite chair reading the script for

144

a "Playmakers" play, feeling somewhat like Ethel Barrymore. Christian was sitting opposite me, and suddenly he picked up his sketchpad and said, "Don't move, honey. I want to make a sketch of you. You look just like you did when I fell in love with you."

I expected something pretty romantic and glamorous in that sketch, but it turned out to be a marvelous cartoon. There I was, hair in curlers, in my old housecoat, curled up in that chair and looking just like I really did, not at all like Ethel Barrymore.

Charlotte said Christian often was the "straight man" for her impromptu comedy lines on many occasions. One evening they were going out to the president's reception, a major annual fall event at the college. Charlotte was dressed in her very best outfit, complete with picture hat and gloves. Mary, then a child of about six, was surprised to see her mother decked out in finery and said so. Christian bowed deeply, complimenting Charlotte on her elegant appearance, whereupon Charlotte replied: "Tomorrow, all those people there tonight will remember me as one classy dame!"

Her husband was noted for his own humorous lines, most of which occurred among friends and family. One of these concerns a discussion of modern art at the Petersen home one evening, during which one enthusiast raved on about the clean, simple, uncluttered drama of a Brancusi sculpture, which was based on a perfectly oval shape. "Brancusi," Christian Petersen observed, "must have produced the same artistic perfection that comes from a hen."

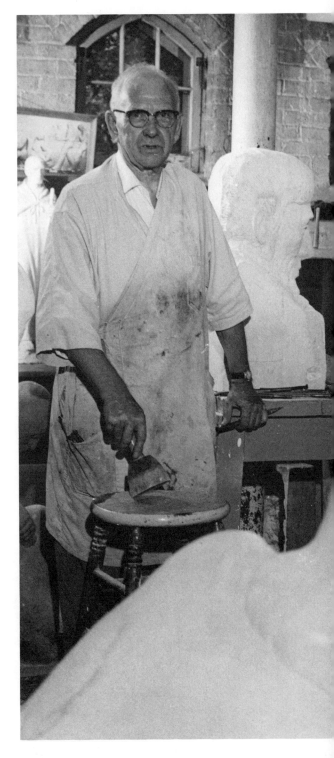

CHRISTIAN PETERSEN IN STUDIO. **CGP**

*"He was a thoughtful,
serious man . . ."*

Charlotte Petersen realized that few of her husband's Iowa State colleagues knew him as a man of keen intellect, with a deep sense of empathy and compassion for others. "He was such a good listener," she often pointed out, "that many people who didn't know him well assumed he didn't have much to say." She added: "I'm sure some professors thought that because he worked with his hands, he didn't think for a living. Little did they know."

"He was a thoughtful, serious man. He loved to read good books— the classics and art books, mostly— and would get into discussions with our friends on philosophy, war, the world, everything going on around us."

Many photographs and documents in the Christian Petersen Papers reflect the artist's lifelong inner search for a personal religious commitment. Said Charlotte: "He was the most gentle, the kindest man I ever met. And he was a very sensitive man—he had a deep faith, but didn't know what to do with it. Finally, he outwardly confirmed that faith and he lived happily ever after."

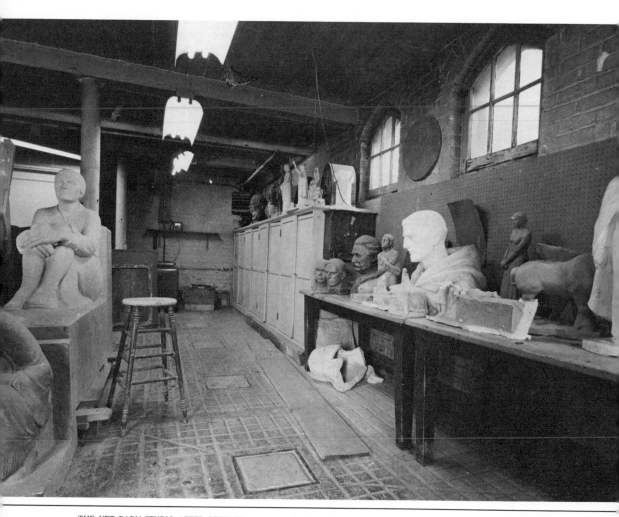

THE VET BARN STUDIO AFTER PETERSEN'S DEATH, 1961. **CPP**

8 Finding Faith in Three Dimensions, *1949*

"Christian was truly a happy man. He had resolved a lifelong struggle."

—CHARLOTTE PETERSEN

CHRISTIAN PETERSEN became a Roman Catholic in 1949, shortly after completing a group of sculptures for St. Cecilia's Catholic Church in Ames. He then went on to create a series of religious theme works, many of which are regarded as the best of his career.

In a letter written in 1949 to Archbishop Henry P. Rohlman of Dubuque, Petersen conveyed his emotions regarding religious conversion and confirmation:

Words are inadequate as an expression of my feelings upon being accepted into your family at the beautiful ceremony in your chapel last Friday evening, at which you administered the sacrament of confirmation on me. I know a great blessing was bestowed—and my prayer is that I may in every way prove worthy thereof.

In 1983 Charlotte Petersen described her husband's lifelong search for faith: "I think Christian had a sense of commitment that he thought about all his life; he struggled with himself over it."

Born into a Danish Lutheran heritage, Petersen had considered re-turning to a denominational religion for many decades, particularly after he married Irish Catholic Charlotte Garvey in 1931.

Charlotte observed that "Christian was a very religious man. But it was more than a faith. It was a reverence toward everything; toward humanity, toward animals, toward growing things around us. And he was a dedicated man. He was what religion should encompass." After their marriage, Christian always attended mass with Charlotte, never outwardly discussing with her—or anyone else—becoming a Catholic. She refrained from suggesting to her husband that he consider conversion, knowing full well he would not respond to such efforts from anyone, not even his devoted wife.

In 1945 he created a small figure of St. Bernadette for Charlotte's church, St. Cecilia, which the Petersens contributed as a gift. The only previous religious sculpture he had created was *Madonna for Charlotte*, a

147

ST. BERNADETTE,
ST. CECILIA CHURCH. **CGP**

black walnut wood figure, eighteen inches high, which he carved as a gift for her at Christmastime about a decade earlier.

When their daughter Mary was ten years old and enrolled at St. Cecilia's parochial school, Christian was commissioned by the parish to design and create a sculpture grouping appropriate for the school setting, to be titled *Madonna of the Schools*. His original concept, as shown in preliminary sketches, centered upon a fountain and portrayed the Holy Mother holding her infant son, looking down upon a group of children who paused during play to pray. One small girl—closely resembling Mary Petersen—kneels in prayer; two young boys put aside their baseball and bat to look upward toward their Saviour.

The fountain and reflecting pool could not be incorporated in the final design, however, for budget and school safety reasons. Ralph and Glenn Netcott, brothers who were St. Cecilia parishioners, were skilled stone and brick masons. They built a brick wall setting for the finished grouping of terra cotta figures, all of which were fired in the campus kiln at Iowa State College during the summer. The sculptures were installed and dedicated in the fall of 1946.

For two decades, the sculpture grouping was lighted at night. Motorists driving on Lincoln Way—then U.S. highway 30—saw the figures as they drove past the corner of Lincoln Way and Elm Avenue, about two miles east of the Iowa State College campustown area.

Some time in the 1970s, however, vandals destroyed the floodlight system and managed to break an arm off one of the boy-child figures. Nuns residing in the convent of St. Cecilia searched for the missing sculpture piece and, fortunately, found it. In 1984, the parish began a fund drive for restoration of the damaged sculpture and refurbishing the terra cotta, which had been eroded by years of weathering. The parishioners of St. Cecilia's planned eventually to relocate the sculptures in a new setting adjacent to their new church building in north Ames, at 30th and Hoover streets.

A local newspaper story told of national publicity regarding Petersen's sculpture for St. Cecilia:

The "Madonna of the Schools," the statuary group erected during the summer on the grounds of St. Cecilia's Catholic church, was featured again this week in two national denominational publications . . . earlier in the sea-

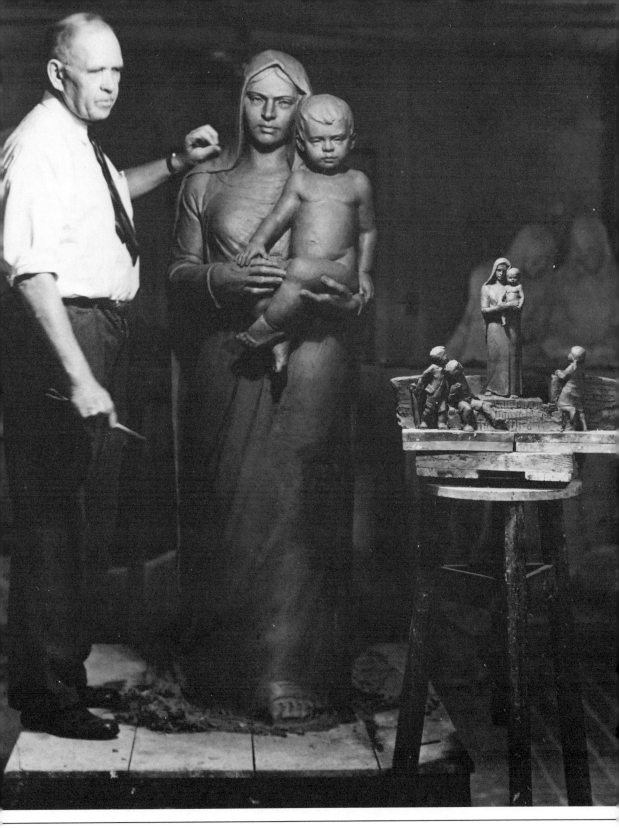

CHRISTIAN PETERSEN WITH FULL-SIZE CLAY VERSION OF ST. CECILIA SCULPTURES. **CGP**

FINDING FAITH IN THREE DIMENSIONS 149

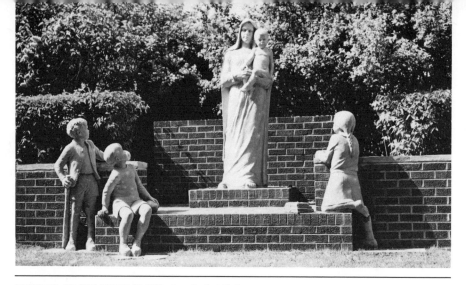

"MADONNA OF THE SCHOOLS." **CGP,** *photo by Fred Sindt.*

son, pictures and stories of the project appeared in all newspapers subscribing to the news service of the National Catholic Welfare conference, Washington, D.C. It is estimated that newspapers and magazines totaling more than 2,000,000 circulation have carried stories and engravings of the Madonna.[1]

The thoughtful study of religious figures and his own confirmation as a Roman Catholic marked the beginning of a series of sculptures that are among his best. Many of them are centered on the figure of Christ—as prophet, priest, king, servant, and saviour. Each of them is of considerable merit from an artistic viewpoint, and certainly of exceptional note as religious theme art.

Figure of Christ, circa 1949

An unfinished plaster cast study of Christ rests in an Ames storage area. Thirty-seven inches high, it depicts a risen Saviour with extended hands. Because the hands have been broken from the fragile plaster, an observer might assume that they were

extended palms down, in a gesture of blessing. Charlotte corrected that impression: "No, that's not how they were . . . you see, he has the whole world in his hands." The model was completed circa 1950.

Christ the King, *for Regis High School, Cedar Rapids*

A regal, ascended Christ in crown and robes is the artist's concept for this forty-eight-inch sculpture, commissioned for Regis High School in 1949. An architect who designed the building project arranged the commission for Petersen, his former sculpture teacher.

Head of Christ, 1950

A magnificent Bedford stone sculpture-in-the-round, twenty inches high, this was carved by Petersen the year after he became a Catholic. A dramatic and strong interpretation, the work has starkly simple lines and a

150

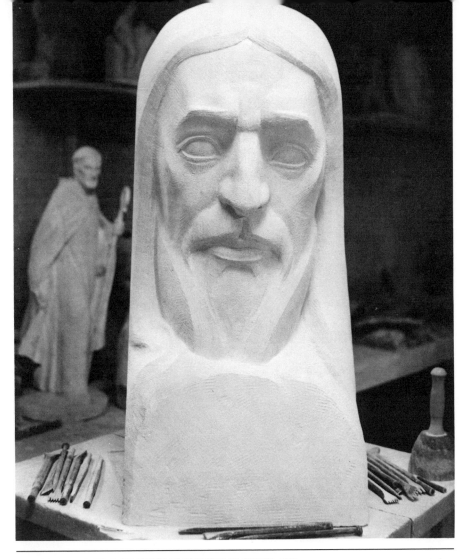

CARVING OF THE HEAD OF CHRIST, IN PROGRESS IN STUDIO. **CGP**

particularly profound treatment of the deep set eyes, which seem to follow the observer across a very wide angle of view.

The piece was purchased by St. Thomas Aquinas Church after Christian Petersen's death in 1961 and installed opposite the altar, centered on a Roman brick wall. It is spotlighted in the sanctuary day and night, a beautifully appropriate setting for what

Charlotte Petersen regarded as "a powerful sculpture, full of the spark of life and faith."

St. Cecilia, *1950*

As a new member of the parish of St. Cecilia, Christian Petersen carved a gift for the church: a Mankato stone bas relief of the patroness

MARKER FOR ST. CECILIA CHURCH. **CGP**

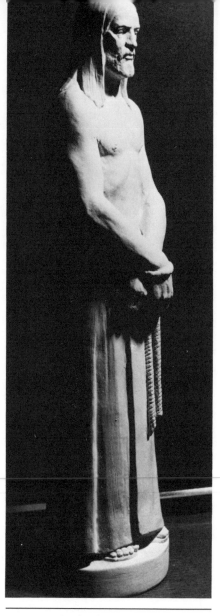

"CHRIST WITH BOUND HANDS." **CPP**

saint of music, St. Cecilia, for an ornamental church sign in 1950. Ralph and Glenn Netcott built an arched and lighted brick and limestone structure to incorporate the church announcement board and Petersen's stone carving. When the parish built a new church in north Ames in the 1970s, the bas relief was moved to a new brick marker wall on the north side of the church property.

Christ with Bound Hands, *1950*

The original terra cotta version of this piece was four feet high and is now owned by a private collector. A smaller version, cast in plaster, was created by the artist as a gift to Archbishop Henry P. Rohlman of Dubuque, who officiated at the confirmation ceremonies in Dubuque for Christian Petersen in 1949.

Thirty inches high, the sculpture portrays the Saviour with bound hands, standing before the court of Pilate. A story by Warren Gore in the Ames *Daily Tribune* on September 29, 1950, explained the artist's concept for this sculpture, which then was in Petersen's quadrangle studio:

152

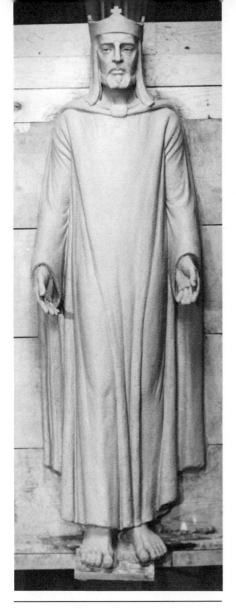

"CHRIST THE KING,"
REGIS HIGH SCHOOL, CEDAR RAPIDS.
CGP, *photo by Jon Morgan.*

Of all the figures in the small room one emerges more than any other because of its quiet intensity. It is a Christ of singular power. It had been in Petersen's mind for some time, and is the expression of a heroic idea in a figure only a few feet tall. But in its small dimension he has packed all the noble suffering as it rises grandly above the world's burden of cruelty imposed upon Christ. The hands have been bound with a rope, the upper body is naked. The face

is, however, "Christ, the judge, not the judged." It is a Christ victorious.

A news release from the Dubuque Diocese in 1950 quoted Petersen: " . . . The Kingship of Christ is timeless; and the opposition to it seems timeless, too. In the statue I have tried to depict the timeless King judging His judges."[2] A small number of plaster reproductions were sold in the 1950s as a fundraising project for St. Thomas Aquinas Church and student center. The last copy of the sculpture is in storage in Ames.

St. Francis Xavier, *1950*

One of the largest sculptures ever created by the artist—a heroic twenty feet high—is a dynamic terra cotta figure of St. Francis Xavier. The work was commissioned by St. Francis Xavier Church in Dyersville, Iowa, in 1950 as part of the celebration for the designation of the church as a minor Basilica by Papal decree from Rome.

St. Francis is personified as a strong, aggressive missionary figure carrying the Gospel, holding aloft the Cross of Christianity. Known as "The Apostle of the Indies," St. Xavier was a Spanish Jesuit missionary in the Far East from 1506 to 1552.

Petersen's artistic concept of the figure was incorporated into the coat-of-arms for the Basilica dedication ceremonies. A model of this sculpture was sold in the 1964 sale of studio works.

A base with three terra cotta bas reliefs completed the work, with the figure measuring slightly less than fourteen feet high. Petersen shaped the clay during the summer, working on

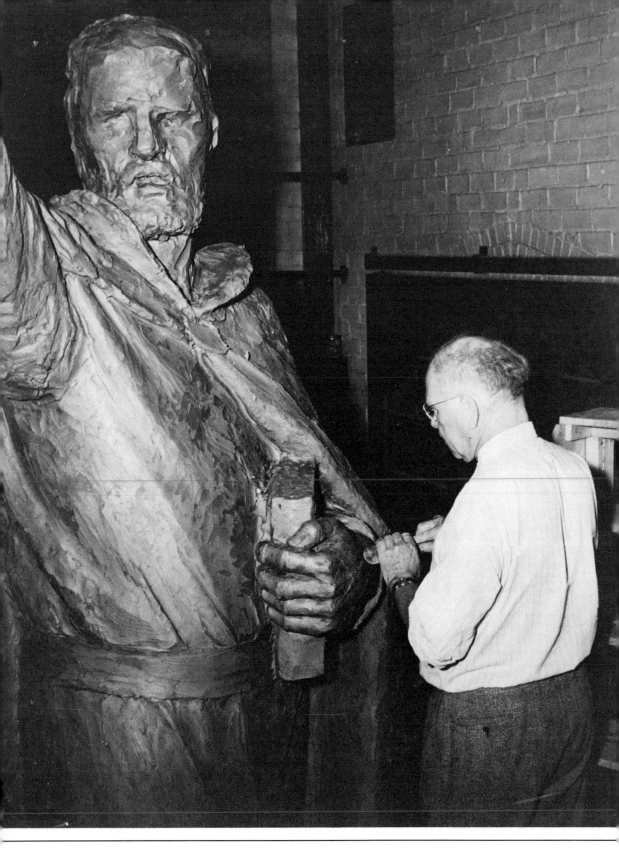

CARVING THE HEROIC CLAY VERSION OF ST. FRANCIS XAVIER. **CPP,** *photo by Charles Benn.*

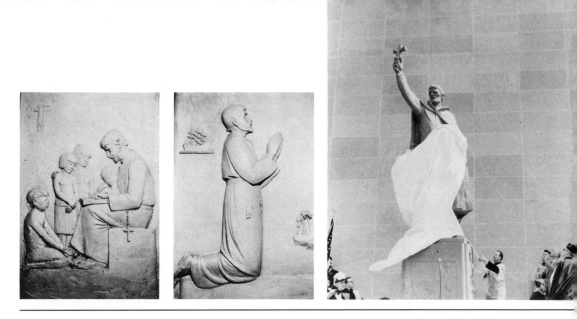

BAS RELIEF FOR BASE OF "ST. FRANCIS XAVIER."
CPP, *photo by Charles Benn.*

UNVEILING OF THE TERRA COTTA FIGURE
OF "ST. FRANCIS XAVIER," DYERSVILLE.
CPP, *photo by John Raddatz.*

a special stairstep ladder. To a newspaper reporter who came to interview him, the sculptor described the figure of St. Xavier as "my vacation project." The terra cotta sections were prepared from the clay version of the figure and shipped to Chicago for firing at a commercial kiln there.

St. Bernard of Clairvaux, *1951*

Christian Petersen created several models and preliminary studies for a heroic figure of St. Bernard of Clairvaux, a Bedford stone sculpture commissioned for the site of a proposed Mt. St. Bernard Seminary in Dubuque in 1950.

The sculpture is ten and a half feet high, on a five-foot base with bas relief panels, located on Carter Road in Dubuque. The work was funded by gifts from Iowa parochial school children of the Dubuque diocese.

Again, this is a strong and aggressive figure, a tribute to a tireless priest who brought the Gospel to

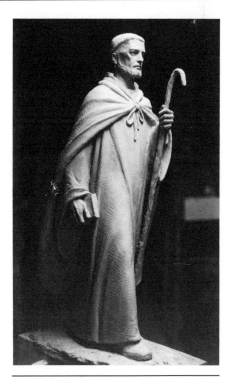

ST. BERNARD OF CLAIRVAUX,
CLAY MODEL. **CPP,** *photo by Charles Benn.*

France in the tenth century. Saint Bernard strides forward, carrying his shepherd's-crook staff, the Gospel in hand.

Petersen sculptured the twelve-ton block of stone outside his veterinary quadrangle studio, since the piece was too large to place inside. The ten-foot finished figure was transported to Dubuque by special truck convoy; the artist personally supervised exact placement of the sculpture by installing blocks of ice under the statue and gradually lowering the massive stone piece as the ice melted, until it was precisely positioned on the concrete base.

A thirty-nine-inch preliminary plaster model of the work and a handsome plaster-cast bust study of Saint Bernard—a heroic-size piece, approximately two feet high, wide, and deep—are stored in Ames.

Small studio pieces in Petersen's religious works

Christian Petersen carved a number of small studio pieces with religious themes in the years from 1949 until his death in 1961. Many of these were Petersen family gifts to St. Cecilia's parish.

MARY, JOSEPH, AND THE BOY JESUS. The artist designed two terra cotta sculptures for the new St. Cecilia's convent chapel, built in 1950. One portrays Joseph as a carpenter, with mallet and chisel; the other is Mary with Jesus at about the age of eight. Charlotte explains that Christian "thought it was important for the St. Cecilia's schoolchildren to realize that Jesus was a very real little child, like them."

MADONNA AND CHILD. In 1951 Petersen presented as a gift to St. Cecilia's elementary school a small sculpture in plaster portraying Mary and a ten-year-old Jesus, again an effort to relate the children's lives to that of Christ as a child.

PIUS X. This is a plaster sculpture of the Pope who was the spiritual leader of the world's Catholics during Charlotte Petersen's teens. Petersen carved the piece circa 1948 as a gift to St. Cecilia Church.

ST. CHRISTOPER. This work was listed "not for sale" in the 1964 inventory. It was a bas relief, approximately twelve inches in diameter, and may have been reserved as a gift from Charlotte Petersen to friends who organized the sale of studio works in her behalf.

CRUCIFIX. One of the sculptor's few wood carvings, this was a gift to the men of Phi Kappa Theta Catholic social fraternity, of which Petersen was an honorary member. Charlotte served as housemother for the fraternity in the mid-1960s.

HEAD OF CHRIST. A rapidly modeled clay study, this piece resulted from a sculpture demonstration by Petersen at the Newman Club Catholic student center in St. Thomas Aquinas Church of Ames. The sculptor presented the piece to the organization.

Finding faith in three dimensions

Petersen was a deeply pensive man who had great empathy for others. All his sculptural works reflect the character of a humane individual who took a special interest in the aged, the weak or handicapped, the victims of suffering, and innocent children.

Perhaps the best illustration of his quietly altruistic and humanitarian inner nature is a letter thanking the sculptor for his twice-a-week volunteer trips to Smouse Opportunity School in Des Moines, where he taught clay modeling to retarded and handicapped children for two years. Until Charlotte came across the letter of thanks from school officials in 1961, she was totally unaware that her husband had served the volunteer role. He had explained his regular trips to Des Moines as "art lessons for young people."

When Petersen became a Catholic in 1949, a news release was issued by the Dubuque Diocese, in which Petersen said: "I had long been in the position of a man looking in a window—

seeing my family and my friends in the glow of a great love and wanting to join them, and yet not knowing how until the light of Grace dawned in my soul. Those who have been Catholics from infancy can scarcely realize the convert's peace and joy after his first Confession and Holy Communion."[3]

After his conversion to Catholicism at the age of sixty-four, Christian embarked on the series of religious theme sculptures. The culmination of his life and his career came in 1961, with a heroic work demonstrating his faith and life philosophy. It became a fitting memorial to the sculptor who created it: *A Dedication to the Future*.

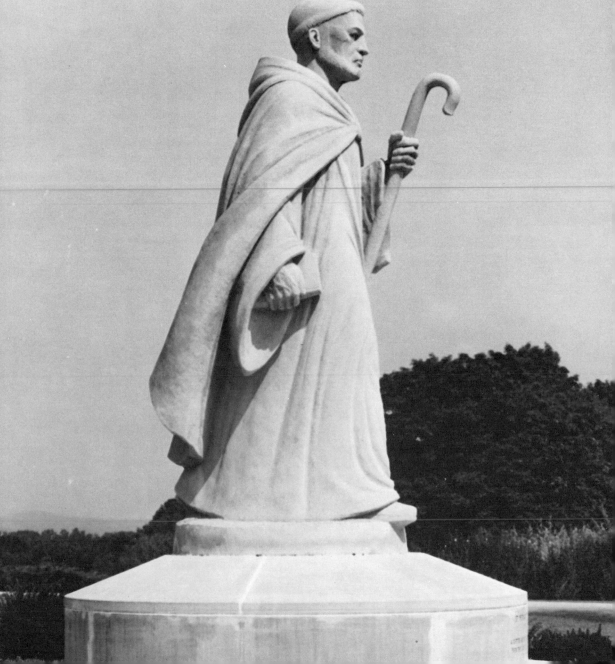

9 A Dedication to the Future, 1961

*This generation . . . lifts the younger to the light,
where he can see what we no longer can."*

—CHRISTIAN PETERSEN

CHRISTIAN PETERSEN died in 1961 just after completing the last of his more than 300 (known) works. *A Dedication to the Future* portrays a heroic bronze father holding high his infant son, who reaches eagerly for the sky with arms joyously outstretched.

The sculpture was commissioned in 1959 by J. W. ("Bill") Fisher, Marshalltown industrialist and chairman of the Fisher Foundation of Marshalltown, as the focal point for a fountain and small lake at the main entrance to the art gallery, classrooms, theater, and community activity areas of the Fisher Community Center.

After *A Dedication to the Future* a number of notable sculptures and paintings were commissioned by J. W. Fisher or selected by him and purchased by the Fisher Foundation for the Community Center gallery. The sculpture collection includes: *Four Seasons,* a bronze by Georges Oudot in 1969; *History of Drama,* a marble relief by Leonard DeLonga in 1969;

Les Tetes Hurlantes, a bronze by Antoine Bourdelle (1861–1929); *Rebecca at the Well,* a marble by Raphael Romenillii; and *Horse,* a bronze by Iowa artist Ray Frederick. In 1968 Fisher's sister, Martha Ellen Fisher Tye, presented *Pomone,* a bronze by Raoul de Gontat Biron, to the Fisher Center theater named in her honor.

Two early Petersen sculptures, *Mountain Mother* and *War* (the latter also known as *After the Blitz-War)* were purchased for the permanent collection of the Central Iowa Art Association gallery located in the Fisher Center in late 1961, shortly after the sculptor died.

Mountain Mother is a charming eighteen-inch Bedford stone sculpture of a mother and her three small children: one a babe-in-arms and two clinging to her long skirt. It was purchased by Petersen's students at the Central Iowa Art Association. The piece was inspired by the Petersens' trip through flood-ravaged Kentucky in 1938 and was based on one of

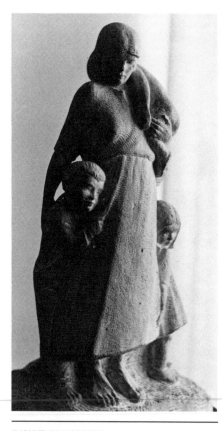

"MOUNTAIN MOTHER,"
CENTRAL IOWA ART ASSOCIATION. **SVO**

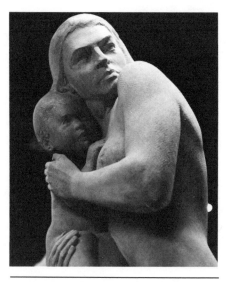

"AFTER THE BLITZ-WAR."
CGP, *photo by George Christensen.*

Christian's many sketches of hill country people who were refugees from floodwaters.

War is another refugee concept; it is based on the terrors of Adolph Hitler's blitzkrieg through Europe in 1939 and 1940. The Bedford stone piece was a gift to the Fisher Community Center from Martha Ellen Fisher Tye in late 1961 and depicts a mother shielding her infant from the onslaught of civilian terror. The piece was done at about the same time as *Old Woman in Prayer,* a Bedford stone sculpture owned by Iowa State University that is also based on the war theme.

In 1984 Patrick Gillam, director of the Central Iowa Art Association, wrote of these two sculptures in an excellent 1984 brochure featuring Petersen's works and including descriptions of other sculptures at the Fisher Center gallery: "Both works are typical of Petersen's oeuvre: compassion carved from Bedford limestone. He lived and died as he worked, extracting tenderness and courage from stone and clay."

A dream commission for a sculptor, 1959

Bill Fisher, having been a student at Iowa State during the early years of Petersen's career there and an active alumnus during following decades, was well aware of the sculptural landmarks created by the artist-in-residence.

After his mandatory retirement in

1955 at the age of seventy, Petersen taught sculpture classes for two years at the Central Iowa Art Association studios. When he was commissioned to model a bust and a bronze medallion of Mr. Fisher in 1958, the two men spent considerable time together in portrait sessions, enjoying lively conversations about world art as well as American and regional art. They became good friends.

Fisher was impressed with Petersen's craftsmanship, artistic integrity, and creative talents. They began discussing the idea of a major bronze sculpture for the Fisher Community Center, then in the stages of architectural design.

In 1959, Petersen was retained by Bill Fisher to plan a sculpture. It was an opportunity to design a heroic work without limitations on size or concept. Charlotte Petersen recalled, "Bill Fisher gave Christian plenty of room to think and plan for the sculpture. It was a dream come true for Christian. And it gave him great joy."

For the first—and only—time in his life, Christian Petersen was commissioned to create a heroic sculpture in bronze, the classic medium demanding the best skills of artist and foundrymen. For decades, Petersen had carved clay studio pieces, most of them in preliminary small-scale versions, with the hope of eventually producing at least some of them as full-size bronzes.

But the necessary funds or commissions for costly bronzes never materialized during the Depression years, the subsequent era of wartime metal scarcity, or the postwar industrial demands on foundries. Bronze was not a financially feasible medium for a midwestern college sculptor, nor

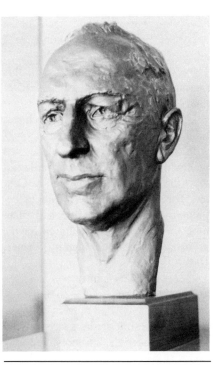

J. W. "BILL" FISHER, MARSHALLTOWN. **SVO**

was it popular among artists of the modern genre, who preferred concrete, steel, aluminum, the new synthetic material called "plastic," or even scrap metal.

Dedication, then, was Petersen's one lifetime opportunity to create a traditionally classic, major sculpture in bronze without severe budget and esthetic limitations. Such a commission is the dream of all sculptors.

The development of an artistic concept

Bill Fisher wrote his friend in September 1959: "We thoroughly enjoyed the stimulating conversation Sunday evening, and I really do be-

lieve we are on the right track for an important new piece of sculpture. I enclose your pencil sketches. . . . They look just as good to me this morning as they did Sunday evening."[1]

Fisher sent a copy of the architectural drawings to Petersen in October, with this message: "Chris, enclosed you will find the print and scale for the little lake at the Community Center. This will be, surely, a proper beginning for your dreaming and planning for an important sculpture for the grounds of our community center. Have fun."[2]

Never in his career had Petersen been honored with such a commission. It came as a belated reward for decades of makeshift studio space, lack of funds for materials and tools, and long hours at night or on weekends laboring on private portrait commissions. For the first time in his life, Christian Petersen had a wide-open invitation to produce his best, extended by an art patron who was noted for his ability to judge and demand excellence in all art media.

Shortly after the letter came from Bill Fisher, Petersen, at the age of seventy-four, was felled by a heart attack. The long and arduous years of hand-chiseling Bedford stone—gruelling physical work—had taken their toll on his physique. "He was determined to get well," Charlotte recalled, "because he wanted so much to do that sculpture."

Christian's slow recuperative process was followed by an acute skin rash and the loss of thirty-five pounds. He kept busy with his sketchbook, however, and in late summer of 1960 was nearing his final theme concept for the Fisher Center work. A year's delay had permitted a profusion of ideas to enter his mind, but he had rejected all of them except one, which he believed would be perfect. He created a small model and submitted it to Bill Fisher, who enthusiastically approved the idea. The contract was signed in the fall of 1960.

Petersen developed the sculpture of the father and son as symbolism of a dynamic gesture of powerful parental love. It also expressed his own deep concern for humanity and the future of all the world's children. In a handwritten letter to George Nerney in late October 1960, he told his longtime friend the news about his major commission:

Dear Friend George—

It is long since I have written to you and I hope you will forgive me for not answering your last letter—A year ago they had me in hospital—heart—but it was followed by an acute case of psoriasis which kept me hospitalized another eight weeks—I am gradually regaining my strength—asked doctor the cause—he said nervous exhaustion. Have lost about thirty-five pounds—am what you might call slender—well anyway by the Grace of God I am still here—

It may be that dormant period has helped—got me out of the rut of thinking—I have finally hit upon an idea for the fountain—and have the signed contract. I am starting construction of the armature and have lined up a part time helper to do the heavy work. [Sketch] This may give you an idea of the design—the theme I have tried to convey—is that this generation lifts the younger to the light where he can see what we no longer can.

It is good to get back to work again but they are keeping tabs on me. They will no longer allow me to work til midnight or so.

This piece is to be cast in bronze and mounted on stone—possibly granite base, with

162

water jets surrounding it. [Sketch] This may give you an idea. I hope this will find you and yours in good health—and with all good wishes

<div align="center">

your friend,
Christian[3]

</div>

In a later letter to Nerney he reiterated his symbolic intent:

> I feel that this piece . . . is one of the most important pieces I have ever done. I have carried out an idea . . . an eight-foot figure there, holding aloft a child. I want to symbolize this generation helping the next generation to see beyond what we have been able to see . . . so the child is looking into the future, having a little more light.[4]

In November, the seventy-five-year-old sculptor again became ill shortly after beginning work on the armature supports for the clay version of the sculpture. He was hospitalized, this time with a diagnosis of incurable and inoperable cancer.

Nevertheless, when three tons of moist Iowa clay arrived in a high-ceilinged loft area of the old Botany building on January 4, Petersen went to work on the sculpture. University officials had arranged a special workspace for him that would allow scaffolding to be built above and around the fifteen-foot-high sculpture.

One of the most amazing accomplishments of his sculpture career took place over the next eight weeks. He finished modeling the figures in late March, despite two weeks of hospitalization for palliative surgery in February. Although he was able to work for only three or four hours daily, Petersen made every minute count.

Charlotte Petersen recalled that Bernard ("Barney") Slater, professor

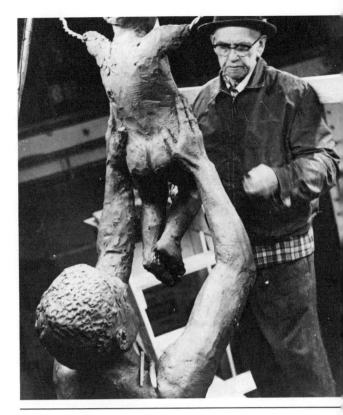

AT WORK ON "DEDICATION TO THE FUTURE."
CPP, *photo by Tom Emmerson.*

of architecture and longtime friend of the Petersens, hired student helpers to lift heavy tools and clay. Slater also arranged for special scaffolding to be built and moved upward every night, with solid guard rails enabling the sculptor to steady himself while he worked.

Petersen hoisted himself to the top of the scaffolding every day using only his powerful arms and chest. His legs were too weak to climb the ladders. Once on the scaffolding, he steadied himself by leaning one arm on a guard rail and working with the other arm.

Few people were aware of the extraordinary courage and tenacity the sculptor found within himself as he struggled to finish the work. Those who did know about his dogged determination now remember a magnificent personal effort and a poignant, well-deserved triumph for an extraordinary man.

A Dedication to the Future became the one exception to Petersen's artistic credo of never being satisfied with past or present accomplishments. For years, whenever interviewers asked what he regarded as his best work, he routinely replied, "I haven't done it yet."

But he regarded *Dedication* as the best work of his career, and he quietly acknowledged it to be so.

The symbolism in Dedication

The father and son figures undoubtedly reflect Petersen's love for two daughters and a son born of his first marriage in Attleboro, Massachusetts, and for Charlotte and Christian's only child, Mary Charlotte. The sculpture perhaps also memorializes the stillborn son he and Charlotte mourned in 1934, shortly after they came to Iowa State College.

In its placid setting, the sculpture demonstrates the artist's keen appreciation for the esthetic relationship between architecture and sculpture. In his youth he had studied the basics of architecture at the Newark Technical and Fine Arts School, and he had once dreamed of becoming an architect.

During his entire sculpture career, Petersen often filled his sketchbooks with fountain designs he envisioned for parks, outdoor gardens, or as part of the settings for churches and public buildings. His first midwestern sculpture was *Fountain of the Blue Herons,* for the A. E. Staley Company in Decatur, Illinois. His last sculpture, *A Dedication to the Future,* was also to be a fountain design.

Among his works at Iowa State were four graceful fountain sculptures: the quietly elegant dairy industry bas reliefs and reflecting pool; the beautiful nude sculpture fountain at Roberts Hall; the charming home economics *Marriage Ring* with its captivating children, and the eloquent Memorial Union *Fountain of the Four Seasons.*

The artist had prepared himself over a lifetime for his last sculpture assignment: a fountain centered in a small lake as the focal point for the Fisher Center. He did not live long enough to see the completed sculpture, which is unquestionably the best work of his career.

On Palm Sunday he attended church with Charlotte, intending to be the guest of honor at a showing of his sculptures in the Gilbert school during the afternoon. By then, however, he was too ill to appear there. Friends provided the commentary on the exhibit.

In a hospital bed on Good Friday he signed his work with a bold script after inspecting the last molds for bronze castings and pronouncing them acceptable. He died four days later, on April 4, 1961.

A Dedication to the Future was cast in a New York foundry that summer and unveiled at the Fisher Center in September. Charlotte Petersen was the honored guest.

The printed program for that occasion concluded:

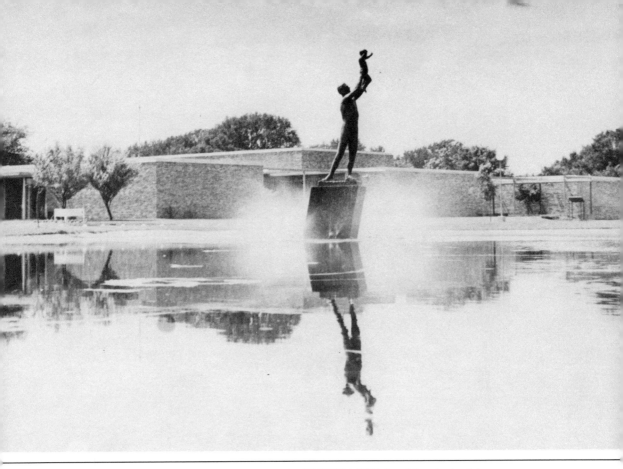

"DEDICATION TO THE FUTURE," CENTRAL IOWA ART ASSOCIATION. **CONT** *Central Iowa Art Association.*

Petersen had said that this was his most important piece of sculpture and now it will stand, not only as a dedication to the future, but as Marshalltown's memorial to its creator.[5]

Requiem and eulogy for an artist, teacher, friend

The eulogy for Christian Petersen by Rev. Fr. William Clarke included this message:

By many it is as a teacher that he will be remembered best, but "teacher" seems such a feeble word. Were his classes only sessions in which he taught the techniques of a sculptor, he would more than have earned his stipend, but they were so much more. Many times it has been my privilege to watch and listen as his masterful thumb would add meaning to a student's efforts and his great heart spoke, quietly dispensing his inimitable philosophy of living.

A chronicler of his times, with a timelessness of his own, Christian wrote with hammer and chisel. His great love of children only reflected his childlike character that kept him eternally young. . . . His eloquence will continue to inspire and teach long after those of us who were privileged to know and love him will have gone.[6]

Christian Petersen's grave, in a quiet little cemetery in Gilbert, Iowa, is not marked with a customary granite monument. "After all," said Charlotte Petersen in 1984, "every sculpture he ever did is a better memorial to the man who gave us so much of himself."

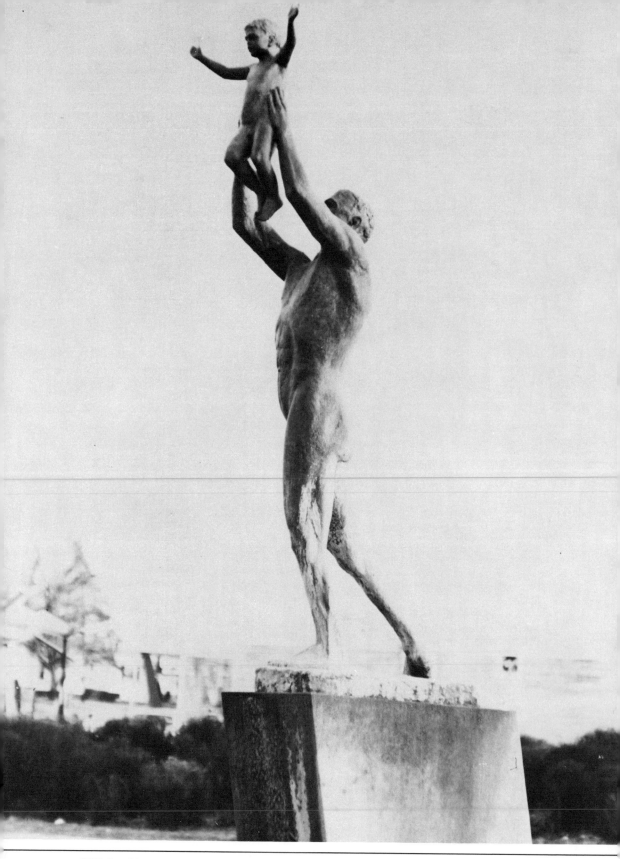

10 The Christian Petersen Papers: A Retrospective

"I have a small bronze bear which you made for Yellowstone Park."

—GEORGE NERNEY, in a letter to Christian Petersen in 1942

IN 1972, with the help of her friend Beverly Gilbert Bole of Des Moines, Charlotte Petersen contributed a gift of documents, papers, photographs, and memorabilia to the Iowa State University library, a collection which is now known as "The Christian Petersen Papers."

The papers, which occupy sixteen boxes, represent glimpses of the artist's long life and career. Among the stored items is a beautiful six-inch bronze bear sculpture, which the artist created for Yellowstone National Park during the 1920s. Aside from mention of the bronze in a letter from George Nerney in 1942, nothing more is known about it.

In a restricted-access storage area of the special collections department are rows of shelved pasteboard boxes of documents contributed by such persons as former Iowa State faculty members, a state senator, a governor who became a United States senator, a newspaper editor, industrialists, scientists, writers, an aviator, an aero-nautical engineer, a wildlife biologist, and a painter.

Some are well known nationally, other names would be recognized only by colleagues in various fields of science or technology. In each case, papers and memorabilia were contributed to the university as a research resource on past lives, eras, and achievements in Iowa and the world.

The papers include evaluations of Petersen's sculptural works by East Coast art critics, midwestern writers, and his colleagues. The papers also reveal a treasure trove of unpublished writings by the artist, in which he considers his own role in an emerging American art of the 1930s.

Stanley Yates, director of special collections for the library, wrote Charlotte Petersen in 1973:

I am pleased to enclose a copy of the information about your husband's papers which will appear in the next edition (1973) of the National Union Catalog of Manuscript Collections published by the Library of Congress in Washington, D.C. This publication is distri-

buted throughout the world and is used by scholars seeking original sources for their research.[1]

The papers were inventoried and catalogued in 1970 by Isabelle Matterson, who was then manuscript curator and who is particularly knowledgeable about Christian Petersen's career. A longtime resident of Ames, she was well acquainted with Christian and Charlotte and is the widow of Clarence Matterson, who was chairman of the history department for many years.

The documents provide a panoply of records from the artist's career. Each scrawled note, once-treasured photograph, yellowed newspaper clipping, handwritten letter, small sketch, and artifact of bronze, plaster, or copper represents a significant moment in the artist's lifetime.

The Christian Petersen Papers afford an exceptional view of a difficult era in American art and public education: the Great Depression years. Christian Petersen's twenty-one-year career at Iowa State and his thirty-two-year span as a sculptor parallel the lives and times of many Americans who struggled, as he did, in a difficult time.

His life story epitomizes the lives of other dedicated college teachers, other artists, and other middle-Americans who pursued the American dream in the first half of this century. All of them left their own heritage of memories to loved ones, colleagues, neighbors, or acquaintances, but very few left behind the documentary evidence of their lives that is found in Petersen's papers.

His contemporaries can also be remembered through his sculptural accomplishments—the more than three hundred landmark and portrait sculptural images of America over a sixty-year period, from 1901 to 1961.

An overview

Although many of the documents in the collection are referred to elsewhere in this volume, an overview of the quality and scope of the papers may be helpful.

In one box of documents is a delightful handwritten manuscript by J. C. Cunningham, an unfinished essay on the artist's life and career as of the mid-1930s. Cunningham's high personal regard for Christian Petersen is reflected in his enthusiastic essay, a loyal and heartfelt tribute to a close friend and colleague.[2]

Programs for sculpture exhibitions at Younker's gallery, 1933; the Memorial Union, 1942; at the Gilbert (Iowa) public school, 1961; the Iowa State University library in 1972; the Brunnier Museum and Gallery, 1976; and the Mason City (Iowa) public library in 1958 list dozens of Petersen's works that are now owned by private collectors.[3]

Petersen usually handwrote his messages, and Charlotte later typed them. Some letters illustrate Charlotte and Christian's constant search for private sculpture commissions to augment his Iowa State College income and expand his sculpture reputation nationally.

Newspaper clippings from the artist's early career in the East, as well as his Iowa years, reveal the scope and acceptance of his work on the East Coast, both in die cutting and in sculpture.

Among the filed publications

about the artist, two items were added to the collection in 1986 as another contribution from Charlotte Petersen: *Holiday* magazine for October 1956, which included a photograph of Petersen, and a color photograph of the dairy industry bas reliefs that appeared in a story on Iowa in the *National Geographic* magazine in October 1939.

An eighty-four page paperbound pictorial memorial to Christian Petersen, by Geraldine Wilson, published in 1962 by Iowa State University Press is included in the file. The booklet has been out of print since 1964. Wilson wrote:

. . . Petersen's legacy goes farther than self-revelation. His work bypasses the purely personal to speak a universal message. Across the barriers of language the artist speaks in archetypal forms. Petersen tried to do this in many of his works and he believed his final triumph lay in his final work. It was a source of great satisfaction to him that his last sculpture, completed with much pain, prayer, and effort, conveyed an inspired message directed to all men. Thus is an artist's work impressed on the world after he is gone.

. . . Though Petersen's work was known throughout the country, its greatest impact was in the Midwest he loved, the Midwest that was kin to his Scandinavian heritage rooted in the land. Here he focused his talents and energies for twenty-eight years, and here, in the state he adopted, his gifts will long be remembered.[4]

Two issues of the *Iowan* magazine carried extensive feature stories on the artist. One in March 1954, by Earl R. Minser and Ray Murray, was a thoughtful essay on the importance of Petersen's landmark sculptures at Iowa State. (See Chapter 11 for quotations from this article.) Another story by Bernice Burns (June-July 1961), then a journalism faculty

member at Iowa State College, tells of the artist's last sculpture, *Dedication to the Future,* for the Fisher Community Center in Marshalltown, Iowa.

A regional view of the importance of Petersen's sculpture career in the Midwest was recorded by James Denney in a photo essay that appeared in the Omaha *World Herald* July 7, 1968. Denney wrote of the works Petersen created at Iowa State:

It's been said that the work of the late Christian Petersen, a longtime Iowa State University sculptor and teacher, reflected his loves and strengths, his sentiment and humanness.

A stroll across the campus of ISU—one of the most attractive in the Midlands—shows that sculptor Petersen loved Iowa State.

Iowa Agriculturist, the official publication of ISU's College of Agriculture, recently observed: "Christian Petersen will never be forgotten. His numerous works, scattered inside buildings and out, have made this one-thousand acre campus an art showcase."

It might be added that the entire State of Iowa is an art masterpiece because Mr. Petersen's work can be found in Des Moines, Marshalltown, Iowa City, Ventura and many other locales.

The George Nerney letters

The best continuity regarding Petersen's career is provided by dozens of letters from his friend George Nerney of Attleboro, Massachusetts.

The letters, some dating from the 1920s, present a chronological record of Nerney's persistent efforts to encourage his sculptor friend and to further Petersen's career in myriad ways. Charlotte recounts that her husband "was not the best in writing letters to anyone," a fact that is reflected in Nerney's plaintive but restrained reminders to Petersen that he would like to hear from him occasionally. "I am

also writing this in the hope that some day the spirit may move you to even send a postcard telling me that you are alive and well and that you do have some chance to work on the things which I know are so close to your heart."[5]

Nerney wrote voluminously and periodically to Petersen, often suggesting possible sculpture commissions (George Washington Carver, for example) or the need for more publicity about the sculptor's work. Charles Rogers, a journalism professor, worked closely with Nerney by correspondence over a number of years, judging from several Nerney letters emphasizing the importance of good stories in newspapers and magazines and urging Christian's cooperation with Rogers's efforts to publicize his work.

Christian Petersen was always reluctant to seek publicity for himself or his work because he abhorred the overpublicized sculptures emanating from many prestigious East Coast galleries. Consequently, his efforts to avoid "puffery" probably served to minimize legitimate publicity about his own accomplishments. For example, he usually failed to return routine questionnaires from artist directories published by regional or national art associations. And he was difficult to interview, being such a good listener that he often ended up listening, not talking, when an interviewer came to do a story for a newspaper or magazine.

Discovery of eleven
N. C. Wyeth paintings

In 1971, while the papers were being inventoried, ISU officials puz-

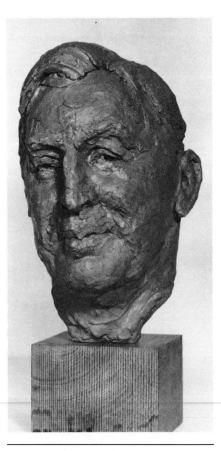

GEORGE NERNEY, PETERSEN'S LIFELONG FRIEND. **CGP**

zled over notations on a routine college art committee report that Charlotte Petersen had saved for twenty-five years.[6] The report mentioned twelve original paintings, completed in 1939 by American artist N. C. Wyeth, and presented as a gift in 1945 to the college from the John Morrell Company of Ottumwa, Iowa. The paintings, which could not be located in 1971, had been commissioned by Morrell for an art calendar; they were valued at $600 each in 1945. Apparently they had never been inventoried

by the college and had been forgotten by 1971. A search of university campus building attics, storage spaces, and cubbyholes went on for months. Eleven of the twelve paintings were eventually discovered in a wall cavity of a storage closet in the president's office in Beardshear Hall. The series is now regularly featured as a major part of the university art collection at the Brunnier Museum and Gallery. The subjects are Coronado, The Mayflower Compact, Jacques Marquette, Benjamin Franklin, Thomas Jefferson, George Washington at Yorktown, Captain John Paul Jones, Lewis and Clark, Covered Wagons, Sam Houston, and Abraham Lincoln.

The twelfth painting, of Daniel Boone, was missing from the collection. The Brunnier valued each painting at $140,000 in 1983, or $1,440,000 for the collection of eleven Wyeth originals.[7] Charlotte Petersen commented with laughter in 1983, "That made the Christian Petersen Papers worth a million and a half dollars to the university."

Photographs

Photographs from the sculptor's lifetime are stored in several boxes. The earliest of them is a picture of the Petersen family home, a large two-story farmhouse in Dybbol, Denmark. A photograph of Christian and George Nerney in a New York bar is an amusing portrait of two young men-about-town in about 1907.

A number of photographs of Petersen's sculptures and die cut medallions from his eastern career furnished valuable documentary data on size, location, and form. Several of these photographs, however, must remain a mystery. One is of a sculptured medallion of President Woodrow Wilson, labeled with his name and the artist's mark clearly visible on the medal, but no other information is noted. The same is true of a photo of a medallion of General John Pershing.

Also in this category are excellent photographs of a set of sterling silver spoons designed by George Nerney, with die work by Christian Petersen, circa 1925. The finely detailed spoons feature openwork designs, front and back, for a series of Americana subjects, including various states, locales, flora and fauna, and national heroes Daniel Boone and General Andrew Jackson.

Perhaps the most touching photographs in the collection were ones taken by a university photographer in 1961 after Christian Petersen's death. His empty studio, with vacant workbenches and neatly swept floors, marks the absence of the man who worked there for more than twenty-three years. Petersen's studio pieces and tools lie where he left them, undisturbed.

These pictures were a valuable aid for identifying a number of studio sculptures that were sold in 1964 or have been in storage since then. The charm of the primitive studio, with its concrete and ceramic tile floors, was captured on film exactly as it appeared, except for the uncustomary neatness of the floors. The sturdy workbenches and shelves built by the sculptor are bathed in west sunlight from the old wooden-framed windows. Many of the students years later remembered the studio with warm nostalgia.

DRAWINGS FOR "CHA-KI-SHI." **CPP**

The area has been remodeled for office space in the College of Education at Iowa State. A brick outside wall was preserved and is the only remaining evidence of the original studio.

Sketches

Charlotte Petersen often remarked that her husband did beautiful sketches, which most people never saw. An astonishing array of superb drawings in pencil, pen and ink, pastels, and colored pencils is reposited in the Petersen Papers. Pages from the artist's sketchbooks include original drawings for the dairy industry, Memorial Union, home economics, veterinary, library *Boy and Girl*, and *Conversations* sculptures at Iowa State.

172

Perhaps the most interesting aspect of these is that the finished sculptures so often closely resembled the original drawings for them, even when the sketches were tiny preliminary ones. The dairy "cartoons" or drawings were done in Iowa City, in Grant Wood's federal art workshop. They are a precisely scaled miniature plan for the bas relief designs.

Many beautiful sketches from the Petersens' trip through Kentucky and Mississippi in 1938 demonstrate the artist's ability to capture the essence of a subject in a rapid sketch. He later transformed many of these into studio sculptures during the next several years.

Drawings for *Cha-Ki-Shi,* a children's schoolbook illustrated by Petersen and published by Scribner's in 1936, are exquisitely detailed in color, a series of preliminary and final sketches of the lifestyle and tribal symbols of the Mesquakie Indians in Tama, Iowa. A copy of the book is included in the collection. The library staff bulletin (1974) commented on the importance of his work for the textbook:

Christian Petersen, Iowa State's famed sculptor-in-residence and faculty member from 1937 to 1961, was particularly interested in the Indians of Iowa. The Sac and Fox tribes occupied the territory which is now Iowa, and the Mesquakie people, as they designate themselves, presently residing in Tama County have brought much to the development of the state. In the mid-'30s, Petersen did the illustration for a school text about the life and culture of the early Mesquakie. The book, entitled "Cha-Ki-Shi," was published in 1936 by Charles Scribner, and is in the Library's collections.
During the past year Iowa State's Cooperative Extension Service developed a slide program on Indian heritage as part of the renewed interest and attention to Iowa's Indian past. Depicting the early days of the Mesquakie in the program are several drawings by Christian Petersen, photographed from the originals in the Library's department of special collections. . . .

The Peterson originals, numbering approximately 50 sketches and pencil drawings, some in full color, are in excellent condition and depict the everyday life of the Mesquakie of the period, roughly the mid-1800's. Male and female figures, groups engaged in agriculture, cooking and traveling, home life, amulets, jewelry and common utensils, clothing, shelter and culture are all richly and painstakingly created in Peterson's fine detail . . . these sketches and drawings have seldom, if ever, been seen by a wider audience.[8]

Family sketches and memorabilia

Small pen-and-ink sketches of Charlotte Petersen and Mary, many of them with a cartoon-style punchline, occasionally show a profile of Christian. He seldom included his own image in a sketch, however. The only known caricature, an excellent likeness, that he did of himself was a quickly done profile in pastels.

In 1939 Christian and Charlotte put together a charming booklet for a Christmas greeting. Charlotte wrote a poem for each page and Christian illustrated them. Called *Hello Beautiful,* the little booklet portrays Mary Petersen at intervals of her day, age three. One sketch of the family in the car, driving through the countryside, is based on this poem by Charlotte:

> You wanted a penny
> When there were so many
> Lovely things to see.
>
> Why,
> You did not even hear
> The cheerful little note
> From the meadowlark's throat;
> Nor see
> The corn as it peeped thru
> And waved 'hello' to you,
> Nor the turkey gobbler

Strut and spread his wings.
No,
You did not see these things.

You wanted a penny
When there were so many
Lovely things to see.

Oh, Mary!
Only grown-ups do that.

The sketch boxes include several delightful linoleum block-printed Christmas greetings from the Petersens as well as the only known copper plate etchings he ever did. Among the latter are Mary's birth announcement in November 1936, and a beautiful portrait of her at about the age of nine.

Artifacts

Several small castings or dies represent the earliest work of the artist. One is a plaster plaque of Samuel F. B. Morse, inventor of the telegraph. Another is a medallion of Captain Arthur Henry Rostom of the *Titanic,* a British registry passenger ship sunk in 1912. It was probably created for the Robins Company in Attleboro, Massachusetts.

Another piece is a plaster plaque of Nikh-Diphn, Greek goddess of victory. This may well be Christian Petersen's earliest bas relief, perhaps created while he was a student at the technical and art school in Newark, New Jersey.

That night you cried in your sleep,
"Home—when going"?
You touched and pulled our heart strings
You, not knowing;
But had we had Pegasus
With his wings
We would have taken you to
Your toy-things.

10

And now that you know
The gay, golden grass
In the silver vase
Is really just
An old hay bouquet
In a pewter pot,
I'm eager to see
Which one of the two
It will be to you.

11

TWO PAGES FROM "HELLO, BEAUTIFUL." **CPP**

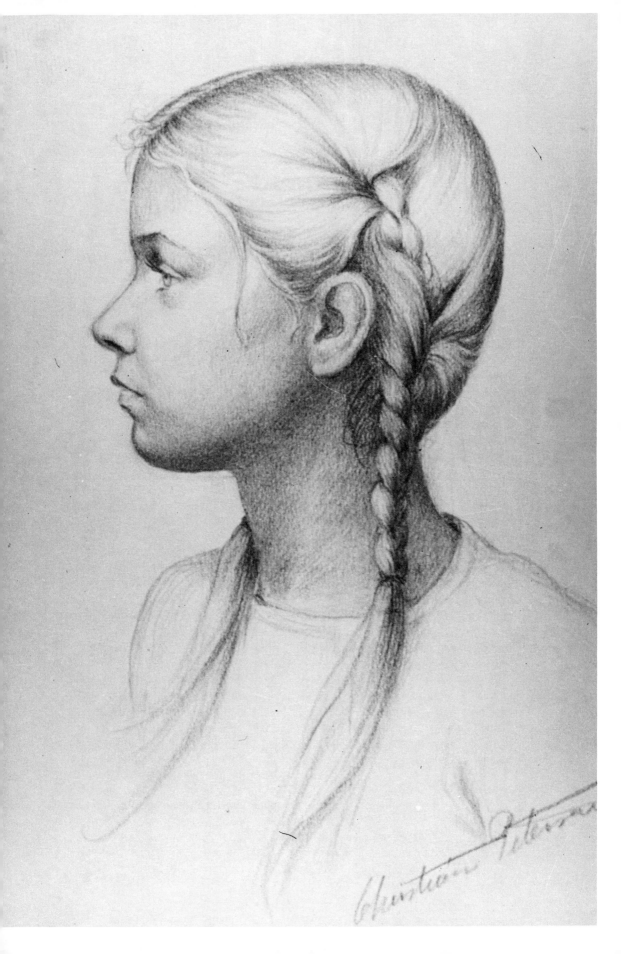

A medal memorializing George Endicott Osgood (George Nerney's father-in-law) and the "hub" or negative steel piece used to strike the medallion were contributed by Helen Nerney Shaw, daughter of George Nerney, in 1972.

Unpublished writings

By far the most notable documents in the papers are Petersen's writings, many of them handwritten. In these are explanations of his sculpture philosophy and techniques; the importance of art in the everyday lives of individuals; his abhorrence of modern art; his belief in craftsmanship in every art form, and his own criteria for excellence in the visual arts.

Many of these are simple notations that Charlotte often found and saved. "He always carried a small pocket notebook and jotted down an idea or did a quick sketch."

A series of preliminary and revised scripts for Christian's lectures on art appreciation in the early stages of his Iowa State College career demonstrate his earnest, thoughtful approach to art and sculpture. Charlotte's original shorthand notes and several typed revisions (with Christian's added notations) furnish an insight on Petersen's views of art in America in the 1930s. Much of what the artist said then would certainly be applicable to art in the mid-1980s, particularly his comments about critics and "isms" in art, and his own philosophy regarding quality in sculpture.

Excerpts from Lectures on Art, 1934 – 1935

The sculptor's art

I have been asked to talk on the sculptor's art.

What is sculpture, and what is art? President Hughes once made the remark, "I wish we could get to know you fellows—we might get somewhere."

And, now that I have been asked to talk about sculptor's art, I am going to try to make plain to you that we artists are just like you are. We are doing our work in our way, just as you are doing yours in your way. Your work calls for one type of expression, and ours for another. Our work, it is true, has been somewhat shrouded in mystery, but after all, there is no mystery to it.

It is just the same as yours—it is just plain hard work. But we love it.

Sculpturing is one of the most exacting of the arts. She is one of the most demanding of mistresses and a jealous one. If you will, think of the sculptor as a working individual, and not—as a great many believe—as someone who sits around or plays around, waiting for an inspiration, then works an hour or two at fever heat, then relaxes for another indefinite period until the spirit moves again.

The best way for a sculptor to get inspiration is to take up his clay, for he is an individual who does have to work at a high pitch, and that high pitch must be maintained through a long period of hard work, really phys-

ical work as well as mental.

So what is sculpture?

It is form. It should be solid, not airy or frivolous. It is worked in a hard, unyielding material. You can't make air of it, nor can you make light of it. You cannot violate the integrity of your material and have a good sculpture. You must keep within the limits of your medium; you cannot paint with stone or bronze.

Sculpture is a solid, dynamic art. It should give one the feeling of force, not the feeling of something resulting from force. It should be the symbol of life itself.

The greater your love of art, the greater will be the art you leave to posterity. It is the reason for Florentine art being as great as it is. Ours can be even greater, and it will be. Perhaps not in our lifetime, but in the period which we represent.

Who is the sculptor?

His first training, of course, has been to learn to draw. Having learned to express himself in this medium, he is given clay, that he may learn to think in the third dimension and become familiar with form. His hands must be trained to carry out his thoughts in clay.

I had a studio in a studio building in Boston. It was not necessary for the sculptors to have signs on their doors. You could tell their studios by the plaster tracks that led to those doors. I always at least made a practice of smiling at the janitor, to keep him in good humor.

A sculptor at work cannot disguise himself as any other sort of artist: he is branded as a sculptor and cannot be mistaken for anything else. So you should look for a sculptor that is actually working. Don't look for one in a silk smock and velvet beret. You are more likely to find him in overalls or something of that sort, and you'll be fortunate if you can recognize his features behind the daubs of plaster.

And—unless he has had a recent urge to clean house—you will find everything in sort of a greyish color, the result of plaster and dust, not a studio hung with fine draperies and tea being served.

Instead, there will be workbenches around, revolving stands—each with its own little model—sketches, pieces nearing completion (some large, some small), scaffolding, plaster casts, probably buckets of water, and tools everywhere.

It is easy to find the piece a sculptor has been working on most recently, for there you will find the most dirt on the floor.

Creating a sculpture

Now, supposing this sculptor has just received a commission. Let's watch him go through with it.

First, you will find him setting up his drawing board. He has his idea of what he is going to do, but to help him line up his composition, he makes pencil or charcoal sketches—any number of them, from all angles. Some of them may be only a few lines, but they all grow toward the ultimate composition, for as you know, a piece of sculpture, unlike a painting, must be composed from every angle.

These drawings serve as notes from which are worked the clay

sketches. In his training, the sculptor must first learn to draw—and draw accurately and fluently. He should have a talent and a love for his work. Sculpture is a good deal like the sea—a hard mistress with the true sculptor as with the true sailor. She demands constant application and hard physical work as well. Once you have professed your love for her, you will never relinquish her.

His next step is to compose with clay. That is, first carry out his arrangement of masses, treating them only as related masses. This also is done repeatedly, since one arrangement generally suggests another. These are generally carried out on a small scale, say one inch to the foot, or something smaller.

Finally, he feels he has arrived as nearly as he can to the composition wanted. Now, with this determined, he makes his working model, and the working model is the desired design carried out on a larger scale, with detailed studies of the figure or figures. He works out what would be a three-foot figure. This is worked out very carefully.

In short, he must carry the model as far as the final piece. The object of this is obvious, when one considers the work involved in changing composition or detail. Even a change in the armature would mean doing the whole thing over.

A work of sculpture should be carefully planned, as an architect would plan a building. The "armature" is the support skeleton for a sculpture, to support the clay in the same manner as the skeleton supports the body. The armature is built as simply as possible, usually with one main support carrying all the weight. For some larger pieces, support is built much as a carpenter prepares a wall for supporting the load of a building structure.

When using plastiline, a rather expensive material, a framework is built large enough so that there will be room left to apply from two to four inches of clay. When regular clay is used (it is not so expensive), we construct one main support, either an iron pipe or a piece of iron forged to the shape wanted, with cross sections of wood or iron bolted in the desired spaces.

From these are suspended what is termed "butterflies," which are merely cross pieces of wood, different sizes fastened together with wire and suspended where they will do the most good. The object of the "butterflies" is to support the masses of clay, to keep them from sagging. The importance of these little gadgets may be illustrated: students building a fairly large statue asked me about supporting the clay. I showed and explained how to use plenty of butterflies, and where to use them. They apparently thought I either didn't know or was having a game with them.

The next morning they concluded I must have been right. The poor chap's head and chest had slipped down to somewhere around his middle.

A sculptor—a working sculptor, and not one of these so-called "exhibiting" sculptors (for there is a world of difference between the two)—must have a rather thorough knowlege of the principles, at least, of architecture. A work of sculpture has to be planned, as you would plan a building. It would be just as foolish to attempt a heroic piece of sculpture without a plan as it would be to start

ENGINEERING DRAWINGS FOR "CONVERSATIONS." **CPP**

a building without working out your plans in advance.

Maetterlinck said, "Sculpture should be the most exceptional of the arts. It should eternalize only the rarest and most absolutely beautiful moments of life, choosing with irreproachable discrimination from the forms, the joys and the sorrows of humanity. A sculptored moment which is not admirable is a permanent crime—a persistent and inexcusable obsession."

So when you approach a piece of sculpture, you should demand just that. Do not be fooled by tricks, for many artists behave in strange ways, with no other object than to attract your attention. Nor should you be swayed by mediocrities or professional critics.

We want art here in America that shall be second to none—we can and we will—but you must help. You must demand the best that any artist can give. You must demand absolute honestly and sincerity in the artist and in yourself.

Say you like a piece because you

like it, not because it is done by someone who has been exploited by others. Don't be concerned with this technique or that technique. Ask yourself, "Is it good? Is it honest? Does it give me anything?" You will be surprised how much of our so-called modern art you will discard.

The human form and human emotions you must all recognize, although in some of the work you have seen is the product of neurotics who have not the insight, let alone the stability to produce a work of art. They have learned a few rudiments of the artist's craft, and usually are too lazy to carry through the careful workmanship which should be second nature to every artist.

Demand the best an artist has—and then demand he do even better. In this, I mean that an artist must never lose the feeling that he has done his best—and he would like to do better.

Perfection should always be hidden in the next block of stone.

The enjoyment of sculpture

Why should you like sculpture?

Why should you — or why shouldn't you?

Who am I to tell you what you should and should not like? Perhaps you don't like olives, or perhaps—as with myself—you don't especially like ice cream. My wife does, and she cannot understand how I can refuse a dish.

Ice cream is good. Olives are good. So is sculpture—each in their own way. So perhaps if I give you a little taste of sculpture, some who have had no taste for it may acquire it, and sculpture (as well as painting or music) is really worth knowing for its own sake.

Craftsmanship in all art forms

Does a piece of sculpture represent a thought, or merely a display of technical skill? Reason and thought are necessary for intense concentration and long application to the creation of finished and well thought-out work.

To paint with paint, or model with clay, or carve in stone does not necessarily constitute being an artist. Painting, modeling, and carving are necessary for the artist to know, as unconsciously as he knows his alphabet and the formation of words.

But words do not make literature, nor clay nor paint make art. The writer or painter merely uses these tools, but real media for all ideas is thought, ideas thought through carefully, thoroughly, even to the point of obsession. This automatically excludes the poseurs—and there are plenty of them—who have no more use for the arts than as a medium to direct attention to themselves.

Many of them are good craftsmen—or technicians—but can not forget self-love long enough to thoroughly think through an idea. Ability as an artist—I mean technical ability—should of course be demanded.

The man who sets himself apart and then calls himself an artist frustrates himself. He must first learn to love people—to think with them—before he can even begin to create a work of art.

True artists are human, only

more so than others.

Personally, I have every confidence that we shall develop a true American art. But first you must gain enough confidence in your own judgement of the subject. People are prone to attach too much importance on art, or not enough. If you would consider art as you would any other activity and demand the same of it, you would soon have it as part of your everyday life.

The uniqueness of sculpture

Sculpture, perhaps more than any of the so-called fine arts, requires cultivation. It is not so easily displayed as paintings, primarily due to its bulk and prohibitive cost of shipping, even in the smaller pieces. So one will largely have to go to the piece of sculpture, rather than have it come to you.

Most sculpture is designed to fit a certain space, be part of a building or a spot in a garden, and there obviously is the best place for all to see it. I don't mean some of those atrocities called "soldier's monuments" dumped about the country in different towns by the ton.

The use of sculpture as decoration—especially with architecture—has been practiced from time immemorial. The cave dwellers carved their walls, probably not so much with the idea of decorating their homes as to record some event of prowess performed by one of their tribe. But whatever their reason, the result was a decoration to the beholder. It must have promoted thought, thus stimulating cultural growth of the people.

The same is true now.

Architects of today are using sculpture more and more. Some of the most important sculptures of the past are those which have been created as a part of some building, for instance, the Parthenon. It was the result of a perfect unity of effort between architects and sculptors, a perfect expression of the time.

So let us think forward, more than backward: what shall the archeologist of another era find here?

Sculpture in the Midwest during the past century

To speak of plastic art of the past century in Iowa, a land so young it has barely begun to creep, is rather difficult when viewed from the standpoint of the artist. However, as the land has been claimed and made to yield the things needed to sustain life, and later profit, the people have found they have gradually acquired some leisure, and with that leisure, a desire to beautify their surroundings.

With the desire to beautify goes the desire to record the experiences of outstanding importance in the development of the land, as well as the urge to capture in some permanent form the beauty one may see in the things which form part of everyday life.

This land, of which the main occupation is agriculture, has a beauty all its own: its far horizons, with fields of corn and grazing herds, where one—with a little imagination—can see the wagon trains of the pioneers, moving westward. From such beauty, it would be strange if some artists did not feel the urge to capture some of this.

So perhaps a man sitting on a

fence, whittling a stick, may feel the urge to express some thought or feeling of the story and beauty around him. Should it happen that this man had listeners, he would probably go right on whittling and express his ideas through the spoken word.

But, fortunately, some of the whittlers had no audience, so keeping on with their whittling, some form eventually crept out of the wood, perhaps just a crude semblance of some object or event which may have impressed him during the day.

As the desire to express experiences or ideas in durable material grew, the need to learn increased. Some went to schools in the east, some went to foreign lands to study art, taking with them the rich background of their early life. Some became sculptors, some good, some bad. But the pity—in most cases—is that they stayed too long in foreign lands, apparently being submerged in the influence of some fad of these so-called "art centers."

Instead of learning the techniques of their trade and using it to express the experiences and ideals of their own folks, these artists have become mere imitators, wearing themselves out and eventually losing the spark which sent them forth, confusing themselves and others with this "ism" or that "ism."

Yet others, stronger and with a brighter flame, have not forgotten and have returned to their native soil some beautiful work, a glory to them and to the land.

One of the finest influences in the field of sculpture, not only here in Iowa, but the whole midwestern area as well, has been the late Lorado Taft, whose constant pleading for good and sound sculpture, together with the work from his hands and those of his pupils, has gone far to giving sculpture the foothold and respect it merits.

One of the most widely known of Taft's works is the colossal statue of Black Hawk, the Sac and Fox chieftain, whose story is part of the history of Iowa. It is placed in a magnificent setting on the shore of the Rock River, near Oregon, Illinois. Anyone having seen this statue, especially in the light of the rising sun or late in the afternoon, when the rays of the setting sun spread a glow over the entire statue, has the feeling almost as though the spirit of the old chieftain had paused there again to view his beloved hunting ground.

Artists of different natures naturally saw differently the phases of life around them, some interpreting the heroic moments, others the more intimate little things of life. Thus we have Gutzon Borglum, the carver of Dakota mountains, who was a native of Idaho. Whether you approve or not of mountain carving, Mr. Borglum has done some great work, and his sculptural recordings of American life and thought will be among the high spots of sculpture, not only of this country, but of the world.

It is fitting that a woman should be the one to interpret a great moment in history, the attainment of woman suffrage, which Nellie Walker (a Taft pupil and a native Iowan, having been born at Red Oak) has commemorated in a bronze relief at the State House in Des Moines. She is represented at Iowa State College on the facade of the library in two stone reliefs, and at Keokuk, Iowa, where she has placed a statue of Chief Keokuk.

These are sculptors who pursued their art at a time when there was not much more encouragement than their own unquenchable flame, the spirit of the pioneer carried over into the field of art. To them, we owe a debt. Even as we owe their forefathers for pioneering this great land, so we owe them for their pioneering in the field of beauty.

The sacrifices and labors of these inspired few are beginning to be rewarded. Our schools and colleges are taking up the work of encouraging and teaching those who feel the urge to record the beauty they see—and what an endless array of beauty there is.

Commentary on Grant Wood

The transcription of an interview with Christian Petersen focusing on the work of Grant Wood is one of the many mysteries among documents in the collection. Although the typewritten transcript carries penciled notations by Petersen, it does not identify the year or the interview. Probably the most valid assumption is that it was broadcast on WOI radio, sometime after Wood's death in 1942, perhaps as part of a memorial program for the famed Iowa painter.

Petersen never commented publicly on Grant Wood's work while Wood was living. This interview resulted in the only recorded statements the sculptor ever made about the man who brought him to Iowa to join the federal PWA art project in Iowa City.

[Concerning Wood's painting "Woman with Plants"] It seems to me that this picture has been painted directly from Wood's heart. Grant did not always sympathize with some of his other subjects, but I think that when he did the picture of his mother, he experienced a very real emotion which he managed to get on canvas.

. . . I don't believe Wood thought of himself as a satirist. I think that he was a completely sincere artist who was gifted with a sly sense of humor which sometimes verged on satire. His humorous mood, I believe, is well illustrated in "The Daughters of the American Revolution" picture. Fundamentally Wood was very conscientious and honest about his work. He seemed to delight especially in working out the tiny details in a picture.

Wood's earliest work was done in the broad, rather splashy style of the time. For some reason, he began to find that style not very well suited to his ideas and ambitions as a painter. He apparently made up his mind to get away from the conventional method of painting, and in so doing he went almost to the other extreme. The painting of his mother was probably his first step away from his old style of work; and the one which is farthest from the conventional style was, in my opinion, the landscape of Hoover's birthplace. This latter picture is almost completely stylized. There, Wood has made the whole picture purely a pattern. This technique created so much attention and fuss that he has done a number of other works in that mood. I think some of his later works have shown a trend toward the general notion of true painting, but the picture of Hoover's birthplace was done purely in the decorative manner.

I remember very distinctly when he was working on the "Dinner for Threshers" he called my attention to a detail in the painting of which he seemed very proud. The picture, as you remember, shows both a dining room with a long table, about which the threshers are seated, and a kitchen in the farm house. Near the stove in the kitchen Wood had painted a box of matches in an old fashioned match holder. He had painted each match separately. Wood called my attention especially to the fact that, aside from painting each individual match, he had painted an accurate picture of the head of each one, and finally he had put a little red dot on the tip of each head!

Another illustration of attention to detail may be seen in his last painting, "Spring in Town," a reproduction of which is on the cover of the current . . . [penciled notation unclear] . . . count the blades of grass and feel the mesh on the screen door. It is practically common knowledge by now that Grant was quite meticulous about the details of dress and farm equipment and the like which he included in some of his pictures. The fact that he had copied the woman's dress and the man's overalls in "American Gothic" from a Sears and Roebuck catalog was highly publicized at the time the picture was issued. As a matter of fact, the Sears and Roebuck catalog was almost Grant's Bible of information on details of a farm picture. He had a collection of these catalogs which ran back to about 1890, and he was constantly consulting them on some point or another. I think that illustrates pretty well the precise way in which he worked.

[Question regarding Wood's in-fluence on his students and other young artists] I think that all students reflect more or less the style and personality of the painter under whom they studied. Wood's style was distinctive and one very easy to imitate, so I expect that it has been imitated more than usual. I don't think the influence is a good one. It seems to me that any painter, in the long run, must work out a style which is adapted to himself and the subjects in which he is interested. I don't believe Grant willfully imposed his methods on his students—it was just his intense desire to help . . . I have noticed that some of the young artists who studied under Wood at one time and imitated him are now beginning to get away from his influence and to work out their own method of painting.

[Question regarding the audience for whom Wood painted; whether they were the very few who could afford to buy his work or a wider group] It is almost impossible for me to give an answer to that question. I have never heard Grant discuss that subject directly, but I think that if he was influenced by either group, it was probably the larger one.

[Question regarding Wood's complete change of painting style after his return from Europe] I expect that you can only account for such a change by seeing Wood as a shy personality, looking for inspiration abroad and not finding it, not feeling himself a part of the life which went on around him—and then coming back to the land and the folks he knew. Certainly Grant felt himself an integral and accepted part of Iowa life, particularly farm life. Consequently, he was able

to express in painting the people he knew so intimately. I think this remarkable change in Wood's style of painting is an excellent illustration of the way in which a man can adequately interpret only those things which are genuinely part of his life.

Comparisons of Art Media

Sculpture compared with painting

Following is Christian Petersen's comparison between the craftsmanship of painting and sculpture, a particularly informative explanation of the important fundamentals of each.

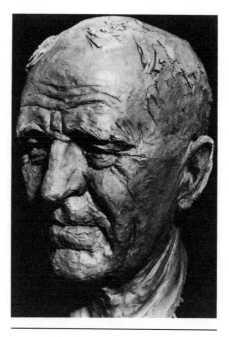

J. C. CUNNINGHAM. **CPP**

Few people realize the vast differences between the task of the artist who paints and the artist who works in clay. They know, of course, that the painter has color and the sculptor does not; they know that the painter works in two dimensions, the sculptor in three. But few analyze the significance of these differences to the tasks of the artists.

Few notice that the painter makes use of many extraneous details in the telling of his story—often depending upon them, rather than the central figure, for the portrayal of time, character, and feeling. And still fewer appreciate the task of the sculptor, who cannot make use of any of these extraneous details.

For example, the painter may show the time of day by adding a clock or by the cast of a shadow; or he may show the time of day or year through the choice of color alone. He

may build environment about his character—a room, chairs, curtains. He may show gayety or drabness, joyousness or misery by the choice of characteristic surroundings or suggestive hues. To appreciate the value of surrounding detail to the painter, lift from nearly any picture the central figure; place it alone, without background or frame, on the wall; and the feeling, the sensitiveness, the art of the piece is lost. Even in portrait painting, this is usually true. And in the portraying of the humanities, it is very nearly universally true.

But the sculptor must do without these aids to the imagination. He cannot depend on extraneous detail. He uses no frame, no background, no environmental trimmings. He cannot show season or hour, gayety or sor-

row, heat or cold with color. He cannot model snow or rain, light or dark. He can only suggest these things through line and form, through skillful placement of lights and shadows. And he usually works with but a single figure.

Because of these differences, the painter and sculptor never portray a given subject in like manner. For the sculptor's piece must be so fashioned that it at once suggests to the observer all that the painter would supply in bold detail. Painting, therefore, is said to be more complete, more concrete, and less dependent upon the imagination of the observer than is sculpturing.

For, while the painter supplies the details as he sees them, the sculptor must, through the lift of a shoulder, the swing of a head, the twist of a body, or the flow of a line, evoke in the mind of the beholder a series of associations which suggest these details. The two arts have little in common, excepting the common subject of the humanities.

But while it may appear that the sculptor is unfortunately limited in medium, he is very fortunate in quite another way. Life is a series of associations. Man is forever associating new sights with old; he is forever judging, understanding, or appreciating the new in terms of the old. He has learned to interpret certain expressions, certain lines, certain lights and shadows in given ways; and he has learned to subconsciously associate new combinations of these things with environmental settings in which he has found them in the past.

Just as the shrug of a shoulder or the lift of an eyebrow have come to take on certain meaning based on ex-perience with those gestures, the sweep of a line, the balance of mass, and the play of lights and shadows have become meaningful. Reaction to the latter may be less conscious but it is as definite as reaction to the former. Through sight, life has made man a creature of associations.

Because of association, one of the painter's chief handicaps is the use of the very details upon which he must depend. If its color is not what the observer has learned to expect the color should be, if some detail is different from that with which the beholder is familiar, the painting is likely to be criticized. Further, these details usually limit the painting in scope and time. The hour of the day, the time of the year, and even the era in history are made clearly evident.

Painting thus lacks the universality of sculpture. For the sculptor has none of these worries. He merely suggests with lines, lights and shadows; the observer supplies his own details and environment.

Further than this, in life all bodies are in three dimensions. The sculptor is able to show in rounded form what the painter is forced to suggest on flat canvas. As the beholder moves about the sculptor's piece, new associations arise as new lines and angles, new lights and shadows, appear. From every direction, the sculptor is able to add to his composite whole.

Comments on quality in art

To excite comments through the excellence of your work is one thing, and to deliberately do a piece so bad that one cannot ignore it is quite

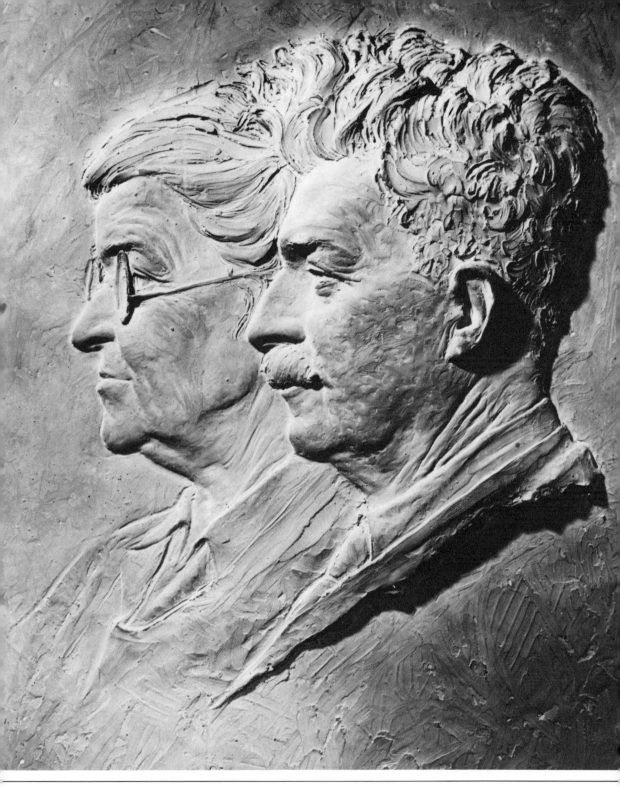

WILLIAM AND ELLA ENRIGHT GARVEY, CHARLOTTE PETERSEN'S PARENTS. **CGP**

another. They are getting away with it simply because people, when it comes to art, are afraid to think for themselves.

* * *

Modern art looks to me like the product of a prolonged childhood. The childish exclamation of "Look, Ma, what I've done" is only natural for any child—but if carried through life, it appears that with some artists the childish effort never does grow.

* * *

An artist is one of you. Very much one of you. He must be in your hearts, and you in his.

* * *

To have beautiful thoughts is to be happy, and I have always found that beautiful objects inspire beautiful thoughts. In this, the artist is privileged that he may create beautiful things. They may be a visualization of your thoughts—or his.

The point is that, by placing his work where it can be seen daily, it will eventually become a part of all who see it.

* * *

While we admit the beauty of Greek myths, we no longer believe them, and, as a result, when we try to use them as symbols, we cannot be sincere. If we can get the lesson of sincerity from them and apply it to art, instead of trying to imitate, we can have a great art.

Some artists have long felt this, but they have tried to force themselves to be different, with the result that we have been subjected to some terrible monstrosities. Some of this has been done with the sole purpose of attracting attention, but then a person walking down main street in his B.V.D.'s with the temperature at zero would also attract attention.

You would surely question his sincerity, not to mention his sanity. If you pay enough attention to him, he will probably do it again. I think the best way to eliminate this type of artist is to ignore him.

* * *

Work done by either incapable or dishonest artists and promoted by certain unscrupulous dealers and professional critics simply to create a passing demand to sell these things (sometimes at fabulous sums), if done in other fields of activity, you would brand them as swindlers. And that is exactly what they are.

* * *

An artist with a foreign accent is immediately hailed and especially welcomed if his work is grotesque. This thought is so instilled in us that we accept it without thought. Among the slides [visual aids for lectures] I have what I call "bad pieces," some of them hideous, that have been exploited by different magazines, galleries, or sales organizations that take an artist and promote him. If he has enough bizarre stuff, they make a "mystic" out of him and give it to you to swallow in the name of art.

The exaggeration of most art today expresses a weakness comparable to the same weakness in expression that causes a man to resort to swearing. It is equally futile.

* * *

The artist may be looked at askance, and, I must confess, some of the artists also look askance at the ones producing the materials of life, when, as a matter of fact, each needs the other.

One of the reasons that I chose to stay at this sort of an institution (Iowa State College, 1935) where they did not have much art as a part of their curriculum is that I figured I could reach people here that I couldn't get to in a university with art courses.

* * *

I have always found the keenest appreciation of my efforts has been by men and women whose work calls for some use of the hands, and this appreciation spurs the artist on to greater effort—and honest effort, not an effort to impress some persons of wealth, perhaps with the aid of some critic or dealer who has no more scruples than the artist.

Aphorisms

In 1983, Charlotte Petersen came across a small tablet notebook her husband carried in his pocket, probably during the 1950s. These are some of the jottings he recorded:

When do you grow old? You are old when you stop growing.

* * *

You find within yourself the resources you need: knowledge, skills, spiritual living.

* * *

Art is a very normal activity of very normal people.

* * *

You can make a living or make life worth living.

Art requires not only eye sight, but insight.

* * *

Art is inspired by something, but not a copy of it.

* * *

Transferring an image draws on knowledge (of the artist) which is far greater than eye sight.

* * *

Who sees? A child sees differently from an adult. Art makes a child sensitive to his own environment.

* * *

Artists use the whole body, mind, spirit to make something beautiful.

* * *

FULL-SCALE PLASTER FIGURES FOR UNION FOUNTAIN, SEED CORN EXHIBITION, ISC ARMORY, 1940. **CPP**

11 Commentary

". . . judge for yourself. Create an American art, here in the Midwest, where America has its roots. Here shall be the soil, and the seed, and the strength of art."

—CHRISTIAN PETERSEN, first faculty lecture, 1934

AS AN artist-in-residence who began his midwestern career on a college campus over fifty years ago, Christian Petersen would be astounded at the sheer quantity of artworks in public places today, particularly at colleges and universities. Much of it has been subsidized by local, state, or federal government funds or commissioned by corporate business in recent years.

His landmark works at Iowa State College in the thirties and forties are singular achievements in American art history because they were not created with government subsidies or grants. Nor were they accomplished with endowments or gifts from alumni or art patrons. They are the results of one dedicated artist's personal efforts.

Petersen's initial Public Works of Art Project assignment in Iowa City marked the beginnings of federal government funding for original artworks in 1934. The success of related programs across the nation has been evaluated in recent years by some art historians, but unfortunately records of such regional programs as the Iowa Public Works of Art Project are lacking; they were sketchy at best, and most of them were destroyed in the haste of terminating federal art programs in the early 1940s.

Petersen was brought to Iowa by the PWAP. His only association with federal sponsorship involved his first work, the dairy courtyard sculptures. Because federal sculpture projects were concentrated mostly in large cities and on both American coasts, Petersen's landmark dairy courtyard and interior sculptures have never been recognized on a national scale as exceptional achievements of the earliest stages of federal art programs.

The dairy and veterinary sculptures are significant landmarks representing the efforts of Petersen, who, along with other American artists, struggled in a shattered economy fifty years ago. Although the brief Public Works of Art Project began a long and productive career for Petersen at Iowa State, no government

190

funding subsidized his work for the next twenty-one years. As a dedicated artist—and with the encouragement of his devoted wife—he created hundreds of works through self-reliance and self-sacrifice, without government or private patronage.

The contrast between American art of that era and of today is dramatic in many ways. Contemporary paintings, mosaics, fibre arts, and sculpture are now part of the everyday surroundings of Americans in schools, public buildings, higher education institutions, and in business districts or corporate centers of many communities.

An American art has indeed escaped the confines of galleries and museums to enrich our lives—as Christian Petersen hoped it would.

Today's public art was only a long-range vision and a personal goal for Christian Petersen at the time he came to Iowa. If he were alive today, the Danish-born sculptor would applaud the vast scope of the National Endowment for the Arts and Humanities and affiliated state arts councils, which fund such programs as artists-in-the-schools, community center art classes for children and adults, and art therapy programs for handicapped, elderly, or institutionalized persons.

He would appreciate the fact that the important relationship between art and architecture has been recognized by law in many states, including Iowa, where half of 1 percent of public building costs must be allocated for purchase of original artworks—preferably by Iowa artists. This Code of Iowa provision was responsible for the purchase of two Petersen sculptures more than twenty years after the art-

ist's death: *Madonna of the Prairie* for the remodeled College of Education in 1980, and *Old Woman in Prayer* for the library addition in 1983.

Fifty years ago federal or state-subsidized art programs had barely begun. Although the Public Works of Art Project and succeeding programs of the 1930s began a trend, it was halted by World War II. Federal art programs were not revived until the early 1960s.

Milestones in regional American art

Petersen personally accomplished many important milestones in widening the enjoyment of art for grassroots Americans. He began sculpture classes for students and art appreciation lectures for the faculty at Iowa State College—a land grant institution that at that time lacked a fine arts department. He taught adults at a community art center in Marshalltown, developed his own art therapy classes for handicapped children of Smouse Opportunity School in Des Moines, and conducted sculpture demonstrations for campus and community groups and Iowa State Fair visitors. All these accomplishments occurred while he was creating a heritage of major sculptures and hundreds of portraits for future generations.

Petersen's dedicated efforts gave central Iowans opportunities to learn about art by observing a working sculptor among them. His multiple accomplishments were not idyllic visions, they were goals reached only through infinite patience, tenacity, and dedication. They resulted from Petersen's own abundant initiative and his

considerable talents for improvising, innovating, and always seeking "perfection hidden in the next block of stone."

Although he and the painters in Grant Wood's federal art workshop were subsidized by the federal government, their salaries were at mere subsistence levels. All of them gave the wealth of their talents creating murals for post offices, schools, and public buildings in the first such program in American history.

Unfortunately, many painters were largely unheralded for many decades. Many WPA murals or easel paintings in the nation were destroyed when the projects were terminated in the late 1940s; some have survived and been rediscovered in recent years. A number of restoration projects in the 1980s were aimed at uncovering WPA murals that had been walled in or painted over in past decades.

Author Richard McKinzie explained in 1973, "Twenty-five years after the WPA, most high schools and universities had lost or destroyed their federal art. Countless murals had disappeared behind institutional green paint while easels went home with bureaucrats, to dank storerooms, or incinerators." McKinzie concluded that a search in the early 1970s "located but a fraction of the mass of WPA art" collected by WPA administrators when the program was terminated in the 1940s.[1]

McKinzie described the tragic disposal of WPA paintings when "a New York City junk dealer had purchased several mildewed bales of canvas—which turned out to be WPA art—for 4 cents a pound in an auction at the federal warehouse in Flushing." In the bales were canvases by painters who were recognized as distinguished American artists. One of them was Jackson Pollock. "Few art historians have shown a special interest in government art projects, and much of what these specialized historians have written centers on the two dozen or so most recognized artists."

Again, it is important to note that sculpture projects in federal programs were concentrated in large cities, mostly on the East and West coasts. Sculpture—because of its inherent scope and cost—was only a small part of subsidized government art programs. Thus Christian Petersen's dairy sculptures represent a rare and surviving art project in a remote locality, a significant artifact of American history.

Sculpture in public places, circa 1980s

As a classic sculptor of his era, Petersen would be amazed at the vast changes in outdoor sculptures commissioned in recent years for schools, colleges, community centers, office buildings, and other public places. Most of the colossal bronze figures of great admirals and generals created for public parks and capitol complexes since the turn of the century still exist. But Petersen would discover a new style of sculpture, which has proliferated across America, crafted in indestructible metal or concrete. Such works are designed for appeal to sight, not human touch, because they must be vandal-proof. Many of today's sculptural pieces, in fact, could tolerate considerable vandalism and remain virtually unscathed. Damage—except for graffiti—would not be noted by a

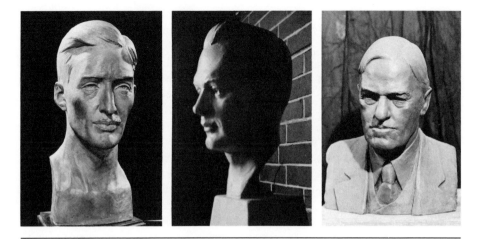

FRANCIS McCRAY
Head, University of
Iowa Art Department, 1934.

BERT ADAMS
Colleague at Iowa City
CWA art workshop, 1934.

FRANK JOHNSON
Portrait painter and
family friend.

casual observer. They are relatively damage-proof and untouchable, because they must be so. But are they beautiful? Are they pleasant and meaningful esthetic experiences?

In some instances, what is now called "sculpture" is not definable as sculpture at all, using Christian Petersen's standards of craftsmanship and artistry:

> WILLIAMSTOWN, MASS. (AP)—The grounds crew at Williams College took a bulldozer to a mound of dirt covered with hay— not knowing the big hump was a work of art.
>
> The work was described by art critic Lucy Pippard in her book on contemporary art as "an earth-covered concrete block chamber" into which one could crawl and experience "the metaphor of a corpse in an ancient tomb."

Other than the dirt-and-hay genre, however, sculpture in the 1980s does offer some innovative forms and media that Petersen would undoubtedly praise: soft three-dimensional works in fibres, well-crafted geometrical forms in acrylics and metals, and finely designed mobiles in colorful or transparent materials designed to float suspended in space. These are contemporary art, but they do not represent the type of modern art the Danish-born sculptor deplored during his own era. The contemporary work he so disliked was what he considered to be shabby in form, concept, execution, and esthetic quality.

His writings give ample evidence that Petersen's criteria for excellence were not confined exclusively to his own choice of media and artistic techniques, however. Petersen was not a narrow-minded, tunnel-visioned artist. He had only two imperatives for any work of art: beauty and craftsmanship. He admired integrity in any art form— but he deplored sham or pretense. He intensely disliked mere technical precision that resulted in ugly forms vaguely suggesting what might be a valid and beautiful concept.

The problems of vandalism and value

What happens when art from the past is neither appreciated nor valued as an irreplaceable heritage?

One of Christian Petersen's sculptures no longer exists. It was destroyed like many of the WPA paintings. His *Fountain of the Blue Herons* was bulldozed in the 1950s to make way for industrial building space in Decatur, Illinois. The work was created for the A. E. Staley Company in 1933. Company officials in 1983 could find no records or photographs of the work.[2]

Vandals broke an arm from one of the *Madonna of the Schools* child figures in the late 1970s, even though the sculpture grouping is located on the busiest crosstown avenue in Ames. The parishioners of St. Cecilia's school and church embarked on a campaign in 1983 to repair the damage and refurbish the weatherbeaten terra cotta surfaces of the figures. They are a particularly beautiful work of religious art. But more than that, they are appreciated and treasured by the people for whom they were created forty years ago.

On the subject of vandalism, Charlotte Petersen explained philosophically, "There's no way to guard a sculpture day and night if someone wants to harm it." And she added, "the problem is that a vandal never learned to love beautiful things, which all children should have the opportu-

VANDALIZED FIGURES, "THE MARRIAGE RING," COLLEGE OF HOME ECONOMICS, ISU, 1983. **AUTH**

nity to do." She always evidenced considerable concern that in future decades some of her husband's outdoor works at Iowa State University would suffer from damage and disrepair and be removed. "I hope they never disappear," she said.

Charlotte was reassured by a story in the May 1984 *Iowa Stater* alumni newsletter by John Anderson:

This spring is the 50th anniversary of Christian Petersen's move to Ames and Iowa State College, without a doubt one of the most significant events in ISU history.

. . . Christian Petersen, who died in 1961, was the famed sculptor-in-residence at Iowa State from 1934 to 1955. His presence had an artistic impact on his campus that remains unparalleled.[3]

Public sculptures that can survive in today's world must withstand the elements—both meteorological and miscreant—to which they are exposed. Thus the beautiful campus works of Christian Petersen are vulnerable artifacts of the past. They were rare art works when they were created, and have become even rarer since. There can be no more like them, ever.

"He left behind a heritage"

What is the esthetic and monetary value today of the sculptural heritage Petersen created? The question may be asked: Is it worth honoring and preserving for future generations?

During a time when sculpture had seemingly become an orphan art, Petersen managed a long and productive career. Most of his more than three hundred works have disappeared from view. Although he lived all his working years in Massachusetts, Il-

linois, and Iowa, his sculptures are now scattered throughout the United States and, perhaps, in several foreign lands as well. Some of them may lie unidentified in dusty storerooms or attics, present owners unaware of who the artist was or, if the work happens to be a portrait, even who the subject was.

At the State Historical Museum in Des Moines, Christian Petersen's bust of Mesquakie Chief Young Bear—believed to be among the museum's collection—could not be found in 1984. Harried museum officials, coping with severe personnel, space, and budget limitations, knew it was somewhere in one of many crowded storerooms.

Petersen's sculptures for public institutions were once known to be located in Massachusetts, Rhode Island, New York, New Jersey, Kentucky, Missouri, Utah, the Philippines, Costa Rica, Denmark, and Mexico. In many instances, sculptures or plaques have disappeared. Unfortunately this has occurred in museums and public buildings where objects of American art have not been carefully inventoried and stored. Custodial care of American art works from the past has been haphazard, at best, in many locales.

Fortunately, all of Petersen's major works are located in Iowa. They can be seen in Dyersville, Dubuque, Mason City, Cedar Rapids, Sioux Center, Ventura, Marshalltown, Des Moines, Gilbert, and Ames. Iowa churches, schools, government and corporate buildings, and Iowa State University possess an unparalleled collection of three-dimensional art representing midwestern history and culture of the 1930s and 1940s, created by a regional sculptor who recorded

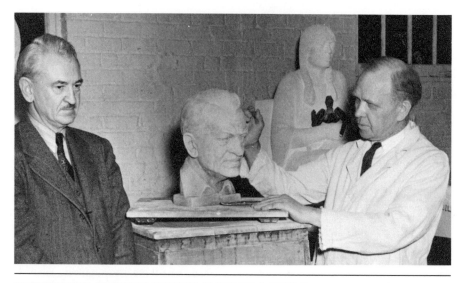

the American scene with artistic integrity and superb craftsmanship.

Landmark sculptures at Iowa State University

The major collection of Petersen's best works is owned by Iowa State University. Each of his sculptures is a one-of-a-kind accomplishment, created despite severe limitations on budgets, materials, and studio space during the Great Depression at a state-supported college. No collection of original sculptures produced at any college or university compares to the quality and scope of Petersen's work at Iowa State.

His campus works were valued at over a quarter of a million dollars in 1954 by writers Earl Minser and Ray Murray in a profile of Christian Petersen published in the *Iowan* magazine.

In a story titled, "He Has Carved a Heritage," they wrote:

Petersen's work at Iowa State has not only helped to grace a beautiful campus, but has also given permanence to the spirit of the farming Midwest. It seems strange to some that this prime interpreter of our Iowa heritage should have been born in Denmark, but then he came from a farming family.

Christian Petersen's compensation does not come from his financial gains. He gets great satisfaction, looking back over the last twenty years, from two different things. He has passed his art on to numerous people in the classroom and has succeeded in dressing up a once-culture-barren campus.

If the value of his contributions to the college could be figured in dollars and cents, their worth would exceed a quarter of a million dollars. The estimate is figured from the average fee of commercial artists.[4]

Transmission magazine, published by the Northern Natural Gas Company in Omaha, Nebraska, lauded

196

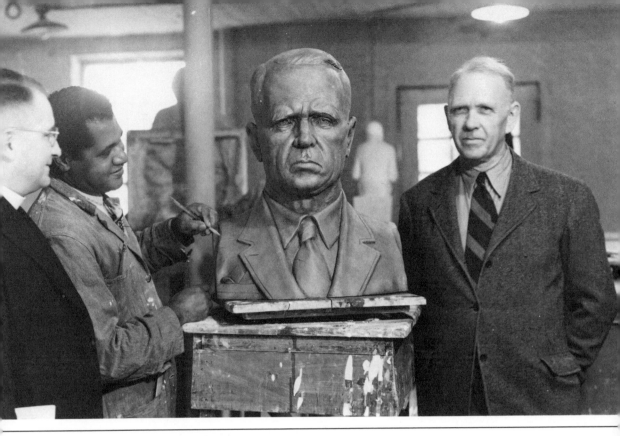

PORTRAIT BUST OF CHRISTIAN PETERSEN AND ITS UNIDENTIFIED
YOUNG SCULPTOR, CIRCA 1950. **CGP**

Christian Petersen:

The hands of Christian Petersen are the tools by which he fashions his dreams. His strong, yet gentle, time-worn fingers have molded and carved a heritage on the campus of Iowa State University that will stand for ages as a memorial to his talent. Examples of his artistic labors abound on the campus where he has spent the last 26 years working to cultivate and foster a cultural environment.

. . . He dedicated himself to nurturing an interest and appreciation in art. Since his retirement as an active teacher in 1955, Petersen has had ample time to reflect on his apparent success at this endeavor. Although financial fortune has escaped him, as is the case with many genuine artists, Petersen says he feels completely gratified in his work because he has succeeded in developing an interest in the arts that was somewhat lacking before he came.[5]

One of the best feature stories ever written about the sculptor appeared in the June 1959 issue of *American Artist* magazine, by artist Frederick Whitaker. He was a contributing editor to the largest circulation magazine for professional artists in America. A working artist and a contemporary of Christian Petersen, Whitaker was an accomplished watercolorist and a member of the American Watercolor Society, as well as a number of art organizations in the Providence, Rhode Island, area. His in-depth story afforded Christian Petersen national recognition for his sculptural accomplishments at Iowa State.

A man with an idea, faith, and the steadfastness with which, unfortunately, nature endows but few, can change the face of his par-

ticular world and leave his impression on it for generations after he has gone.

Christian Petersen, sculptor, is this kind of man; so is Dr. R. M. Hughes, and so were Dr. Charles E. Friley and Grant Wood, whose positions and friendship facilitated the materialization of Petersen's greatest dream—his greatest, that is, to date. Through his sculpture, Petersen has given a unique and unforgettable aspect to the Iowa State College physical plant, and through his teaching, he has given his students a cultural outlook that will interpenetrate many lives.

Whitaker explained that Petersen began his art career in die cutting and "became one of the foremost commercial medalists in the country." He then explains:

Many marble and stone sculptures seen today are exact, mechanical reproductions of models first made in clay. They are not truly "carvings." Often the sculptor himself limits his work to the making of the clay model, leaving subsequent procedure to commercial cutters. Petersen has no patience with such methods. He adheres to the revered principle that stone should be handled as stone.

The writer pointed out the differences between carving in stone (subtracting something from a parent mass) and modeling in clay (building a sculpture by addition of a material). He added:

Terra cotta is kiln-fired clay. Petersen's work in this material is frankly clay modeling, embracing all those nuances and individuality that only a practiced and sensitive thumb can produce. For modeling is done mostly with the thumb—a fact difficult to believe when one views a heroic bronze. But when Petersen's plans encompass stone or marble, he carves.

How much of today's sculpture is modeled or carved by the artist? Have the two most ancient art forms been totally replaced by commercially welded, fabricated, poured and assembled media? The craftsmanship and artistic skill required for creating realistic human forms in classic bronze or stone may be reviving as an American art form. Three startlingly lifelike bronze figures by sculptor Frederick Hart were installed in 1984 adjacent to the Vietnam war memorial in Washington, D.C. These gained immediate recognition and praise from veterans who regarded them as appropriate representations of their comrades memorialized in the 1982 granite tribute to the war dead. These figures exemplify themes of realism—as did Christian Petersen's—in sculpture and are meaningful contemporary visual art.

A regional sculptor of midwestern subjects

As an American regional artist, Christian Petersen portrayed midwestern subjects: pioneers of the prairie, a champion cornhusker, farmers, flood, drought, dairying, prize draft horses and cattle, and veterinary care. These subjects have—if at all—rarely appeared in the work of other American sculptors, perhaps because few of them lived or worked actively on a farm. Thus Petersen's many pieces on an agricultural theme are extremely rare.

His works also represent extraordinary sculptured forms and media: most of his bas reliefs and sculptures-in-the-round were of terra cotta. Petersen's work with Paul Cox was a singular and notable accomplishment in art and in ceramic technology. Together they crafted the most ancient sculpture medium, "cooked earth" ob-

tained from native clays.

The dairy industry mural and interior panels were fifty years old in 1985, while the veterinary bas reliefs and *Gentle Doctor* sculptures neared their fiftieth year. The latter two works are worthy of national recognition as historic landmarks in American art and education. Nothing of their quality and significance exists on any campus.

Petersen's role in American art history

As artist-in-residence at Iowa State College from 1934 until his retirement in 1955, Christian Petersen is the only sculptor known to have served such a lengthy and productive career—twenty-one years—at a state-supported college. As a working teacher-artist, he pioneered in hands-on sculpture classes and art appreciation for rank beginners and non-art majors at a land-grant agricultural college, enhancing the lives of students, faculty, and townspeople for decades thereafter.

Emma Lila Fundabirk and Thomas G. Davenport, in their comprehensive book titled *Art in Public Places in the United States,* noted, "[Iowa State University] is primary among those schools which have made efforts to place art on their campuses." The authors ranked Iowa State along with Princeton, the University of California, University of Texas, California State College at Long Beach, and the University of Houston.[6]

In their book, *Art at Educational Institutions in the United States,* Petersen's library *Boy and Girl,* Memorial Union fountain, veterinary sculptures, dairy, home economics, and Oak-Elm figures are pictured and listed in a handbook-directory of significant art in colleges, universities, and public schools. Fundabirk and Davenport compiled data from 10,000 inquiries sent as research for the 600-page book. If a more outstanding collection of campus-created sculptures exists, or if any artist-in-residence served a longer or more productive career than Christian Petersen, such accomplishments are not evident from study of Fundabirk and Davenport's extensive listings.[7]

Fundabirk's *Visual Arts in the United States,* co-authored by Mary Douglas Foreman and published in 1976, also noted: "Iowa State University has long been known for the many sculptures by Christian Petersen which were created for that campus in the 1930s and 1940s." Until the turn of the century, Fundabirk reminds us, art was confined mostly to big city museums, churches, cemeteries, and capitol buildings. But "art has been brought out of its former confines and has been made available to the public in places where they work, trade, travel, rest, and play." She lauded federal art funding of the 1930s, "which put artworks into schools, libraries, post offices, and other public buildings" but noted that World War II ended that trend. "The government did not again become a patron of the arts until the mid-sixties."[8]

Thus Petersen's sculptural works at Iowa State represent a monumental achievement in a difficult era of American art history. He was a talented but unrecognized regional artist who quietly dedicated his life to capturing the essence of the Midwest

in images of Americana, modeling clay and carving stone into portraits and studio pieces of pioneers, Kentucky hill country sharecroppers, Osage and Mesquakie Indians, great scientists like Carver and Pammel, beautiful young women, sturdy midwestern college students, classic Jersey cows, a champion Percheron draft horse, saints and sinners, ministers, athletes, a gentle veterinarian, governors, presidents, a 4-H youth, a famed Iowa painter, soldiers, and the beloved children of his midwestern world.

Christian Petersen, teacher

Petersen's exceptional career was notable in another important respect. He gave hundreds of college students a lifelong appreciation for sculpture as an art form. As they struggled with clay or stone in the primitive veterinary quadrangle studio, they developed a lasting respect and understanding for the esthetics of all visual art forms and for the accomplished artists who create them.

Petersen represented teaching at its best. He left his students with memories of his constant dedication to excellence, and confidence that they could judge for themselves what is good and valid in art. He opened their eyes to the artistic beauty they might find in the world the remainder of their lives.

He also epitomized those dedicated and unrecognized educators at Iowa State College who devoted their careers to all students, not only the exceptional ones.

Gifts

Although Charlotte and Christian Petersen gave tremendous contributions of personal effort to Iowa State College, they were never well-rewarded financially. He was severely penalized for lacking a college degree all during his career. Reaching the rank of associate professor only shortly before his retirement in 1955, he received minimal pension benefits because annuities and retirement plans for state employees were just beginning to be established. He had worked in a low-salary era and retired at the age of seventy without the extensive Social Security and public employee benefits.

From the Iowa Public Employee Retirement System his pension was $21.01 a month; from an annuity program called "TIAA," he received $36.58; and from the federal Social Security program, his pension was $98.50 per month. Thus the Petersens retired at an income only slightly above his salary level during the depths of the Depression, twenty years before: $150 monthly. Of course postwar inflation had cut the buying power of a 1955 dollar to about half what it was in 1935.[9]

What, then, were Christian and Charlotte's rewards for their years at Iowa State? Why did they choose to remain there? Their treasured compensation was a rich accumulation of caring and sharing the delights of the world and people around them. They were entertained by the graceful wigglings of their baby daughter's toes; buoyed by the respect and intellect of their friends among the faculty, students, and townspeople; rewarded by the first violets of spring or the

first watermelon of the summer. Above all, they found quiet exultation in each new sculpture Christian completed or the next one he had in mind. The Petersens reaped an abundant harvest of an enriched life because the best things in their lives were not measured in money. The world around them offered other treasures they valued more.

They gave wholeheartedly of themselves in countless ways, such as offering a perpetual open-house welcome for friends and neighbors or furnishing bed and board for students who needed a temporary place to stay. After World War II, when campus housing was scarce, they furnished temporary shelter to a number of veterans who needed a place to stay—for a night, a week, a quarter, or in one case, for a year. They never charged rent.

They were devoted to each other, to their daughter Mary, and to Christian's career and students. Academic credentials and professorial politics were not Christian Petersen's style. The opportunity to be a working sculptor and share his knowledge with students was golden—even if the paychecks never were.

"We gave it all willingly," said Charlotte, in retrospect, "it was growing—being part of a college campus, with all the young people. We grew right along with them." She added, "Of course we didn't have the social events, the travel, or the campus entertainment they have now, but life was wonderful in Ames. We had many friends, we adored the students, and we enjoyed potlucks or picnics or impromptu get-togethers. It wasn't a sophisticated life by today's standards. But it was a wonderful life."

CHARLOTTE PETERSEN, 1984. SVO

Tributes

Charlotte always loved to tell audiences about her husband, because of her concern that a lot of people at Iowa State knew very little about him or his college sculptures. She regretted that many faculty or students had never seen or heard of the beautiful dairy courtyard, for example, and that few people on the campus could name most of her husband's major sculptures.

Charlotte long harbored three wishes for Christian's works: that each be marked with the name of the sculptor who did them, that they be preserved and protected from vandalism and weather, and that Christian Petersen would be honored and remembered for the heritage of sculptures he left for each new generation of faculty or students.

During his lifetime, the Danish-born artist was deeply appreciated and often praised. J. Raymond Derby, chairman of the English department in 1938, told a WOI radio audience in November of that year, "[Petersen] has made the plastic arts come alive in central Iowa. No longer is sculpture something that has survived Grecian antiquity, to be confined within museum precincts."[10]

Petersen's friend Charles Rogers called him " . . . an artist of the people. He believes that the beauty of any art object must ultimately be decided by ordinary men, unsupported by the artist's 'name' or previous recognition."[11]

The Ames *Daily Tribune* editorialized: "The death of Christian Petersen last week was a loss to the community and the University. We sincerely hope the works of Mr. Petersen will be appreciated and long remembered by the students and faculty of Iowa State."[12]

The Attleboro, Massachusetts *Sun* also ran a tribute on its editorial page:

Christian Petersen's work in Attleboro has not been equalled or excelled. He enabled the Robbins Co. to achieve a foremost position in medallic art and in some branches of silverware. His artistry and craftsmanship started the Balfour Co. on a plane above competition. The bronze Ruth Holden-Alice Haskell Memorial, which was in the Attleboro Public Library, and will be placed in the new nurses' home at

DETERIORATION OF TERRA COTTA AND MASONRY MORTAR JOINTS OF ROBERTS HALL FOUNTAIN, 1983. **AUTH**

Sturdy Memorial Hospital, was designed and modeled by Petersen soon after World War I. A deserved recognition of his ability came with many honors after leaving Attleboro. His achievements were many.[13]

Marcia Olson, a staff writer for the Iowa State *Daily,* student newspaper, never met Christian Petersen. She wrote in June 1975, fourteen years after his death:

> Christian Petersen, sculptor . . . has created all of the large artwork to be found on this campus. The curious explorer will discover that some of Petersen's statues, panels and fountains are still noticed and appreciated, but others have fallen into hard times, being neglected, overlooked, and forgotten.[14]

At that time, the Roberts Hall fountain basin had been removed and few students or faculty had ever seen the bas reliefs there. The dairy courtyard bas reliefs were obscured by an overgrowth of vines across the surface of the terra cotta panels, the fountain was turned off, and the reflecting pool was full of scummed, stagnant rainwater.

Christian Petersen's widow was gratified when, in 1976, the original weather-worn terra cotta *Gentle Doctor* was refurbished and placed on the main floor of the Scheman building at the Iowa State Center. A new bronze casting of the figure took its place in front of the bas relief murals at the new Veterinary College building complex. "Those vets," she says with pride, "have never forgotten Christian Petersen."

At the age of 86, Charlotte Petersen added one more wish: that the Roberts Hall bas relief sculptures could be moved to an indoor location where the gentle fountain could be restored and the bas reliefs would once again be enhanced by an appropriate setting. Charlotte believed that the beautiful nude sculptures need not be hidden and forgotten in the 1980s.

Christian Petersen remembered by Iowa State University

The College of Design at Iowa State University established an annual Christian Petersen Design Award in 1980 to honor staff, faculty, alumni, and friends of the university "in respectful memory of his tireless efforts in encouraging a lively interest and appreciation for the arts among his many students from all departments of the University." The first recipient of the award was W. Robert Parks, president of the university.

In the mid-1970s the Brunnier Gallery produced an outstanding audio-visual presentation on Christian Petersen's Iowa State University sculptures, a sensitively written tour of his campus works. The presentation deserves wide circulation within the state of Iowa so that more Iowans can discover the remarkable accomplishments of the artist.

By 1985 the Brunnier had gained museum status and was renamed the Brunnier Museum and Gallery. Under the able direction of Lynette Pohlman, a walking-tour map of visual art at Iowa State was published, featuring Christian Petersen's sculptures. This tribute appeared in the introduction:

> It has been said that rarely has a college been so unified by the stamp of one artist . . . Iowa State University is more than just a campus of science and technology, it is a campus rich with the visual arts: everything from abstract sculpture to ceramic murals to stained glass.

RELIGIOUS FIGURE AND PORTRAIT BUST, IN STORAGE, 1985. **SVO**

Of special interest will be the gentle "people" created by the late Christian Petersen. . . . Petersen's sculptures encompass many facets of student and family life and have been much loved by Iowa Staters since the artist's arrival on campus in 1934.

Christian Petersen's extraordinary sculptural accomplishments deserve to be recognized, preserved, and honored as our heritage in American art because they were created for us. Fifty years ago, when he foresaw an emerging American art, Petersen believed the Midwest could be an important place for it to grow. He then asked for our help as he reminded us:

For it is you who make your artists, and through them, you shall be remembered.

Epilogue

SINCE this manuscript was completed in February 1985, these events have occurred:

With the help of longtime friends Bernard and Virginia Slater, Charlotte moved to a retirement home in Rockford, Illinois, in late May 1985. Studio pieces and items of memorabilia in her collection were sold to private collectors in Ames. The Memorial Union, Brunnier Gallery, Veterinary College, and ISU library Department of Special Collections purchased original sculptures and sketches (noted in Chapter 6).

In spring 1985, Charlotte and Mary Petersen discovered four original sketches by Christian Petersen for *The Gentle Doctor* stored in Charlotte's Ames apartment. Presented as a gift to the library of the College of Veterinary Medicine, the sketches were among a collection of more than a hundred, which had been unseen since about 1945.

Also discovered were a number of photographs and negatives. These included photographs of Christian Petersen posing for a portrait by an unidentified sculpture student; a bust of Frank Johnson, Rockford, Illinois, painter who loaned the Petersens money for travel to Iowa City in 1934; Charles Rogers, Iowa State College journalism professor, posing for his portrait with the artist; a bust of Burt Adams, one of Petersen's colleagues at the Iowa City PWAP art workshop; and a bust of Francis McCray, head of the University of Iowa art department in 1934.

After Charlotte Petersen's death December 15, 1985, a number of original sculptures remained in storage, subject to purchase negotiations by Mary Petersen and institutional or private collectors. Among them were Petersen's bust portraits of Johnson, McCray, and Rogers.

In spring 1986, Pegasus Productions of Ames, Iowa, under a 1984 royalty agreement with Mary and Charlotte Petersen, announced the availability of several sculptures reproduced in bronze and Durastone, plans for publishing a series of sketches, and publication of a guidebooklet to Petersen sculptures in publicly accessible locations in Ames and the state of Iowa.

With the assistance of university officials, the author submitted a preliminary nomination of the sculptor's dairy courtyard sculptures to the National Register of Historic Places in October 1985. The formal application nomination was pending in May 1986.

The vandalized home economics children's fountain was again scheduled for repair in the summer of 1986.

Iowa State University's Brunnier Museum and Gallery announced an art conservation program in which all Christian Petersen outdoor sculptures were to be inspected and repaired by a professional art conservator in 1986, in an annual maintenance program.

The Christian and Charlotte Petersen Memorial Fund was established by the Iowa State University Alumni Achievement Fund through the Brunnier Museum and Gallery in January 1986, with initial contributions from Dr. and Mrs. John Salsbury, Robert and Beverly Gilbert Bole, Pegasus Productions, and the Veterinary College. The Fund will be reserved for maintenance of Christian Petersen's campus sculptures, acquisition of pieces now privately owned by collectors, and assuring continuing recognition of Christian and Charlotte Petersen's contributions to visual art at Iowa State University. The first project will be marking each of Petersen's campus sculptures with commemorative bronze plaques in the summer of 1986. Inquiries may be directed to Lynette Pohlman, director of the Brunnier Museum and Gallery.

An excellent portrait of Christian Petersen was discovered among Charlotte Petersen's treasured mementoes in fall 1985. A pencil sketch by artist Frank Johnson of Rockford, Illinois, the portrait was completed when Johnson was at Iowa State College in 1943, creating oil portraits of faculty members and of his longtime friend, Christian Petersen.

P.L.B.

May 1986

Pencil portrait of Christian Petersen by Frank Johnson, Rockford, Illinois, portrait painter who loaned the Petersens traveling funds for their trip to Iowa City in January 1934. CGP

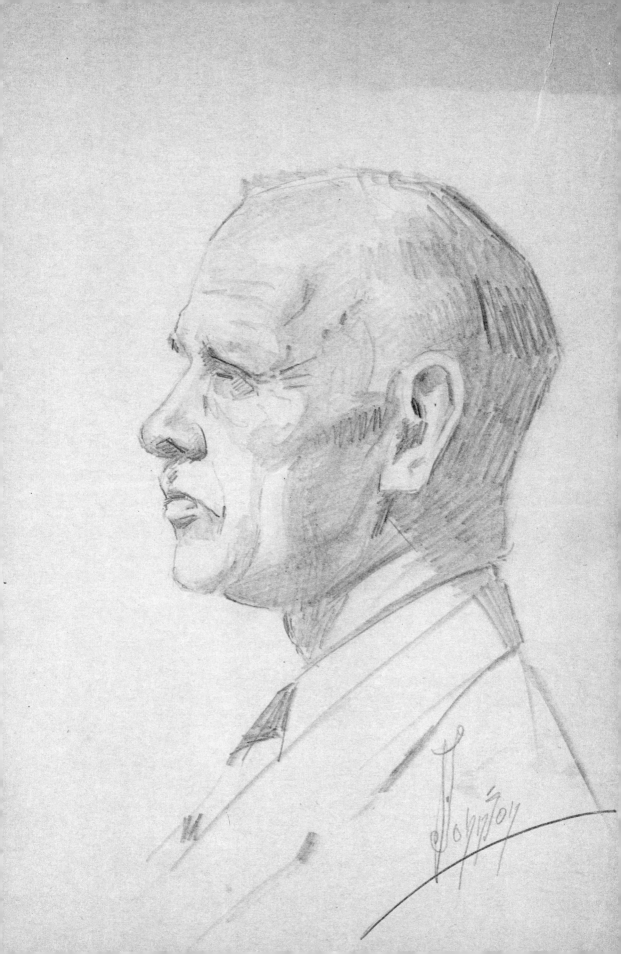

Notes

ABBREVIATIONS

CPP: The Christian Petersen Papers, Department of Special Collections, Iowa State University Library.

CGP: Documents furnished to author by Charlotte Garvey Petersen, 1983, to be added to the Christian Petersen Papers.

COMMUNICATIONS: More than ten hours of interviews with Charlotte Petersen from March 1983 to September 1984 provided the continuity and personal reminiscences that augment the documents in CPP.

PROLOGUE *A Letter from Grant Wood, January* 1934

1. Grant Wood, letter to Christian Petersen, January 16, 1934, CPP.
2. Christian Petersen, letter to Grant Wood, January 18, 1934, CPP.

CHAPTER 1 *A Journey from Denmark to America, 1894–1929*

1. Jessie Merrill Dwelle, *Iowa, Beautiful Land*, 1958 edition revised by Ruth Wagner (Mason City, Iowa: Klipto Loose Leaf Co., 1952), pp. 182 –184.
2. George Nerney, letter to Charles E. Rogers, July 6, 1942, CPP.
3. *Who's Who in American Art*, Biographical Directory (Washington: American Federation of Artists, November 15, 1935), p. 362; also see *Iowa Civil War Memorial, 1908 –1911*, Adjutant General's Office, State Capitol, Des Moines, p. 38.
4. Nerney to Rogers, 1942.
5. Boston *Transcript*, June 1918 (mimeographed typescript, no exact date), CPP.
6. Boston *Traveler*, 1920 (mimeographed typescript, no exact date), CPP.

7. Boston *Transcript*, circa 1924 (mimeographed typescript, no exact date), CPP.
8. *National* magazine, (Boston) January 1922 (mimeographed typescript, no exact date), CPP.
9. Richard D. McKinzie, *The New Deal for Artists* (Princeton, N.J.: Princeton University Press, 1973), p. 4.
10. Thomas Craven, *Harper's* magazine, 171 (September 1939), p. 430.
11. Jessie Merrill Dwelle, *Iowa, Beautiful Land*, p. 184.
12. Rene d'Harnoncourt, quoted by Matthew Baigell, *The American Scene, American Painting of the 1930s* (New York and Washington: Praeger, 1974), p. 55.
13. Christian Petersen, unpublished writings, CPP.
14. Christian Petersen, letter to Edgar R. Harlan, June 21, 1929; The Harlan Papers, State Historical Library, Iowa Historical Department, Division of History and Archives, Des Moines, File 25b, part 3, Grp II.
15. J. C. Cunningham, handwritten biographical sketch of Christian Petersen, CPP.

CHAPTER 2 *A Scandinavian-Irish Partnership*

1. *Time* magazine, 33 (February 19, 1934).
2. Des Moines *Register*, January 1, 1934, p. 1.
3. Ames *Tribune-Times*, March 3, 1934.
4. Ames *Tribune-Times*, January 2, 1934.
5. Document on file, Iowa State University Archives, Department of Special Collections, Library.
6. Eastman Weaver, letter from Harlan, December 5, 1932; The Harlan Papers, State Historical Library, File 86F, part 11, 1916 –1936; File 25b, part 3, 1916 –1937; File 10f, part 13, 1930 –1932.

7. Paul Francis Jernegan, letter to author, December 31, 1983.

8. Grant Wood, letter to Christian Petersen, January 10, 1934, CPP.

9. John Pusey, letter to Christian Petersen, April 1935, CPP.

10. Robert Hilton, *Profiles of Iowa State History* (Ames, Iowa: Iowa State University Press, 1968), p. 41.

11. Neva Petersen, interview with author, June, 1985; "Artistic and Historical Features of the Library," 2 (November 19, 1947), Iowa State College Library; "Beauty on the Campus," Lillian Hall Crowley, *Social Progress:* 9 (March 1925), pp.72–73.

12. Christian Petersen, unpublished writings, CPP.

13. Margaret Gilpin Reid, "Iowa Incomes, as Reported in Iowa Income Tax Returns," *Agricultural Experiment Station Research Bulletin* 236 (1934).

14. Iowa State College Salaries, *Report of Iowa State Board of Education* (June 1934), pp. 286–319.

CHAPTER 3 *Iowa State College Artist-in-Residence*, 1934

1. Lewis Minton, letter to author, October 10, 1983.

2. Raymond M. Hughes, letter to Christian Petersen, June 13, 1934, CPP.

3. Paul E. Cox, letter to Hughes, June 12, 1934, CPP.

4. Cox, letter to T. R. Agg, April 16, 1935, CPP.

5. Edna Mortensen Kiely, letter to author, April 17, 1984.

6. Raymond M. Hughes, annual report to faculty of Iowa State College, *Iowa State College Bulletin*, 34 (September 18, 1935), pp. 21, 25, 28; see also Arthur C. Wickenden, *Raymond M. Hughes, Leader of Men* (Oxford, Ohio: Miami University Alumni Association, 1966), p. 80.

7. Typed notes by Charlotte Petersen, CPP.

8. Christian Petersen, unpublished writings, CPP.

9. Mrs. Lewis Worthington Smith, Iowa Author's Club, unpublished manuscript, circa Fall 1935, CPP.

10. *Iowa, a Guide to the Hawkeye State* (New York: Viking Press, 1938), p. 147.

11. Lea Rosson DeLong and Gregg R. Narber, *A Catalog of New Deal Mural Painting* (Des Moines: privately published 1982).

12. Charles Rogers, interview with Martha Duncan, WOI radio, November 1942, CPP.

CHAPTER 4 *A Gentle Sculptor Creates* The Gentle Doctor, 1936

1. Harriet Allen, interview with author, June 11, 1983.

2. Mac Emmerson, DVM, interview with author, May 10, 1985.

3. Charlotte Petersen, typed notes for Veterinary sculptures, circa December, 1935, CPP.

4. Raymond M. Hughes, letter to Christian Petersen, October 25, 1935, CPP.

5. Hughes to Petersen, May 10, 1935, CPP.

6. Petersen to Hughes, December 29, 1935, CPP.

7. Petersen to Hughes, January 10, 1936, CPP.

8. Charles Murray, notes for publicity on Veterinary mural sculptures, CPP.

9. L. M. Forland, DVM, letter to author September 15, 1983.

10. Marie Born Green, letters to author, September 30, 1984 and October 14, 1984; telephone interview, October 20, 1984.

11. P. H. Elwood, letter to B. H. Platt, May 10, 1938, CPP.

12. Richard B. Talbott, letter to Phillip Pearson, April 30, 1980, CGP.

13. Frank Ramsey, DVM, letter to Charlotte and Mary Petersen, June 3, 1985.

14. Annual awards program, College of Veterinary Medicine, Iowa State University, May 1, 1984.

15. Ames *Daily Tribune*, October 14, 1976, CGP.

CHAPTER 5 *Creating Campus Landmarks*, 1938–1955

1. Ames *Tribune-Times*, January 1, 1935, CPP.

2. Ibid.

3. "Sancta Ursula," William Aspenwall Bradley, *Century* magazine, 94 (July 1917), p. 405, CGP.

4. Christian Petersen, unpublished writings, CPP.

5. Lois LaBarr Moses, interview with author, September 20, 1983; interview, October 12, 1983.

6. George Nerney, letter to Petersen, August 19, 1941, CPP.

7. Charles E. Rogers, interview with Martha Duncan, WOI radio, November 1942, CPP.

8. August Bang, *Julegranen* (December, 1943), CPP.

9. Nile Kinnick, Sr., telephone interview, October 20, 1984.

10. Rogers interview.

11. Ruth Deacon, letter to author, November 22, 1983.

12. Ames *Daily Tribune,* June 10, 1949, CPP.
13. Dycie Stough Madson, letter to author, September 28, 1983.
14. Iowa State *Daily,* December 11, 1978, CPP.
15. Ames *Daily Tribune,* February 7, 1961, CPP.
16. Des Moines *Register,* January 10, 1954, CPP.
17. Iowa State *Daily,* December 11, 1978, CPP.

CHAPTER 6 *Imagery in Clay and Stone,* 1934–1961
1. Charles E. Rogers, interview with Martha Duncan, WOI radio, November 1942, CPP.
2. Edna Mortensen Kiely, letter to author, April 17, 1984.
3. Journal and inventory, sale of Christian Petersen studio property, 1964, CPP.
4. Christian Petersen, unpublished writings, CPP.
5. Marion Link, interview, August 20, 1984.
6. Inventory, 1964, CPP.
7. Christian Petersen, unpublished writings, CPP.
8. Business correspondence file, McGuffey Committee letter, CPP.

CHAPTER 7 *Christian Petersen Remembered*
1. Ames *Daily Tribune,* September 29, 1950.
2. Leo Peiffer, letter to author, August 18, 1983.
3. Maggie Kolvenbach, letter to author, August 1, 1983.
4. James Dixon, letter to author, August 15, 1983.
5. Viola Kietzke Barger, letter to author, August 13, 1983.
6. Glen Jensen, letter to author, September 14, 1983.
7. Robert Copenhaver, letter to author, February 7, 1984.
8. Lois LaBarr Moses, letter to author, September 1, 1983.
9. Dale Welbourn, letter to author, August 24, 1983.
10. Dycie Stough Madson, letter to author, September 28, 1983.
11. Mary Jean Stoddard Fowler, letters to author, April 15, 1984; May 15, 1984.
12. George-Ann Tognoni, interview with author, June 11, 1983.
13. Marian Moine Beach, letter to author, September 29, 1983.
14. Sheila Dunagan Sidles, letter to author, May 23, 1984.
15. Margaret Leonard Buck, interview with author, August 10, 1985.

16. Barbara Taylor Davidson, letter to author, February 8, 1984.
17. Dori Bleam Witte, letter to author, August 23, 1983.
18. 1951 Iowa State College *Bomb* yearbook.
19. Herb Pownall, letter to author, March 11, 1984.
20. John Edenburn, DVM, letter to author, January 1, 1986.
21. Program, Veishea Central Committee, 1957, CGP.
22. Marjorie Garfield, letter to author, November 12, 1983.
23. Ann Munn McCormack, letter to author, August 31, 1983.
24. Mrs. Bayard Holt, letter to author, August 31, 1983.
25. Martin Fritz, letter to author, September 20, 1983.
26. Martin Weiss, letter to author, June 26, 1984.
27. Louise and Harry Beckemeyer, letter to author, November 29, 1983.

CHAPTER 8 *Finding Faith in Three Dimensions,* 1949
1. Ames *Daily Tribune,* October 4, 1947.
2. News release, Dubuque Diocese, 1950, CPP.

CHAPTER 9 *A Dedication to the Future,* 1961
1. J. W. ("Bill") Fisher, letter to Christian Petersen, September 15, 1959, CPP.
2. Fisher, letter to Petersen, October 3, 1959, CPP.
3. Christian Petersen, letter to George Nerney, undated, circa late October 1959, CPP.
4. Petersen to Nerney, undated, probably in February 1960, CPP.
5. Program for unveiling of *A Dedication to the Future* at Fisher Community Center, Marshalltown, Iowa, September 29, 1961, CPP.
6. Requiem eulogy by Fr. Clarke, SS. Peter and Paul Catholic Church, Gilbert, Iowa, April 7, 1961.

CHAPTER 10 *The Christian Petersen Papers: A Retrospective*
1. Stanley Yates, letter to Charlotte Petersen, March 5, 1973, CPP.
2. J. C. Cunningham, biographical sketch of Christian Petersen, CPP.
3. Sculpture exhibition file, CPP.
4. Geraldine Wilson, *Christian Petersen, Sculptor* (Ames, Iowa: Iowa State University Press, 1962), p. 8.
5. George Nerney, letter to Christian Petersen, March 16, 1939, CPP.

6. Report of Iowa State College Art Committee, June 1945, inventory of college-owned art, CPP.
7. Lynette Pohlman, interview with author, September 1984.
8. Iowa State University Library, notes for faculty, 6(Spring 1974), CPP.

CHAPTER 11 *Commentary*
1. Richard McKinzie, *The New Deal for Artists* (Princeton, N.J.: Princeton University Press, 1973), pp. 124, 125, 194.
2. A. E. Staley Co., letter to author, March 10, 1984.
3. John Anderson, *Iowa Stater,* 10(May, 1984), p. 8.
4. Earl Minser and Ray Murray, "He Has Carved a Heritage," *Iowan* magazine, 8(March 1954), CPP.
5. *Transmission* magazine, Northern Natural Gas Co., 8(1960), CGP.
6. Emma Lila Fundabirk and Thomas Davenport, *Art in Public Places in the United States* (Bowling Green, Ohio: Bowling Green University Popular Press, 1975), pp. 228, 483.
7. Emma Lila Fundabirk and Thomas Davenport, *Art at Educational Institutions in the United States* (Metuchen, N.J.: Scarecrow Press, 1974), pp. 173, 175, 222, 224, 257, 259, 263, 486, CGP.
8. Emma Lila Fundabirk and Mary Douglas Foreman, *Visual Arts in the United States* (LuVerne, Alabama: Fundabirk, 1976), p. 217.
9. Salary and retirement data for Christian Petersen, notations by Marjorie Garfield and Henry Eichling, 1955, CPP.
10. J. Raymond Derby, transcript of radio broadcast on WOI radio, November 22, 1938, CPP.
11. Charles E. Rogers, interview with Martha Duncan, WOI radio, November 1942, CPP.
12. Ames *Daily Tribune,* February 6, 1961, CGP.
13. Attleboro, Massachusetts *Sun,* April 8, 1961, CPP.
14. Iowa State *Daily,* June 12, 1975, CPP.

Index

214

216